T0301174

BEYOND THE
THRONE

KRISTIAN NAIRN

BEYOND THE
THRONE

Epic Journeys, Enduring Friendships,
and Surprising Tales

SPHERE

SPHERE

First published in the United States of America by Hachette Books,
an imprint of Hachette Book Group Inc. in 2024
First published in Great Britain in 2024 by Sphere

1 3 5 7 9 10 8 6 4 2

Copyright © Kristian Nairn 2024

The moral right of the author has been asserted.

A CIP catalogue record for this book
is available from the British Library.

Hardback ISBN 9781408731369
Trade paperback ISBN 9781408731376

Print book interior design by Amy Quinn
Printed and bound in Great Britain by
Clays Ltd, Elcograf S.p.A.

Papers used by Sphere are from well-managed forests
and other responsible sources.

Sphere
An imprint of
Little, Brown Book Group
Carmelite House
50 Victoria Embankment
London EC4Y 0DZ

An Hachette UK Company
www.hachette.co.uk

www.littlebrown.co.uk

To the person who showed me how to be stronger than I could ever imagine,
and who gave me a lifetime of love, support,
and laughter while having the heart of a warrior.
My mum, Pat.

Contents

INTRODUCTION IX

CHAPTER 1 LISBURN 1

CHAPTER 2 THE PAINT HALL 13

CHAPTER 3 ONE STEP FORWARD 25

CHAPTER 4 WHAT THE HELL DID THEY SEE IN ME? 37

CHAPTER 5 BATTLE LINES 47

CHAPTER 6 LANDING ON PLANET GEORGE 61

CHAPTER 7 I LOVE THE NIGHTLIFE 67

CHAPTER 8 THE DRAFT EXCLUDER 77

CHAPTER 9 OUR RAINBOW COALITION 89

CHAPTER 10 JEDI JOHN 99

CHAPTER 11 FREAK MAGNET 109

CHAPTER 12 HODOR, YOUR POUCH IS RINGING . . . 119

CHAPTER 13 STOP MELTING MY UNICORN, BITCHES! 129

CHAPTER 14 FAITH IN ME 139

CHAPTER 15 ON THE RUN 149

CHAPTER 16 THE DOPPELGÄNGER 161

CHAPTER 17 BALLYHORNAN 171

CHAPTER 18 BEYOND THE WALL 177

CHAPTER 19 BECOMING KRISTIAN 187

CHAPTER 20 A FREE CAPTIVE 195

CHAPTER 21 RAVE OF THRONES 205

CHAPTER 22 THE FINAL PUSH 213

CHAPTER 23 OWNING THE THRONE 225

CHAPTER 24 OUR FLAG MEANS DEATH 237

 ACKNOWLEDGMENTS 247

INTRODUCTION

"Turn around, Kristian." Connor's voice sounds insistent. Urgent, even. It's midday on a late summer Saturday in 2009—the kind of day when Belfast's redbrick buildings sit distinctively against the Celtic blue sky.

"Turn around? What? No! I'm on my way to lunch."

It's my kind-of agent on the phone. In truth, more of a local talent booker—a guy who saw me perform one night but whose name also appears in the back-page classified adverts of *The Stage* magazine, the oracle for wannabe actors. He'd sprinkled some crumbs of confidence over me.

"I have this feeling about you, Kristian," he'd told me when we first met. "You have this energy about you. The first thing you're cast in, it's going to take off." I didn't believe him, of course. I'd heard bullshit like that before. Besides, not much had worked out so far.

"Sorry. I'm meeting Jim," I snap. Jim is a friend who I've known for twenty-something years. Through breakneck highs and thunderous lows he's been by my side. Unbelievably, he's still loyal. That has to count for something, doesn't it? Plus, I haven't eaten—hangry when my blood sugar is low. "I'm in the taxi already. I'm not turning anywhere!"

Why are you even calling me? I think, irritated.

Jim and I had been due to meet in Union Street just north of the city center. Once, that area had been filled with factories and warehouses as Belfast's industry boomed. Later, bombed-out pubs punctuated the rows during the years of Northern Ireland's bloody Troubles. Now it's filled

with bars and bottomless brunches—a mecca for bottoms in tight tops and tops with tight bottoms. Rainbow flags unfurled proudly—flags that in bygone years would have remained firmly in the closet.

"Kristian, call your friend. Explain you can't make it. Head to mine. I'm telling you, it's the perfect opportunity. I strongly advise you to come," Connor pleads. It doesn't *sound* perfect to me. The creators of a new fantasy show, to be filmed in Ireland the following year, are casting.

"They need a strong, tall character. A giant. He only says one word, so not exactly a speaking role," Connor explains.

"I don't think that's for me," I reply.

"*They've* called *me*. The casting director has asked for you specifically."

"Really?"

"Yes, Kristian!"

"And who is that?"

"Nina Gold."

"Nina Gold? *What?* And *how?*"

I had met Nina once, but I'd paid almost no attention to who she was. Quiet and nondescript had been my first feeling. I certainly didn't have her marked out as a powerhouse in the film and TV industry, albeit in the UK or in Hollywood. Hollywood, for Christ's sakes! That was another universe.

In any case, how could Nina Gold have remembered me? I'd made such an awful impression. Our paths had crossed four years previous when I'd hauled myself to London for an audition for a new Simon Pegg movie called *Hot Fuzz*—his second since the cult zombie film *Shaun of the Dead*. The venue was just off Leicester Square and I'd walked corpse-like onto an early morning flight. After DJing an all-nighter in Belfast—a cocktail of amphetamines still coursing through my body and my hearing shot to pieces—I was hardly in the headspace to give it my all. Besides, the character was a lurching, monosyllabic supermarket assistant called Michael Armstrong who only said two words: "Yarp" for yes, and "Narp" for no.

I'd rolled my eyes, agreed to go, but it hadn't set my pulse racing. The hulk. The big dumb guy. Yes, physically I was spot-on. At six foot, ten

inches tall, no one can argue with that, but I'd fought against the stereo-type of the colossal eejit all of my life.

"Please, can you stand facing this direction and say 'Yarp'?"

"Sure," I said, glancing over at Nina, feeling a mixture of resentment and humiliation.

"Whenever you're ready . . . "

Nina had sat cross-legged making notes as I repeated the same word over and over. *All this way for thirty seconds of "Yarp,"* I thought. She must have heard the rumble of could-not-give-a-fuck horses cantering over the brow of my limited talent. When I looked at her again, she was staring back, expressionless.

"Thank you for coming. Next!" she announced.

As I'd boarded a flight back to Belfast later that afternoon, I knew it would be unlikely I'd hear back. I didn't. Not a word—until now.

I must have done something right . . . but what?

"Apparently, Nina Gold can't think of anyone else for this role. The character is called Hodor. 'Hodor' is the only word he can say," Connor continues.

Here we go again, I think.

"Why? What's his story?"

"No idea. He's a stable hand with a mental disability who looks after a lame boy. That's all I know."

Connor isn't exactly selling this character to me either, but maybe I'd be a fool if I didn't give an audition a try. *What is there to lose?*

"Okay. Where do I need to be? What do I need to do?"

"They want to see you act with a small boy. I've found one. Meet me and I'll take you there. They've asked me to send a taped audition."

"I'll be there," I concede reluctantly.

I ring Jim, apologize, and redirect the taxi from a buzzing Union Street to a suburban housing estate on Belfast's outer limits. Some days can take the weirdest of turns. More than that, the wee fella that Connor has me lined up to act with is attending a family birthday party near to Connor's home. I take a deep breath. *Let's get this over and done with.* By the time I

arrive at Connor's, he's waiting, ready to run through the audition format before we shamelessly gate-crash the party.

Try as I have done over the years, I've still never been able to erase that tape's existence from this universe. It's still out there somewhere, roaming the Internet like a virtual Bigfoot. Even now, the mere thought of it makes me cringe: my bleached-blond hair, my baggy jeans and faded Batman T-shirt, lugging myself around a stranger's back garden.

"Can you do an amble? Look as if you're in a hurry?" Connor calls out. *Sure.* I stagger my way up and down the square patch of grass, arching my back so it looks as though I'm dragging an iron weight.

"Can we see some interaction with Bran?" Bran is the lame boy's name, although the boy acting alongside me is called Thomas in real life. He's lovely and eager and desperate to please.

"Hodor!" Thomas shouts.

"Hodor," I repeat as he climbs on my shoulders and rocks himself up to a piggyback position, legs dangling around my shoulders. Then, more running up and down the garden with Thomas on my back while my belly roars with hunger and beads of sweat break on my forehead.

For fuck's sake. How much more of this do you want?

"Hodor. Table," Thomas shouts once I've placed him down. Now my caveman strength is being tested. I wrestle a mahogany dining table that has been left outdoors to weather in the elements, wielding it above my head like a world championship title belt. Then I carry an ornamental wooden wishing well. Yes, an ornamental wishing well. No one can say I don't suffer for my art, but I am as clumsy as fuck.

"Hodor!" another guest shouts from a corner of the garden.

"Hodor!" I repeat, spinning around in the opposite direction. The name gets passed from person to person like a football and I run towards each caller repeating it, momentarily trapping it before it moves on.

Out of character, I stare down the lens awkwardly and speak briefly about myself. I grew up nearby in Lisburn. I spent my life on a farm.

"You're a person of some exceptional strength," Connor prompts me.

You have no idea how much, I think. *It's taken me a lifetime to think that this is even possible.*

"Yes, I am," I say through gritted teeth and nod politely.

"And please, can you say your name again," Connor directs me.

"*Kr-is-tia-n Nai-rn*," I repeat, almost spelling it out to cover over my thick Irish brogue. I'm worried that anyone watching won't understand my accent, even though I feel sure that no one will even remember my name.

By the time the taxi arrives to drop me back into town, I've tried to shut out the whole bemusing afternoon from my brain. Without doubt, it is the most random shit I've ever done, and I wince with embarrassment. Even as we'd wrapped up filming, the whole birthday party had gravitated outside to gawp at the spectacle. *I am going to get laughed out of the park*, I reckon.

By the time Connor calls me some days later, I've already resigned myself to the thanks-but-no-thanks call, if there has been a call at all.

"Hi, Connor. What's up?"

"Kristian, the producers want to meet you. They really liked you. I think you're going to be offered the part," he tells me excitedly.

I feel my chest lurch forward, but I keep my voice calm. I don't want to feel the sting of disappointment if none of this comes true.

"I am?"

"Yes, they want to meet you in person."

"They do? Who does?"

Considering the epoch-defining phenomenon *Game of Thrones* is to become, there is zero buzz about it around Belfast. Not even a frisson. This fantasy show is being produced by the American network HBO.

"It's going to be massive," Connor tells me. "Everyone in the US is talking about it."

No one is talking about it here, I think, wondering whether Connor is stringing me a line. Apparently, the brains behind it are two American showrunners called David Benioff and Dan Weiss. Connor's never met them.

"They're meeting actors in the Fitzwilliam Hotel," he tells me.

Actor. Even that word sounds strange. I'd been performing for years. In stiletto heels I'd been an eight-foot drag queen. A DJing drag queen called Revvlon and now a DJ under my own steam. But an actor? I *do have* heaps of potential, I know that. And a barrelful of resilience—trust me, I've needed it. But "actor" sounds far too grand for the likes of me.

"Okay, I'll go," I promise. Fake it till you make it. That's another life lesson I've learned. But the Fitzwilliam? It's only one of a handful of luxury five-star hotels in Belfast city center. Ordinarily I wouldn't be seen dead there. I do have delusions of grandeur, but elevator music and velvet wingback chairs is not my style. Give me Dracula's living room any day— a touch of the Gothic is where I feel most at home. But, whatever doesn't kill you makes you stronger.

In the meantime, I need someone to tell. I always need someone to share my anxiety with. Am I making the right decision? Am I on a path that's good for me? What if I fail? I don't trust my abilities at all, and I still don't trust Connor's call. But I also don't want to be the guy who says no. I want to embrace opportunity—be a yes guy who steps outside of his comfort zone to see where life takes me.

There's only one person I know who will give me the most honest feedback: my mum. I know, I know. I'm a grown man—thirty-four years old—but I need her now as much as I've always done. I'm not afraid to admit it: I'm a guy who needs a wee bit of looking after, and Mum is all ears.

When I reach her that evening, she's in the kitchen of the house we're renting just south of Belfast. I tell her about the weird-as-fuck audition and the upcoming meeting at the Fitzwilliam Hotel.

"What's the part?" she asks.

"Oh, it's this big guy. He's mute. It's a fantasy thing. I'm not sure about it," I explain.

"What does he do?" Mum seems genuinely interested.

"Carries a boy around. That's about as much as I know." I shrug.

A faint smile breaks across Mum's face.

"That character sounds very familiar," she frowns.

"He's called Hodor. The TV show is going to be called *Game of Thrones* but apparently it's based around some books: *A Song of Ice and Fire*."

Admittedly, I've never heard of the series before or its author, George R.R. Martin.

"Kristian! I've read those books. They're amazing!"

Mum's eyes widen and her mouth drops open like she can't quite believe it.

If there was ever a sign, this must be it.

"Oh yes. I can picture you in that part," she laughs. "There's something very special about that character. I know there is."

At that moment, my outlook switches. It's been hard for me to see beyond an imbecile who can't talk. But if Mum is telling me this could turn out to be a life-changer, then I have to listen. A story with the same gravitas as Tolkien's *The Hobbit* or *Lord of the Rings*, she says.

—

DAYS LATER, MUM'S WORDS ARE STILL RUNNING AROUND MY head when I reach the Fitzwilliam Hotel. The meeting takes place in an upstairs room where there are conference facilities and function suites. It all feels very corporate. As I sit in the waiting area, I've been asked to sign a piece of paper promising I won't blab about the upcoming discussion, which I do without question. I have no sense of the vast machinery behind this production until I enter the room.

Holy shit. Then it hits me. Sitting upright at a top table is a line of people quietly examining me. I'm Jennifer Beals in Flashdance. All I need is a leotard, some 1980s legwarmers, and the Irene Cara track "What a Feeling" blaring in the background. I'm dancing for my life. And the weird thing is, I care. I *really* fucking care. The uncontrollable flutter in my tummy tells me everything I need to know.

"Kristian? Pleased to meet you. I'm David," a chiseled fortysomething with a goatee calls over and beckons me in.

"Hi." I clear my throat and pray my voice doesn't sound like a whimper.

David runs through who's present. Producers, I think, but I'm not taking in their names at all.

"And this is Dan," he continues.

Dan looks around the same age as David: shorter, quieter, and with a shaved head. Both seem intense and focused, and while I can't initially put my finger on it, there's something about them that I admire. As they continue to talk, it strikes me that they are obvious fanboys. Their passion for George R.R. Martin's books has gotten this production off the ground, but while these guys are intimidatingly businesslike, it also sounds like they just love the material. As I listen, they explain more about Hodor the character. Because I take care of Bran, I will have to carry him around a lot.

"Physically, are you prepared for that?" they ask.

"Absolutely," I say. I am physically strong, plus I've been working out in a gym for the past year or so.

"We know the character only has one word, but we're sure he'll be one of the most well-loved characters in this series," David reassures me.

I don't know whether this is all part of their Hollywood spiel, but David and Dan talk about fan forums lighting up over me, memes of Hodor spreading across the Internet. It sounds far-fetched, but I nod appreciatively.

"As a matter of interest, if you are offered the part, have you thought about how you might say the word 'Hodor'?" David asks in his American baritone.

Apart from my dreadful audition tape, I haven't given it one iota of thought. *What do I say?* I panic. *Is Hodor a name? Or something else? Something more profound? What would a "real" actor say?*

I sit in silence for a few seconds knowing that this could be make or break.

"I want it to be less of a name or a word. More of an expression. A reaction," I tell them.

Jesus, Kristian. Will you listen to yourself? I think. If only your school drama teacher could hear you now! I'm the kid who grumbled if he was asked to "be a tree." Yet when I look around, there's a consensus stroking of stubble.

"If you were offered the part, would you be interested in it?" David continues.

Yes . . . and no . . . and back to yes . . . or it could be a no.

"Sure," I say as confidently as I can feign.

"There's just one thing," David says, raising an eyebrow.

"Yes?"

"We would need you to appear naked in one of the episodes. How do you feel about that?"

How do I feel about it? Disgusted. Appalled, in truth. My naked body on show to a million-plus TV audience? *Fuck off!* Mum never mentioned this. Besides, I've spent years trying to hide who I am. For most of my adult life I've been chasing rainbows that never formed the perfect arc. Some have been more Technicolor than Dorothy making her way down the yellow brick road. Others have been far darker and twisty. Some rainbows I've fallen off completely. Being unashamedly "me" feels way too exposing.

Say yes, Kristian, just say yes, I tell myself.

"Okaaaay," I reply, trying to hide my horror.

"Hodor *is* very gifted in that department . . . "

"Right." I pause. *I hope to God they don't want my vital statistics.*

"As you will be acting with a child, we could look at fitting you with a prosthesis."

"I'd prefer that," I say, quickly exhaling. Bad enough that I am going to be naked, but the thought of dancing around on a film set with a small boy, like a giant sex offender, does not appeal at all.

"So you'd be okay with that?" David repeats, just to make sure.

"Sure," I conclude. *If only they knew*, I think. The Kristian of the past would never have dreamed of saying yes. Not to this. Not to any of it . . .

LISBURN

"WHAT'S YOUR NAME?"

"Who are you working for?"

"Who gave you your orders?"

Mum is standing rigid in front of me while I bark out questions. This time she won't get away. I have her imprisoned and this is an interrogation. It's 1979 and I am Wonder Woman. Or at least I think I'm Wonder Woman. I watch Lynda Carter every Saturday night on our geriatric TV. It sits in a wooden cabinet on stubby legs in the corner of the living room and we have to slap it to make it work, but when she appears, she lights up the room.

Wonder Woman has a red-white-and-blue star-spangled suit. I love the way her cape billows out from behind her as she high-jumps onto buildings and fights the forces of evil with her Amazonian powers. If only I owned a pair of those red-and-white knee-length boots with the cute kitten heels! I don't know why I'm drawn to them, but they are to die for.

My Lasso of Truth is *the* favorite weapon in my arsenal. Okay, it's not exactly the same as Wonder Woman's Lasso of Truth. Instead, I have a Hula-Hoop of Truth. It's indestructible and makes bad people confess. Mum's budget can't stretch to gold rope, she says. Anyhow, my blue plastic Hula-Hoop mostly does the job. If Mum is too quick and I can't get it over her head, I just bash her legs with it.

"Okay, Kristian, enough now," she calls out, exasperated, bending so that I can easily drop the hoop over her. Mum wears a wry smile. She knows all the twists and turns of this story. I am *always* a roving reporter inexplicably languishing in prison when I get news of a crime. Arms outstretched, I spin around and around until I make myself dizzy before I bust out to save humankind. My poor mother has played every shade of villain drawn from my overactive imagination.

She helped me with other parts of my costume, too. I have thick cuff bracelets. Mine don't shine from each wrist like Wonder Woman's do, but I wear them with pride. They are brown cardboard toilet-roll tubes and I wield my hands around like shields to defend myself against bullets and attacks. I am less bling, more Sellotape and string, but I don't care. I *love* dressing up.

At four years old, almost all of my superheroes are women. They are the roles I want to act out, the people who inspire me. More than that, I see myself as a protector of the universe. And as far as I can tell, the protectors of *my* universe are women, so I take my cue from those around me.

Mum and I live on her parents' farm: six of us crammed into a dilapidated three-bedroom house. Until I am around twelve, she and I will share a tiny room. In my earlier years, we share a double bed before it's replaced with bunk beds. Her brothers, Lawrence and Raymond, sleep in a separate room. My granda, Alfie, takes the remaining bedroom, while Evelyn, my nanny—who I call Nan—can be found curled up on the downstairs sofa, covered over with thick woolen blankets so that all you can see is her bonnet of dyed red hair poking out. I never think it looks comfortable, but according to Mum, she prefers it to climbing into

bed with Granda. I don't question why—it's just the way things are—but I think I have some answers. Granda seems unpredictable. He's someone I watch carefully in a way I rarely have to with Mum or Nan.

As far as I'm concerned, though, we live in a rural oasis. Ours is a unique blend of family dysfunction, but largely undisturbed by outside forces. I see them not as a crazy, angry, mixed-up family, but simply *my* crazy, angry, mixed-up family, and I love them. They are my territory to defend, especially my mum, who I know I would lay down my life for.

Where we live, the crackle and spit of city life barely touches us. In Belfast I've seen the metal cranes lining the famous Harland & Wolff shipyard, arching their backs over the River Lagan and the vast stories of scaffolding encasing the hulls of ships being built. In other parts of the city, there are rows upon rows of terraced houses that have bricked-up windows and graffiti scrawled across high walls.

"Belfast is dangerous," Mum warns whenever it flashes up on the news. And it feels bleak whenever I go there with Uncle Lawrence to Smithfield antiques market. He collects military memorabilia and treats me to a comic or two—a reward for making it through the concrete and the corrugated iron and the soldiers on street corners clasping their guns. Mainly, though, I'm oblivious. Only eight miles south in the Lagan Valley, we are surrounded by rolling hills, fields filled with potatoes, carrots, or barley, and land scattered with grazing livestock.

Nonetheless, our house has its own demarcation lines negotiated by a cease-fire of unspoken rules. Nan runs our home from her seat of power: the kitchen table. She is as steadfast as the coordinates on any map. You can always find her in the same spot, knuckles plunging into freshly mixed dough, writing shopping lists, or totting up sums on scraps of paper. She appears a timid woman, soft and quietly spoken, but I sense underneath she is as tough as boot leather.

Mum often joins her at the table, and I love sitting with them and listening when they talk. I especially love the story of my birth. I could listen to that story over and over. I feel invincible, as if I'm the star of my own legend. I'm up there with the giants and banshees, fairies, leprechauns,

changelings, and pots of gold at the end of every rainbow that fill my childhood fairy tales.

"You were always a force of nature, Kristian," Mum says.

"He was," my grandmother nods in agreement.

"Tell me about it again," I plead.

"Born in a storm," Nan smiles.

I know this story is true. A snap of lightning electrified the night sky and shattered the window in the maternity ward where Mum agonized in labor. Thunder growled and I entered the world at bang-on midnight. It was November 25, 1975.

I know it's true because I have described to Mum in detail the hospital room with the cracked window where I was born.

"It was a white room with a chair in the corner and a big yellow teddy bear sat on it, wasn't it?"

"How on earth could you remember that?" She looks gobsmacked.

I don't know whether the room has come to me in a dream or Mum and Nan have told me the story so many times, or whether that memory is actually mine. Whichever way, it's as clear as an autumn sky.

I also know it's true because Mum is always running outside our house dragging me back whenever there is a storm. Raw, elemental power draws me in like no other. I'm Kristian Nairn, heaving open our front door and charging headfirst into the wind, the sheets of rain, and the firebolts, clutching an iron bar, which is usually a golf club taken from Granda's pile of junk in the garage. The gods will never fry me like an egg! I don't have a bulging six-pack or long, flowing hair, but when it comes to fire-power, I am the Norse god Thor: warrior, maker of worlds, and defender of the realm.

As a boy, I'm what you might call a self-mythologizer, always building inner characters that make bad things seem better, even though life never feels that bad . . . but it *is* different. And *I am* different, although I'm not sure why. When I made my entrance into the world, I had the longest legs and the largest body the midwife had ever seen.

"Sure, you were nine pounds when you popped out," Mum recounts.

"The midwife held you up," she continues. "She said: 'Would you look at him? We've never seen anything like it. He's going to be a strapping fella!'"

"Everyone said it," Nan agrees.

I think it's a superpower. In fact, I know it's a superpower because Mum and Nan tell me that. From earliest boyhood I am head and shoulders taller than anyone of my age. It gives me the strength to help work on the farm with Lawrence and Raymond, who mainly take care of it. I also think I might need superhuman strength if Granda ever turns on me. So far, I've been saved from his temper, but I've seen him rear up to Nan. He's like an elastic-band ball tight with tension and rage.

"Is that you stealing my mail again, Evelyn?" he snarls.

"For goodness' sakes, Alfie, what are you talking about?"

Granda is always accusing Nan of reading or hiding his letters. At times he's consumed with paranoia, like he's concealing state secrets. Salvos are exchanged, but before it comes to blows Mum or Lawrence or Raymond step in. We all know the letter he's been expecting will drop through the letterbox in a day or two. The word "sorry" is not in his vocabulary.

While Nan has claimed the back of the house as hers, he occupies the living room. It's the only intersection of the entire house—the thoroughfare—and I detest walking past him. Normally, he's glued to his chair studying his *Belfast Telegraph*. If his head is buried in it, I pray he doesn't notice if I tiptoe past. I'm on high alert, but so are my olfactory senses. There's a stale bouquet that hangs in the air around Granda on account of him never washing. His face is stubbly, too. You never want to get too close, and I don't suppose he ever wants anyone to get too close either.

Granda is a broad-shouldered and burly man—a builder by trade and also a farmer—but more and more, it's a rare day that he moves from his seat. Some evenings I'll find him hunched over the TV adjusting the set aerial if the reception is patchy, which it often is. Maybe on a Saturday evening he'll treat us all to a cat's-lick wash—bits and tits, we call

it—before venturing out to the local pub. When that happens, it's as if the whole house, including the walls that he built himself, exhale.

Mostly, though, he prefers to sit indoors with the 1960s psychedelic wallpaper crashing in on him and the room's velour curtains clamped shut.

"Close the door. Close the fecking door!" he roars if anyone forgets and a chill draft blows around his feet. With or without the door open, it feels like a nuclear winter in there.

The house has been fitted with central heating, but none of the radiators work. Sometimes in winter, I clasp my fingers around the top of one just in case I can feel any warmth, but nothing changes. Instead, I run the gauntlet of icy cold from mine and Mum's bedroom to the airing cupboard at the top of the stairs where the open coal fire in the living room has warmed the water heater. One blast of that and I feel able to start any day. My next destination is the kitchen, where Nan will have the oil heater running.

Nan is always up before anyone else and whenever I enter that kitchen it's like hitting a wall of love. It's the same when Mum appears. And although Mum lays down the law far more than Nan does, she's an explosion of fun.

As soon as I can ride a bicycle, Mum and I race down the lane together—me on my bike and her behind riding a push scooter. Once, I was far ahead when Mum's giggles mutated into a yelp, like an injured puppy. When I spun around, she'd fallen off and into a large pothole in the gravel track. Her legs and arms were flailing like an upturned beetle. One half of me wanted to burst into tears but the other couldn't help but find it hilarious.

"Are you okay, Mum?" I shouted, turning back, ready to step in as her savior. When I reached her, she was rolling around but crying with laughter, so I joined in, too. Mum and I are always laughing. Like Wonder Woman, Mum makes bad things go away, and whenever I feel overwhelmed by anger or emotion, Mum magically brings me back down. She's two parents rolled into one big ball of kindness.

My father, David Nairn, doesn't live with us. He didn't show up to my birth and so far he hasn't shown up to my life. I do know that he visited me when I was around two years old. After that he never came back. On occasions, I ask Mum about him because I see other kids with mums *and* dads, and I don't understand why I have a missing half.

"We didn't get on, Kristian," she tells me. Mum is sincere but she hasn't yet given me an answer that I'm satisfied with. *That's about you, not me*, I think. *Didn't he like me? What did I do to upset him?*

They met at work, with jobs in the same civil service department near Strabane in the west of Northern Ireland. Mum occupied a higher rank than him, but after they separated, she quit her job. From as far back as I can remember, she works in the local bakery. She starts at 9 a.m., after I'm dressed and fed, and when I start school, she is always there to meet me at the gate.

"I never want to be an absentee mother," she tells me. My father, on the other hand, had his whole career ahead of him and, with no responsibilities, kept on rising. He remarried soon after and, as far as more Nairn offspring were concerned, I was the end of the line.

No one is sure which side of the family I get my height and build from because on both sides there's tall people, but the fact that I am bigger than other children is rarely mentioned at home. No one tells me I stand out. I'm surrounded by strong farmers, and it's seen as a blessing.

We have a small herd of cattle and fields of potatoes, and hard, physical work becomes second nature to me. When I am older, I'll be able to lug hay bales around and help milk the herd of cows, which I love to do even though cows can be unpredictable and kick out their back legs. While other kids want to be astronauts or firemen, my only ambition is to be a long-distance truck driver transporting livestock throughout the European Union (then called the EEC). Alive or dead, I don't care, but I am fixated on Europe.

And while every man in our house thinks work like this is the making of men, Granda has also given me the nickname of Collie. It means I have the temperament of a border collie dog: soft, playful, protective,

and affectionate. I can spend hours feeding the calves, which I do from a young age. When they are newborn, we bottle-feed them and I gently dab some milk on my forefinger and let the calf suckle on it. Its warm tongue feels rough against my skin, and I ease out my finger before replacing it with the teat of a bottle in its mouth, just as I've been taught. The calves gulp down the milk like it's their last supper while I stroke their necks and backs to calm them. I like that they rely on me for their care.

—

KINDNESS POURS FROM MUM AND NAN, AND I SEEK THAT OUT in others when I am old enough to start school. Then, I need it more than ever, and I'm drawn to women who remind me of them. I hope others will protect me in the same way, even though I've learned that not everyone is the same.

I attend Hillhall Primary School, which is exactly as the name suggests—one tiny hall in a field on the outskirts of Lisburn, and around a fifteen-minute walk from our house. There can't be more than twenty children who attend, and when Mum first takes me, it feels like a warm cocoon. But I'm sensitive to the outside world because ever since I've been left places on my own, I feel a strange undercurrent. There's something about me that causes people to react in peculiar ways. Away from home, my size doesn't feel like a superpower at all. It's something to be looked at, pointed at, commented on. Something I have started to feel ashamed of.

It started at my preschool playgroup. That was when I first heard the adults comment: "Oh, he's a big lad."

Or: "Just keep an eye on him around the others."

Those didn't sound like insults, but I knew by the way they were spoken from the corners of people's lips that they weren't compliments either.

Occasionally, we take the ferry over to the mainland to visit my great-aunt and -uncle in Newcastle, but the last time we traveled I could have died. We were in the shopping center when a group of teenagers

began pointing and laughing. Mum was with me and I covered my face with my hands and tried to pretend that it wasn't happening.

Sunday school makes me feel especially anxious. From the moment I wake, my stomach feels like a tangled mass of wire. I'm sure Mum sends me to get me out of the house so she can enjoy some rare peace and quiet, rather than to thank the Lord for our existence. As far as religion goes, we're a nonpracticing family. Whichever way, I can't forgive her.

"Don't make me go!" I plead, looking up at her with my tearful cartoon anime eyes, but that tactic rarely works.

One reason I hate Sunday school is that I need to dress smartly—an ironed shirt, colored braces, and smart trousers. The whole ensemble makes me feel as stiff as a tin man. Besides, nothing off-the-peg fits me, as though my body is spilling out from every seam. And at Sunday school I don't just harbor a vague feeling that I'm different. I know I'm different, so I don't want to stand out more than I have to. Dressed like this I may as well have two flashing neon arrows above my head: "Over here! The weird kid!"

There, people don't hold back or whisper from the corners of their lips. If I'm around other kids, I hear comments like: "He's not aware of his own strength, is he?" When I look up, I see adult mouths agape, or eyes wide as if they're on tenterhooks, poised to step in and wrestle me from a kid in Bible class. It's as if I've set out to break other people's children. But I do know my strength, and it's not in my nature to break anything. Even Granda knows that—it's why he calls me Collie.

At Hillhall Primary, though, I *loved* my teachers. I only have two, but I *loved* them. I say "loved" because that's also changed. Mrs. Duffy is a teacher who doubles as the school's principal. She's round and matronly with sculpted hair, teased and sprayed into place. Behind her smile she has a formidable edge, and she reminds me of the British prime minister Margaret Thatcher, who is always on TV saying what she will and will not stand for, especially when it comes to Northern Ireland. Mrs. Duffy walks a similar tightrope between "kindly mother figure" and "teacher you never want to mess with." She has three canes in her cupboard, one

with decorative hawthorns all around the handle. If you're going to punish a defenseless child, you may as well do it in style. Thankfully, I've never felt its sting across my hands or my backside.

At first, I worked hard for Mrs. Duffy and gold stars rained down on me. I was a sponge for learning, especially when it came to stories. Mum has always read to me. Whenever I've been afraid of the dark, we sit in bed together and she opens a book. And like Mum, Mrs. Duffy was my ally and my defender, but I've been far more wary of her since that's been shattered: not once, but twice.

The first time it happened, I'd drawn a picture of a dragon's head on a knight's body clothed in armor. I was a young Leonardo, sure that Mrs. Duffy was going to pump me up with praise, like a beach ball.

"You're so clever, Kristian." That's what she was going to say when it was my turn to bring my drawing up to her desk. Then she would hold it up as an example to the rest of the class.

"If you need to look at a drawing to see how it's done, just look at this dragon that Kristian has painted." I would feel myself going scarlet with embarrassment, but secretly my heart would be dancing.

I still don't know why, but that is *not* what happened. Instead, when I placed my drawing in front of Mrs. Duffy, she hardly looked at it. She snatched it from me and began writing the alphabet on the lines in her thick black pen: *a a a, b b b, c c c.*

The feeling that gripped me was alien to my body: a simmering rage that worked its way up from the pit of my belly before it grabbed me by the throat and stopped me from speaking a single word.

"Are you okay, Kristian?" I heard her say, but it took ages for me to reply. My breath became shallow, as if I'd landed in icy water, and my chest was heaving in the throes of a shock response.

"Y-y-yes," I lied.

"Do you want to go home?"

I could hear Mrs. Duffy's tone shift from sharp to concerned.

"I f-f-feel s-s-sick," I stammered.

"Shall I send you home, Kristian?"

"Y-y-yes, p-p-lease."

The next day, I told Mum I didn't want to go to school. But when I got there, I knew Mrs. Duffy was sorry. She called me over to her desk.

"Kristian, are you annoyed with me because I wrote on your drawing?" she said in a voice softer than her usual.

"No," I replied quietly under my breath and took my seat.

I rarely have words to explain.

But this latest incident, I'm still reeling from. I was in the play area when a nameless, faceless kid hurled insults at me as if it were a sport. It was break time and there were other kids around.

"Fat frog. Fat frog," he taunted me, like a bee circling around my head so fast that I couldn't swat it.

I've heard this insult before. Fat Frog is a staple of any Irish kid's summer: a limey, appley ice pop in the shape of a frog with two red bubble-gum eyes and a stupid smile. This time when he said it, the same rage crept through me, but I still couldn't reply. I was mute. I looked at him, then at the swarm of faces laughing.

When I looked up again, Mrs. Duffy was striding towards us, frowning and pushing her squarish steel-rimmed glasses up her nose.

Thank God, I thought. Glinda the Good Witch is landing in Munchkinland. Better still, she'll bring out her Lasso of Truth. She'll wrap it around that boy and make him confess.

"Why on earth would you say that to Kristian?"

That's exactly what she'd say, and he'd stand there with his head hung low.

"Come on. I'm waiting for an answer!" she'd continue.

There would be no explanation, of course, but she'd make him apologize if it was the last thing he did.

"Say sorry to Kristian."

"Sorry, Kristian," he'd mumble.

But again, that is *not* what happened. When Mrs. Duffy reached us, I purposefully locked eyes with her. "Help," I said without saying a word. But all I could see were her lips purse and anger flash across her eyes.

"Kristian!" she shouted, sweeping the boy aside with one hand.

"Yes?"

"For goodness' sake, Kristian. Stand up for yourself! You're so soft you could fly!" she cried out.

What? I thought. My insides folded over. I couldn't stop warm tears from trickling down my cheeks.

Me? You're shouting at me? What about him? Aren't you going to destroy him? I thought.

As Mrs. Duffy marched away, I brushed the wetness from my face.

Since then, I've realized that Mrs. Duffy is not my backup. As much as I want to, I can't trust anyone like I trust Mum and Nan. I feel myself changing, too. I've been working on a new strategy. If anyone hurls insults like that at me again, I'll be ready. From now on, there's going to be fire. One girl has already had a taste of what I can unleash.

"Look at you, you're like the Hulk!" she shouted.

"And you're a green horse with diarrhea," I snapped back, on account of the awful green coat she was wearing, but I didn't feel good saying it.

Other casualties have been my teachers. "Why do I need to work hard for you?" I've figured. I'm not going to please you anymore, Mrs. Duffy especially. Instead, I'm going to silently withdraw from my gold-star status. Every day, I feel like the outsider, the new boy at school, desperate to fit in but primed for attack. Every day I wake up and put my armor on.

THE PAINT HALL

THE NEW BOY. THE OUTSIDER. IT'S TAKEN DECADES FOR ME TO throw off the shame and confusion of that feeling, but it engulfs me as I step into Belfast's Paint Hall. It's May 2010 and the city has been transformed. The giant yellow Harland & Wolff cranes still frame Belfast's dockyards, but the shipbuilding industry is virtually a museum piece. Today the area is called the Titanic Quarter. It marks the spot where the famous transatlantic liner was built the year before it embarked on its ill-fated journey. There's a marina now, surrounded by waterfront apartments, restaurants, and builders' barricades, behind which is the drill sound of even more development and recently built film studios. Where funnels, bows, and sterns were once painted, alternate realities are now being constructed.

Before today, I have no concept of the guts of a building being this cavernous. I stare up and around as I step inside. I never feel small, but this is something else. It causes me to catch my breath. There are

nerve systems of wire and thick multicolored cables running overhead supporting rows of cameras. There's scaffolding and wooden ballasts as sets are being built. Filming on *Game of Thrones* will start for real in just over a month's time, but today I've arrived to meet my costar, the boy who's been chosen to play Bran. His name is Isaac Hempstead Wright and he's ten years old.

Already, I've decided that I'm not going to like him. For starters, he has a double-barrel name, which automatically sets my teeth on edge. He's going to be one of those obnoxious private-school oinks, I know it. He'll come from a well-to-do family, speak the Queen's English, and be as entitled as fuck. Everything I feel I'm not. Besides, we don't *do* double-barrel names on this side of the Irish Sea. One whiff of privilege and a person gets cut down to size. Obviously, I'll try my best to get on with him. It is important that we gel. Without Bran, there is no Hodor, and without Hodor, there is no Bran. During the series we'll be joined at the hip, I've been told, although given that he's ten years old, it's more likely to be my knee. Even Mum has impressed upon me what a much-loved duo Hodor and Bran are throughout the *Song of Ice and Fire* books, so there's a high expectation.

Another problem is that I feel Isaac is a usurper. Unbeknownst to me, the wee fella Thomas who stood in to film my audition tape had also been auditioned for the role of Bran. My agent, Connor, had known on the day we gate-crashed the family party that he hadn't gotten the part, but Thomas hadn't yet been told—what a brutal world the entertainment industry is to newcomers. I also feel that Thomas would have been home-grown talent, whereas Isaac has been flown in from the mainland. It makes me want to like him even less—there's a rivalry between London and the regions.

Other than what I already know, I've been told very little about my character. I haven't read *A Song of Ice and Fire* yet, but I plan to. I haven't even seen a script. But I have been sent a miniature of Hodor by George R.R. Martin himself. The message that accompanied it was funny and warmhearted:

Here you go Kristian. I don't think this version looks like you, but welcome to Game of Thrones and the role of Hodor.

Immediately, it put me at ease, and he is right about one thing: there is nothing of me in that replica. The small pewter Hodor that I turned over in my fingers looks more like Jesus of Nazareth with his dark, shaggy beard and unkempt hair. He's wearing a long medieval tunic and carrying Bran on his back in a cloth holdall, a version of which I need to be fitted for today.

Inside the Paint Hall there are people running everywhere, but I'm too overwhelmed to smile or say hello. Some have iPads, pieces of paper, clipboards. Others are lugging technical equipment. It's something I will never get used to about a production set: hundreds of ants scurrying around with a job to do, even though it's hard to work out who does what. It's organized chaos, impossible to learn everyone's name, so the panic hits me. *How can I fit in quickly here if I don't know anyone?* I'm always worrying about how I can fit in quickly—not just physically, but personally. The new-boy feeling always consumes me in alien situations.

"Kristian, pleased to meet you." A woman suddenly appears and guides me through the hall to a set of trailers.

"Isaac's already here," she tells me. "And his mother. She's called Helen."

"Oh, thanks," I say, grimacing slightly.

As I approach, I can see a woman beaming at me and a boy running around. In appearance, Helen is nothing like I've imagined, which in all honesty is a horse with two heads, buckteeth, and a cucumber stuck up her arse.

"Hi, you must be Kristian." She holds out her hand warmly.

In reality, Helen is incredibly beautiful but in an understated way. She has dark, shoulder-length hair, wears very little makeup, and radiates a natural charm. Her face reminds me of the British actress Kristin Scott Thomas.

"Hi, lovely to meet you." I swallow hard.

"This is Isaac," she continues, beckoning for him to come over.

Isaac feels like a sunbeam hitting me, and I'm momentarily disarmed. He circles my legs like a puppy dog wagging its tail, and when we sit down, he is surprisingly unafraid to jump up and climb all over me.

"Do you mind him doing that?" Helen checks.

"No, no," I say politely, but inside I'm not sure. I'm not used to a stranger being this affectionate and I can feel my stomach clench. The twenty-five-year age gap between myself and Isaac also hits me. It's as if he's confused me for his very own Barney the Dinosaur. Or a long-lost brother or uncle who has "fun time" slapped in capital letters on his forehead. Yet however much I try to resist, I can't stop my shield from slipping.

Helen and I talk some more while we wait for the wardrobe department to take measurements for our costumes. We also have to try out the harness that has been custom made so that I can carry Isaac on my back. Isaac, it turns out, isn't the private-school toff that I've convinced myself he'll be. He hasn't been hothoused as a child star either, which I'd also assumed. Instead, he got the part of Bran after joining a Saturday morning drama club in his hometown of Faversham in Kent, near London. He's cut his teeth in small roles in commercials but, like me, this is his first proper acting role. We're both newbies. If I feel overcome, I wonder how the hell he is coping. Fine, as it happens. He's jumping around like a pogo stick and singing his heart out. He appears to have zero fear. I'm reluctant to admit it but being around him does feel joyful.

In between fittings there's a lot of hanging around and we've been given a trailer to relax in. I don't know it then, but hours of killing time is something I will have to get used to. It must feel like an eternity for a ten-year-old. In one period of downtime, I bring out my phone and start playing games. I need something simple and repetitive as a distraction, so I've downloaded a Harry Potter game of spells and puzzles onto my newly bought iPhone.

"Can I have a go?" Isaac asks. He adores the Harry Potter books and films, and plays the game on his computer at home, he tells me.

"Sure!" I offer. It's good that we can bond over a daft game, I figure. But a few seconds later I realize the mistake I've made. Isaac is already on my knee, but no sooner has he grabbed the handset from me than he is waving his arms around like a drunken octopus. One hand flies past my face when I see the phone slip from his fingers. Now it's in free fall, hurtling through the air as if in slow motion. Neither of us are quick enough to grab it, and my eyes follow its trajectory as it arcs upwards before falling and hitting the floor with a loud crack. *For fuck's sake*, I groan inwardly.

There's stunned silence as I bend over, scoop it up, and turn it over. A spider's crack has spread across the screen and I stare at it, disbelieving.

"I'm so sorry!" Helen cries, rushing over to see if anything can be salvaged. She looks horrified, but this expression turns into one of quiet submission.

"Kristian, this is what Isaac is like. He never sits still and he does break things and he spills things. I'm afraid you're going to have to get used to it," she tells me apologetically.

"But it was the case! It was slippy!" Isaac protests.

Brilliant, I think. He seemed like a nice kid but maybe my first thoughts were right. Maybe he is exactly the little shit I'd predicted. I look at Helen and pretend everything's okay. I've had my phone for precisely seventy-two hours and now it's bust. Inside, I am stamping down my irritation.

"I'm giving you the money for that right now," Helen continues.

"I can't accept that!" I say indignantly as a feeling of shame creeps through me. Isaac *is* only ten years old, I remind myself.

"It really isn't a problem," I lie. I know it's going to cost around £400 to have it fixed, which is far too much money for Helen to offer.

"We've only just met! I can't take money from you," I repeat, but Helen won't take no for an answer. We argue back and forth until she is so insistent that I give in. In truth, it's a minor disaster—a first-world problem—and it also turns out to be the most unexpected icebreaker.

On the drive home, a feeling of relief washes over me. Today I have been introduced to my young costar, but it feels more than that—it's as

though I've been introduced to a family. Because Isaac is underage, I'm
going to be spending a lot of time with Helen, who will accompany him
throughout filming. Sometimes his stepdad, Tim, will be on set, too. I
might be without a functioning iPhone, but a hurdle seems to have been
jumped.

—

WHEN WE MEET AGAIN SIX WEEKS LATER, ON OUR FIRST DAY OF
filming, the same anxiety has built up in me but, just like before, it's
quickly knocked down.

"Hi, Kristian!" Helen smiles. "Great to see you again!"

There's no awkwardness, no excruciating small talk. Isaac launches
himself at me like I'm his very own crash mat and gives me the biggest
bear hug. "Kristian! Kristian!" he shouts, which feels unbearable and irre-
pressible in equal measure.

Castle Ward is the location for these initial days. For the first season of
Game of Thrones, it will transform into the outdoor set of Winterfell—the
northern capital of the series' fictional continent of Westeros, and strong-
hold in the north of the Stark family, of which Bran is a member. It's an
hour's drive south of Belfast and sits on the banks of Strangford Lough.

The idea that I am going to work at a location that I have visited so
many times as a kid feels surreal. For years Castle Ward was a regular
go-to for school trips: a single file of children jostling their way through
its eighteenth-century mansion and sixteenth-century tower listening to
precisely nothing of its history being retold by an exasperated guide. One
year I also remember it being the site of the most boring family picnic
ever. It was Easter and it rained relentlessly. I spent the whole afternoon
hoping that a reward would come in the form of a gilt-edged notebook
from the gift shop, which is all I ever wished for on any family trip to
Castle Ward. Whenever I was bought one, I wrote lists: lists of things
I wanted and lists of friends to invite to my birthday party. I'd fill three
pages before the notebook was shoved in a drawer.

It's an early morning start and there's a new routine to get used to. Arrive, breakfast, makeup, get into costume, and wait before filming begins. Rarely will we ever film in plot sequence during *Game of Thrones*, but this first week of filming will form the opener to the epic story. Ned Stark, played by Sean Bean, and his wife, Catelyn, played by Michelle Fairley, will assemble with their children and staff as Robert Baratheon, ruler of the Seven Kingdoms of Westeros, makes his grand entrance to Winterfell alongside his entourage. During his visit he'll appoint his loyal friend Ned as the Hand of the King. It's also the episode where Bran will be pushed from a window, resulting in him being paralyzed from the waist down.

If I'm finding my feet with Isaac, the thought of being surrounded by bona fide actors takes me back to square one. I am shitting myself. It takes every scintilla of positive thought not to get swept up in a twister of insecurity. The arrival of King Robert to Winterfell will be one of the few scenes throughout the entire series where so many stars are gathered in one place at one time. I've only ever seen Sean Bean before on film or TV. To me he's Boromir in Peter Jackson's *Lord of the Rings*, or Richard Sharpe, the heroic soldier in the British series *Sharpe*, which aired when I was a teenager. King Robert, played by Mark Addy, is Dave in the male striptease hit *The Full Monty*. In fact, I barely recognize him with so many clothes on! The legendary Donald Sumpter, who will play the part of Maester Luwin—tutor to the Stark children—is here alongside Ron Donachie, who will play the part of Ser Rodrick Cassel. In my eyes, these people are titans, and I squirm at how inexperienced I am.

I sit in the trailer until I get the call to make my way onto set. Fear grips me—even more so when I enter the courtyard. There, I'm surprised to hear whispers around me.

"That's Hodor. Hodor's arrived."

I may be imagining it, too, but crew members are also pointing.

"It's Hodor."

"Look, he's here."

"Where?"

"Over there!"

In a heartbeat, I've rewound twenty years and I can feel myself bristle. Part of me is tempted to throw out one of my defensive "fuck you" looks—the kind of frown and lip curl that I've perfected. A look that says: "Come close and I'll rip your head off." But I have to remind myself that in this scenario I'm different. This is not real life, and I am not Kristian.

Be friendly, I think. *You're Hodor. Not Kristian. Hodor.* Whoever Hodor is, he is the opposite of rude or defensive or dismissive. He's innocent and trusting—everything I've had to learn never to be.

In fact, in the intervening weeks, I've been thinking about how I'm going to play Hodor. At the meeting in the Fitzwilliam Hotel, I'd told David and Dan that I wanted his name to be more of an expression, but I'm not entirely sure what I meant by that. All I know is that Hodor is also a feeling, rather than simply a living being.

Bravely, or stupidly, I've decided not to fill in any of the blanks by reading the books yet. I do know that I want Hodor to be spontaneous and reactive to whatever happens around him, and I'm scared that if I overthink his character, he'll become exactly the dumb stereotype I don't want him to be. This way maybe I can bring more of myself to the part. But I have created a scant backstory for him—he's been kicked in the head by a horse and that's why he's disabled and mute. It's a tiny piece of Hodor mythology that I think might help me imagine his journey better. Mostly, though, I oscillate between feeling I can do this to being abysmally out of my depth. It's why I need to get started on my scenes so that a director can reassure me about what I'm getting right, or step in when I'm way off the mark.

———

JUST LIKE IN THE PAINT HALL, THERE ARE CAMERAS EVERYwhere at Castle Ward plus a small army of cameramen—a truly 360-degree set. There are also microphones on booms, and sound operators. Overhead rigs support more cameras, and giant balloons carrying

set lights are tethered to the ground with thin wires and flap overhead in the breeze. The production is so huge that there are three autonomous units that will operate throughout: Dragon is the largest, Wolf sits in between, and Raven is the smallest of the units, and the one that Isaac and I will mainly be attached to. Each unit has its own sound, lighting, catering, makeup, costume department, and crew while a pool of directors drop in and out. Today's scene, with so much pomp and ceremony, is under the umbrella of Dragon.

As I stand longer in the courtyard, I become transfixed by the detail of the set: the flags; the regal banners draped down the sides of the castle walls displaying the Stark sigil—a gray dire wolf; the burning cauldrons that light the way for King Robert and his approaching party. The shield and swords and armory on display show true craftsmanship, and the horses lined up are some of the most beautiful animals I've ever seen. There's chestnut-brown beasts and white dappled stallions. Their coats shine, and in between takes groomers dress each horse while trainers direct the herd in and out of the set. To recreate one six-minute scene it will take a whole day, and I watch with fascination at the animals' patience during that time.

Each take requires around twenty minutes setup, which gives us an opportunity to huddle in groups and chat. Some of these people I will never see again in the entire six years I act in *Game of Thrones*, while others will become firm friends. I have been instructed to stand with the servants while the Stark family and nobility stand in line a little farther forward. Yet after around the third take I can hear voices again, this time more loudly and behind the crowd.

"Why is Hodor standing with the nobility?"

"He's not!"

"He shouldn't be that far forward. He should be with the servants. He's a servant."

I am with the servants, I think, feeling self-conscious. I'm standing exactly where I've been positioned, not hogging the limelight as the voice suggests.

"He *is* standing with the servants!" another crew member shouts emphatically, as if I'm not there.

"I am with them," I mutter quietly, looking back to see what the fuss is about.

It turns out that from the rear of the set, I appear as though I'm much farther forward than I actually am. My height compared to everyone else's creates its own optical illusion. As the debate ricochets around me, I automatically feel my shoulders hunch and I push my spine down. Without thinking, I take one step back to move the attention from myself.

"Okay, fine. Just ask him to stand straight," another voice calls out.

I'm confused now. It's one or the other, I think.

Thankfully, it isn't long before the crew is diverted elsewhere, and when the action moves on, I feel my shoulders soften. Today of all days, when there are so many stars and spectators on set, I don't want to be singled out.

Soon, however, filming is halted again, this time for longer. It's another shattering of the grand illusion of TV. As we line up with the entirety of House Stark to greet the king, a horse-drawn carriage will transport Robert's queen, Cersei Lannister, as it trundles through the front arch of Winterfell. Cersei is played by the actress Lena Headey.

"And once more," the director calls out. From the corner of my eye, I see the procession enter through the gate. Armored soldiers, spears raised high, and horses trotting in front and beside the carriage. When it stops in front of us, I'm fully expecting Lena to emerge in all her regal splendor.

"Okay, cut," the director shouts.

But nothing happens. No one steps out from the carriage. Instead, Lena is brought out from her trailer through the muddy courtyard. She isn't even in the carriage when it approaches, yet when she makes her grand entrance and steps down into Winterfell, it will be made to look as though she's been there all along. *So that's how it's done*, I think. I have no idea of what the finished production will look like, but the amount of segments filmed in different parts of Castle Ward makes me wonder how

it's all going to be knitted together into a fluid story. I have so much to learn.

And it's just as well that Lena doesn't travel in the carriage. Several takes later when it enters through the front gate one more time, we hear the most unedifying of noises.

Sraaaaaaaaaaaaaaaaacccccckkkkkkk.

This is followed by a loud crack, which sounds like wood breaking. Some of the fortress walls around Old Castle Ward have been temporarily attached to the real building. Sheets of fake stone rubble sit around the building's real sixteenth-century tower house and stable yard. Elsewhere, the castle's original four-hundred-year-old stone is on display, and the front gate where the carriage pulls through is not fake. The cart comes to a grinding halt.

"And cut," the director shouts. Now several of the producers and assistant directors are running out, horror on their faces.

"What's happened?"

We can hear a babble of crew, more of whom are now scurrying out from behind the set.

"It's the cart. It's hit the gate wall!" I can hear someone shouting.

Oh fuck, I think. That's the sound of history being destroyed.

"Is anyone hurt?" another voice calls out.

Fortunately, nobody is, and the horses pulling the carriage also look unperturbed. But there's a swarm gathered around inspecting the carriage inch by inch.

"Let's have a short break and back the carriage up," another voice shouts.

It's already after lunch and there's discussion about how the light will fade if too much time is lost. Filming of the cart's entrance has been late in the day's schedule and production don't want this to run into a second day. There are too many star actors to accommodate and animals to manage.

Besides, the damage to the cart hasn't rendered it unusable. Time is money is another element of production I have yet to master.

As filming resumes, we take our places.

"Okay, everybody, as you were," the director shouts over. I make sure I am as far back as I can be, conscious of the discussion that has gone before. But out of the corner of my eye, I can feel somebody staring. When I glance across, Isaac is smiling up at me. I give him a brotherly wink, knowing that he has no idea how moments like that have shaped my life. In a weird way, it's as if he understands. His eyes feel like an anchor, a symbol of steadfastness among the fear and confusion of this strange adventure we are on.

ONE STEP FORWARD

I CHOOSE MY FRIENDS CAREFULLY. SO CAREFULLY, IN FACT, that some of them aren't even real. *Star Wars* is often on TV, and Luke Skywalker is the kind of guy who I call a friend. He's a farm boy like me, so I think we have a lot in common, but he seems more comfortable in his skin: blond-haired, blue-eyed, perfectly proportioned. Everyone at school palpitates over Princess Leia's cinnamon-swirl buns, but I'm definitely more persuaded by Luke's lightsaber. I quietly hero-worship him.

At eleven years old, I am also transfixed by the cops in the American TV crime show *CHiPs*, which plays on repeat. There's Ponch, who's tall and muscular, but not too muscular, and has smoky eyes. Then there's Jon, who's a sun-kissed Californian with hair the color of buttermilk. I like Jon the most. To me, he is like a golden god onscreen, and I aspire to be the same kind of leading man. He's traditionally handsome—a

Prince Charming type—the opposite to me or my band of burly farmers. Sometimes I close my eyes and imagine myself cruising on my motorbike beside him, beaming up at him and catching his rays of confidence.

I'm also infatuated with Ponch and Jon's friendship. Whenever they are out on highway patrol, they are the best of buddies. Unquestionably, they have each other's back. I want to be friends with boys in the same way, but something stops me. I can't explain it and I don't have a name for it, but instinctively I can feel myself edging away if anyone attempts to get close. Besides, at school I don't believe anyone has my back. I hate going, I hate getting out of bed each morning. Home feels like a safer place.

I attend Dunmurry High School for one year, but Mum secures a place for me at Methodist College Belfast—Methody, as it's known. It's a fee-paying grammar school but a handful of children are admitted on academic merit. I sit in that group, but my grades are borderline, which is why it's taken a year for the college to accept me. Mum says it's a far more prestigious school than Dunmurry and it's renowned for its legendary music department, a subject I excel at because I've had music lessons drummed into me by Mum since I was knee-high to a gnat. Besides, Mum's fought tooth and nail for me to go to Methody, so I run with it.

Academically, I'm at the top of the class at Dunmurry, which is not hard. It's the local high school, hardly bursting with ambition, but I have found a way to exist there. I can navigate teachers and classmates, mostly by avoiding confrontation. I switch to autopilot and survive, so I feel a dread about moving.

"Try it, see if you like it," Mum says.

"Can I leave if I don't?"

"Try it," Mum repeats, which is always Mum's way of saying: "No way."

Mum is always encouraging me to take one step further into the world than I am ever comfortable with. She sees how shy I am away from home. She's not a pushy parent, even though it feels as though she is very pushy at times. It's only when I finally get to Methody in 1988 that I understand what pushy *really* is.

The school is set in its own grounds on the southern outskirts of Belfast: an imposing redbrick building with steeples and turrets and a wood-paneled library that feels more like a fusty stately home than a school. My uniform is a navy blue blazer with a blue-and-white-striped tie. Nothing quite fits me properly and I'm back to feeling like the tin man. Worst of all is the bus ride there.

At Dunmurry, Mum dropped me off on her way to work. Now I have a whole new world of pain to navigate. I avoid the upper deck if I can help it because whenever I reach the top of the stairs my head thumps off the roof.

"Haaahaaa." There are sniggers from the kids who notice, and I crouch down and slip into the closest empty seat. If there's one free, I always opt for an empty double seat, but if the bus gets crowded and I'm forced to share, this adds to the ordeal. I bunch up against the window and get hot and sticky as the sunlight streams in. I know that whichever poor soul has to sit beside me won't have enough room.

"Sorry," I want to say to the kid whose arse cheek is hovering over the metal seat rim and whose hands are clinging to the rail, holding on for dear life whenever we swerve around corners. But I'm too mortified to offer up a "sorry." Anyway, what if it's a kid who smells my vulnerability and decides to weaponize it? Call over to the rest of the bus:

"Jesus, Nairn's so big he needs two seats!"

I pull my blazer collar up to my face and push myself farther into the corner.

Some mornings Mum and I play a game of cat and mouse. She drops me on the roadside in view of the bus stop and waits to see me get on. As soon as I'm out of the car, I hang fire, labor over each step until both of us watch the bus pull in and off before I can step on.

I turn to Mum, who's throwing daggers at me, and shrug. "Sorry, Mum, missed it," I mouth to her.

"Kristian, you didn't even try!" she cries when I slump back into the passenger seat. The tone of her voice hits new octaves.

"Methody is too far. I can't keep driving you to school, Kristian!" she says.

I remain silent, watching the condensation form on the windscreen from all of Mum's furious hot air.

"I'll catch the bus up and you can get on it," she threatens.

"Don't, Mum, please. Can you take me, just this time?" I plead.

I know that Mum partially sympathizes with me, so I search for the crack in the front line where she's weak, but her patience is wearing thin.

In class I've gone from being one of the brightest to feeling as though I can never run fast enough to catch up. It's not that I find the subjects hard, but I switch off if they don't interest me. Give me a Bunsen burner and an exploding petri dish of sodium any day, but make me stare at an equation on a whiteboard and my brain shuts down. Also, other kids brim with hubris. When they announce they are going to be astrophysicists, they present as peacocks fanning their tails. Part of me thinks they may not be dreaming—their paths seem preordained.

It seems I have a destiny, too, although it's absolutely not one I've been consulted on. My initial interview was taken by the soon-to-retire principal, Dr. Kincade. He had my journey through Methody mapped out the minute I stepped into his office. His eyeballs almost popped out from his head.

"So, we've got Kristian Nairn, is that right?" he said.

"That's right, sir."

"And you want to come to Methody, Kristian?"

"That's right, sir. I do."

I smiled and sat upright like Mum told me to do in front of the headmaster. "You have one opportunity to impress," she said.

"Well, I can see that you'll make a fine rugby player. We'd love to have you on the school team," Dr. Kincade continued.

A rugby player? I thought. *Are you serious?*

Of course, all of my best counterarguments were in my head, but I knew better than to spell them out in my transfer interview. But, for the record: One: I've never played rugby in my life. I've barely played touch football. Two: I'd rather poke my own eyes out than get up at the crack of dawn on a Saturday morning to roll around in mud or scratch my balls in

an ice bath. Three: If my school uniform barely fits, how the hell is Mum going to find me a rugby kit? And lastly: Team sports make me dissolve into panic, like a white-hot flame creeping through me.

I smile again and Dr. Kincade smiles back.

"We'd really love to have you," he repeats.

—

I'M NOT YET A TEENAGER AND ALREADY I'M SIX FOOT, TWO inches. In my first year at Methody, I'm the same height as the sixth-form graduating class. In sports, that should make me an A-team champion rugby player or the guy everyone begs to be on their basketball team, but so far in my school sports career I've never scored a basket, so I'm never picked. It's not that I can't dribble the length of the court and hook the ball over the hoop—that's the easy part—it's that I stop myself every time I get close. I'm conditioned to withdraw.

"Always stand your full height, Kristian," adults often say to me whenever they see me go into my shell. I have a habit of hunching my shoulders, compressing my spine as far as I can. Mostly, it's not conscious. It's my default stance—a preemptive apology to make others feel comfortable—a peace offering before the comments fly. And ever since Sunday school, I haven't wanted to be known as the bull in the china shop, so I don't tackle hard or push hard or draw attention to myself by scoring baskets or goals or tries or conversions, even though I do have a competitive streak.

I also hate the changing rooms. In Methody there are no cubicles, only open benches. Among the scrum of boys taunting and elbowing each other, I turn to face the wall when it comes time to undress. I find a spot on the cream tiling and stare at it so hard it could bore a hole. This isn't just because of my size. Something else is eating at me, too, although I don't know what. All I know is that when I can, I look. I take sideways sneaky peeks at calves and thighs and bottoms and torsos. It's the same when I'm stood in the U-shaped shower room, where I pray to God that the steam will provide cover. Sometimes, before I can stop it, a sneaky

peek tumbles headlong into a prolonged stare and I have to jolt myself out of it.

One time, when Mum had written one of her many notes to say I was ill and couldn't do sports, I sat outside the changing rooms on a bench in the corridor. From there, I had a clear view in. My eyes couldn't stop roaming over the curves and lines of one boy bending over to take off his boots and stretching his shirt over his head. He must have felt the weight of my stare because he moved towards the door. A hot flush fanned up across my neck and face. Then, I heard the door click shut. None of it makes sense, but I do know there's something wrong with me because I'm not like other boys. I'd like to talk to someone, unpick this confusion, but something tells me I would be shoved out further in the cold than I already am.

I know for sure that I'm not attracted to girls in the same way that boys around me are, but I do like girls. For years at primary school, I gravitated towards them. Even so, I placed myself on the outside: the big bad wolf crashing through their playhouse and stealing their tea set—never inside at the heart of the happy nuclear family.

When I started at Dunmurry, I felt like a brother to girls, even though I've never had a brother. All I know is that when there was talk of kissing girls, I didn't join in. I'm not interested in physical contact with a girl. Not even holding hands. The thought terrifies me. But there are girls I've been drawn to. At Dunmurry there was Fiona: weird, posh Fiona. She was sporty and looked like a young Dame Edna Everage, with almond eyes and jazzy spectacles. She sparkled like a diamond in a silt bed of grubby kids, and I loved that she was unafraid to shine. When one teacher wanted to find out which musical instruments we played, that's when I developed a soft spot for Fiona.

"Does anyone play the recorder?" the teacher called out, making her way around the class.

"I do, miss." An arm shot up.

"And the piano?"

"I play piano," a voice called out.

Then I watched as Fiona's hand stretched up so far that her long, elegant fingers almost hit the ceiling.

"I play the *graaaaand* piano, miss," she said, yawning out the word "grand" like a never-ending vowel and with no hint of embarrassment whatsoever. *Who does that? Who says that? Who shows off like that?* I thought. *More than that, who the fuck owns a grand piano in Lisburn?*

I oscillated between finding Fiona's confidence nauseating and being wildly impressed by it. I could never put my hand up like that, even though I do play the piano and I can bash out more than a few chords on our upright at home. In fact, I'm pretty good. I adore the big notes of Bach and Handel, even though the piano is an instrument I don't want to master. I want all the drama of an organ, the kind you find in churches with big chunky pipes and an almighty blast. The church can kiss my arse, but I'd give anything to sit behind the multiple layers of keyboards and work the stops and the foot pedals and hear the sound that fills that space. But Mum has insisted that the piano is where I must start.

As for any romance between Fiona and I, that flame got truly extinguished. I did give her a peck once, half on and half off her lips, but it felt like pressing up against a cinder block. And our only lunchtime date ended in disaster when we walked together to the van that sells chips and I bought a bag. As we chatted on the return journey, my stomach churned over like a cement mixer. Then, I swear I smelled dog shit on one chip just as I was about to pop it into my mouth. An involuntary spasm overwhelmed me and my mouth filled with vomit.

"Ewwwww, Kristian," Fiona shouted when she realized what was happening: me doubled over retching my guts up on the pavement.

"Jesus, sorry," I said between gasps of breath. Unsurprisingly, she didn't ask me out again.

At Methody there's one girl called Li Jing, although she prefers that everyone calls her Rachel. Her family owns a dynasty of Chinese restaurants and a hotel. She's funny and different with her bottle-shaped legs and a skirt that never fits her, and I've promised that I'll marry her. Not only can I get free Chinese food but she's a miscellany of perfect manners

and Asian mysticism. And if I'm ever forced to marry a girl, then I'd rather marry a puzzle that will take a lifetime to solve than a girl from Northern Ireland who I'd understand.

When it comes to my studies, I'm treading a fine line between pleasing Mum and not giving an actual fuck. Ever since I've been catapulted into the rugby team, I've lost enthusiasm. If the school doesn't care about what I want, I don't care about maths or English or chemistry. And it doesn't feel like this school cares for people at all. It cares about grades.

"How do you think this will reflect on the school?" This is a phrase I hear on repeat. And teachers have noticed that I can't stop drifting. "Kristian doesn't listen. Kristian could do better." They write this on my report card constantly.

Partly, this is because I can't always hear people. From the age of around seven, I've had several operations. First, I had my tonsils removed because I got groggy with tonsillitis two or three times a year. The relentless sickness clogged up my eardrums so badly that I needed implants called grommets that allowed me to hear past the glue. I don't remember much about it, other than the tears I cried as the curtain shut around my hospital bed as Mum turned to leave. When the surgeon said he'd give me an anesthetic called a butterfly scratch, it was enough for me to imagine a massive holographic butterfly as it took hold and made everything okay.

Since then, I've had more procedures, including being fitted with more grommets, which act as ventilators for your ears. As far as my hearing is concerned, it comes and goes, so I've learned to concentrate on people's expressions. I read wide eyes, narrow eyes, blinking eyes, mouths that smile, or lips that curl. I'm hypervigilant. At home I read Granda's mood and at school I follow teachers' faces like fishes mouthing underwater words.

But I also don't listen because the longer I'm here the less I engage with anything that I love. Even music lessons—the very reason Mum sent me. The department has every instrument under the sun, but in group classes we do nothing more than sing "Molly Malone" or "Marie's Wedding" and bang a glockenspiel. Outside of lessons, there are orchestras and choirs that I do want to join, but every time I ask, I'm never

accepted or my request is ignored. And the school has three pipe organs. *Three!* It should be all of my dreams come true, but the first time I sat behind one, I couldn't fit my legs under its frame. Even the pipe organ is not built for me.

Because of this, I find it easier to learn on my own.

—

WHEN I AM AROUND THIRTEEN YEARS OLD, MUM MOVES OUT of our room at home. Uncle Lawrence has gotten married and doesn't live with us anymore and Raymond has gone to England for work. This has left Nan heartbroken. She breaks down sometimes without warning and her eyes fill with tears. She's become a lot more brittle when it comes to dealing with Granda, too.

"Shut up, Alfie," I hear her spit whenever he complains that his food is too tough or that she hasn't cooked his favorite potatoes. In the past she would have stayed silent.

It's been like a game of musical beds. Now that we can spread out, Mum has moved into Raymond and Lawrence's old room.

"You can have a bit more space for yourself, Kristian," she tells me.

"Okay," I nod.

"A boy of your age *should* have his own room—a bit of privacy," she stresses, although she's never too specific about what this means. I am over the moon, though. I've never told anyone at school that I sleep on the top bunk in the same room as my mother. Imagine the rounds of ammunition that would provide.

One of the first things I do is dismantle the bunks so that I have my own single bed. I do it with such force, like I've taken a sledgehammer to it. Liberation at last! The posters on my walls also start to multiply with images similar to those I have plastered over my schoolbooks and binders. There's Kerry King and Jeff Hanneman from the thrash metal band Slayer wielding their guitars. There's Megadeth, Anthrax, Sepultura, Steven Tyler from Aerosmith, and Slash from Guns N' Roses. There are

so many cutouts Sellotaped to them that they appear laminated, and I've drawn the Metallica insignia in thick black marker pen on everything. I love heavy metal, thrash metal, death metal—any deep growling sounds and guitar solos that soar like cathedral spires. There's a classical triumphalism and primordial rage that sets me on fire.

I've also bought myself a guitar from Smithfield antiques market in Belfast. I saved up my pocket money until I had £60 to spend on a white Encore axe, which I brought home in a black plastic bag. Initially it only had three strings and I had no clue how to play it. Instead, I stood in my room and posed with it. I don't have a full-length mirror or even a vanity mirror. I've never wanted any clear reflection of myself, so I wait until it's dark, turn on the light, and position myself in front of the window. I jump around to Aerosmith's "Dude (Looks Like a Lady)" or Megadeth's "Holy Wars" or "Monkey Business" by Skid Row. I fling my long mullet-cut hair back, open up my chest, and head-bang my way through each track. I don't need an audience. I could perform in front of a steamed-up mirror and still feel the same pure joy.

Over time I've replaced strings and learned how to tune my guitar and I've even begun working out lead guitar parts, so I can play along with the easier tracks. I'd never get to do that at the music department at Methody.

There, I'm even less interested in learning, but I have gravitated towards one person who I would call a friend. Martin and I are in the same class, and we've gelled. We look like Laurel and Hardy. He is rakishly thin and wears drainpipe trousers and pointed shoes. He has three sisters and a coterie of girls he hangs out with, but just as friends. Unlike me, he's brilliant at subjects like home economics—always showing off his fairy cakes—but we do share the same wacky sense of humor. Mr. Palmer, our English teacher, now separates us immediately when we step into his classroom.

We don't bitch about people or poke fun at people. Instead, bizarre stuff tickles us. Not long ago in our maths class I sketched a horse. Martin watched over my shoulder as I created my equine masterpiece. Then,

at the last minute, I thought *fuck it* and drew in the goofiest pair of horse's teeth, just for fun. Once Martin burst out laughing, he couldn't stop. I thought he was going to piss himself.

We're competitive, too. Especially about music. We're both know-it-alls when it comes to the metal bands we love, and we volley back and forth about who owns what album. When Martin feels he's losing, he always plays one of his older sisters as his trump card.

"Well, Joanna saw Metallica live in 1984," he boasts.

"That's not the same as *you* seeing Metallica," I stab back.

But while Martin feels like a best mate and a sparring partner, there's another boy who I also feel a strong connection to. He plays rugby in the B-team and he's one of my regular changing room "stares." He's also tall and slender, with the best bum I've ever seen. Although we're in the same class, we don't speak much. And we especially don't speak since the incident that has left me spinning like a fair ride.

It happened completely without warning. Mum drops me at school, and whenever she does, I always get there early. She wants to avoid the traffic, so I arrive by 8 a.m. On that morning, I sat in the corridor in M block where we have English classes. The joke is that *M* stands for masturbation. I was on the bench reading my Anne Rice book quietly—the kind of vampire horror page-turner that I love.

"Hi," I heard.

When I looked up, Rory was walking towards me.

"Hiya," I smiled back and we sat in silence together until the caretaker appeared, jangling his set of keys.

"Okay, boys, I can let you into the classroom now," he said. The caretaker always does this for me so I can enjoy a warmer room until the others drift in.

"Thanks," I nodded before he disappeared.

Rory was hanging in the doorway when I brushed past him. Suddenly, I felt his hand on my shoulder gently nudging me back. When I raised my head, he was staring at me the way I must stare at him when he is undressing. A week of time passed in those few seconds.

Farther into the classroom, he pushed me back against the wall next to the blackboard, harder this time. *What the fuck?* My heart was thumping but a strange detachment came over me. Nothing of me tried to stop him. Instead, my face froze like an open-mouthed carp fish and when he pressed his tongue into my mouth, I just stood there. As his tongue explored my mouth, it felt so perfect that my head almost exploded. *Wow. This is how kissing should feel*, I thought. All of this time, I'd been adrift. Now I had a North Star: the beginnings of a navigation course that I could follow.

Moments after he broke off, another classmate casually wandered in and we scuttled towards our desks. I picked up my book and buried my head in it again. I listened to nothing of that morning's lesson. We've not spoken since, but I can still feel his fingers pressed into my shoulder pushing me back against the wall and his breath against my face.

WHAT THE HELL DID THEY SEE IN ME?

AFTER OUR FIRST DAY AT CASTLE WARD, BRAN AND HODOR'S story is to begin proper. This is the first time that Isaac and I will be filmed interacting with each other after Bran's fall from the window of the tower that leaves him paralyzed from the waist down. In *Game of Thrones* lore, Bran has been pushed by Jaime Lannister, brother of Cersei Lannister, after Bran accidentally stumbles across Jaime and Cersei engaged in incest.

For these scenes we won't remain on location. Instead, filming moves to the Paint Hall in Belfast, where we'll stay for around a week. There, sets have now been fully constructed and there are several different interiors to move between. The bedroom where Bran recovers from his fall is

situated here, as well as the Great Hall, which is the gathering place of House Stark in the Kingdom of the North.

I am eager to get started. I want to understand more from the director about what he needs from me as an actor. I feel uncomfortable as Hodor and uncomfortable about my performance. While every regular actor on the show has dialogue to help them shape their character, I have a big fat zero.

Already, outside of filming, there's been some smart-arse quips on social media from people who see mine as one of the easiest roles on *Game of Thrones*: "The guy literally has nothing to say!" But I've tried to resist the urge to read posts on Instagram or Twitter. From the moment I was cast, David and Dan warned me that doomscrolling was a *really bad* idea.

"Don't do it, Kristian. It will make your head spin," they said.

They weren't wrong. While initial reaction to me landing the part has been mainly positive, I did read posts that cut me far more than I'd expected. Fans of the books had clearly Googled me and discovered that I'm a Belfast DJ. There's been several comments about me not being a "proper actor."

"He'll make a complete mess of the role," one post read. It's been tough not to take that personally and it's put me on the defensive. *How dare they? They don't even know me!* I think. Quietly, though, it's also made me ultra-determined to give this everything I've got. If there's one thing I hate, it's not feeling like I've done a good job. Once I'm committed, I want to do my best, but more than that, I want to prove the naysayers wrong.

Besides, I couldn't disagree more about Hodor's part being easy. In fact, I'm offended. Whenever I stare at the script, I draw a blank. Nothing on the page helps me. For that reason, I've avoided reading it. I keep thinking back to Nina Gold singling me out for the role, and then my taped audition with Thomas. *What the hell did they see in me?* I wonder. It wasn't just my size. I know that because David and Dan told me so. It's the way I express myself. Yet if I analyze this too much, I'm scared I'll lose any spontaneity. The only way I know I will truly gain an understanding of Hodor is by trying him out on set.

In theory, I'm hoping that I may be able to draw on some of my own experience. I don't see the person I am now as anything like Hodor. I love to talk. I love being around friends. I love to be funny. I love juggling words, but that's not who I've always been. Growing up, interacting with the outside world felt excruciating. Because of that and my hearing problems, I'm also adept at observing facial expressions. I understand that happy or sad or angry or frightened can be so much more than words can ever convey. If I can, I want to try to use this as part of my technique.

All this is running through my head as I sit in my trailer.

"Hi, Kristian!" I hear a singsong voice and a head pops around the door. Helen has arrived with Isaac, and it makes me feel unexpectedly euphoric. I've been here since the crack of dawn. A taxi arrived to pick me up from home because apparently my makeup and costume will take longer than everyone else's, so I've been busy making polite conversation with people I've only just met. Helen has no idea how focused I am on her and Isaac. Here, they've become my North Star. Familiar faces who radiate warmth and energy while I steady my uncontrollable ship of nerves. Seeing them makes the day ahead feel possible.

The first scene that we are to film will take place in Bran's bedroom. There, Bran is being looked after by the retired servant Old Nan while his mother, Catelyn, is away from Winterfell. She's on a journey to King's Landing, the capital of the Seven Kingdoms of Westeros. Old Nan is the storyteller in *Game of Thrones* who sits with Bran and recounts Winterfell's history and the legends of Westeros, and is played by the actor Margaret John.

As Bran's bedroom is upstairs, the set designers have built a full set of stairs that I will climb before making my way along a narrow corridor. In the story, I have been called to Bran's bedroom to carry him to the Great Hall where Robb Stark, his elder brother, is waiting. Robb is holding a meeting with Yoren, a sworn brother and recruiter of the Night's Watch who guard the Wall that keeps out the savages—the wildlings—and the ice creatures—the White Walkers—from Westeros. Also present at the

meeting is Tyrion Lannister, brother to Cersei and Jaime Lannister and otherwise known as the Imp, given that he's a dwarf.

Both scenes are to be shot in one day.

"This is your ten-minute call, Kristian," an assistant director tells me.

Are you kidding? I think. It's still early and someone has only just come to take my order for breakfast. A bacon sandwich should be winging its way to me from the on-site canteen anytime soon. Lashings of butter. Now the day job is going to get in between me and it.

"Okay, fine," I nod, taking a sip of coffee. The coffee is disgusting. Dishwater swilling around in my mouth, and I've made a mental note to ask for the next cup to be extra strong. Mainlining caffeine will help me concentrate, I figure.

"Hodor to set," I hear in the distance.

"Hodor ready for set," the assistant director beside me says into her headset. As well as being unceremoniously separated from my food, this is another aspect of filming I must get used to. Wherever I am, a crew member will shadow me like Nosferatu's silhouette. I can't even go for a piss without someone needing to know where I am *at all times.*

"Nope, not ready. Hodor's taking a shit. He may be some time." I am waiting for the day when this message reverberates around people's earpieces. The shame would crucify me.

The director for this episode is Brian Kirk. I know that I won't remember his name. When I'm this stressed, names escape me. However, the minute we are introduced I do feel a connection. Unlike Tim Van Patten, the director for the shoot at Castle Ward whose husky New York drawl sounded like we were taking instruction from Al Pacino, Brian is from Northern Ireland. *Kinship may mean he cuts me some slack*, I think—he'll see me as one of his tribe, help me if he sees me struggling.

By now, I've been shown around Bran's room to familiarize myself with its layout. One of the first things that strikes me is how I am transported to another universe immediately. World-building on *Game of Thrones* isn't just about the thick tapestry cover on Bran's bed or the drape curtains or the stone walls or the creaking wooden door. It's the smell that hits me. It

was the same at Castle Ward. There, it smelled like rotting flesh, because there *was* rotting flesh. Real pigs' carcasses hung around the courtyard. Here, it's the smell of wood burning and wax candles, deep and musty, as if someone has liberally sprayed the room with medieval eau de parfum.

"Can we turn on the atmos, please?" a crew member shouts out before we get started. Then, a sickly smell of smoke wafts up. *Jesus, the cancer molecules must be multiplying inside of me*, I think. None of this can be good for my lungs, but as far as a dense, charcoal ambience goes, it does the job.

I've been introduced to Margaret John briefly on set before our first run-through. She is tiny and her face is etched with lines of experience. Margaret is probably in her eighties, but already she's made me laugh. In the story, I'm her grandson, but in real life she's gotten a little confused.

"Goodness, I'd never have got you out of me!" she says, looking me up and down. She thinks I'm her son, but the mistake puts me at ease.

Thank God. Even the old pros get it wrong, I think.

"Where there's a will, there's a way," I joke back, pretending not to notice.

I see that Margaret is shivering, too. We all are, but unlike me, she is skin and bones. That morning, it's subzero temperatures in the Paint Hall and there's only the fire in Bran's room to warm her.

"Are you okay?" I ask.

"I'm fine, dear, but I could do with a warm cup of tea," she says.

Because of her age I'm fully expecting Margaret to fluff her lines or forget who she is. But when rehearsal starts, I become mesmerized by her. Margaret doesn't miss a beat. She knits, she watches Bran dream, and, when he wakes up, she delivers her lines to perfection. She switches into gear like nothing off set matters, not even the freezing cold. *Wow*, I think.

For reasons that have not yet been explained, it's been decided that in season 1 I will not carry Bran in the leather harness that has been fitted for us. Instead, I'll have to scoop him up and carry him in my arms like a baby.

"Are you okay with this, Kristian?" Brian double-checks.

Faced by a small army of executives, I don't question it. Besides, Isaac has continued to climb all over me from the minute he arrived. He has the sharpest of elbows, the skinniest of torsos, and legs like a sparrow's. I'm confident I can spin him around on my little finger.

"No problem," I reply.

In fact, David and Dan did offer me a specialized workout program before the show started, which I refused. I reckoned my bench presses and strength training in the gym would be enough to get me through.

In the scene, the character Theon Greyjoy, played by Alfie Allen, will enter Bran's room before me, call my name, and wait for me to appear.

"Okay, Kristian, ready?" I see the assistant director mouth.

"Ready," I mouth back.

"Hodor!" I hear the call. The assistant then gestures silently and I begin to lurch along the makeshift corridor. *Fuck.* Then it hits me. There are so many things to remember. The door is barely built for a five-foot-something Alfie Allen, so I'm going to have to duck at just the right angle to avoid hitting my head; I have to say the name "Hodor" not once, but twice; I have to be good-natured and eager to please, but not moronic. Then, I have to pick Bran up from the bed. He's paralyzed, so I can't be heavy-handed. On the other hand, I have to wrestle him up so he can straddle across my chest. *And* he can't be seen to help me because he's paralyzed. *Fuck. Fuck. Fuck.*

As I am walking, I feel myself float above my body as if I'm watching myself from a corner of the room. I walk in, turn to Alfie, say the name "Hodor," and pick up Isaac. Then, I carry him to the exit. I'm so flustered that I forget to maneuver Isaac at an angle, almost jamming his legs in the frame.

"Great, thanks, Kristian. One more?" Brian says after my first attempt.

Brian is not quite the soft touch I'd been expecting. In truth, he's surprisingly strict and he's already told Isaac off several times for hopping around the corridor and singing the theme tune from *SpongeBob SquarePants* at the top of his voice. I don't reckon he'll show me much mercy.

"Sure," I say, studying his face. Is he happy? Unhappy? Is he going to give me a debrief? A rundown of all the problems and things I must do better? When I glance over at Margaret, she is beaming sweetly at me, and Alfie is staring blankly at the floor. Isn't anyone going to say anything?

There's nothing. After an uncomfortable pause, I get the hint and turn back along the corridor.

"Sound, picture . . . and go," I hear Brian say.

Then, I wait for the call.

"Hodor!" Alfie shouts again, and I lurch my way back in.

This will be the second take of what turns out to be around twenty. By take fifteen it dawns on me that the phrase "One more" means absolutely nothing. It's a big fat lie, and if there's one thing I hate, it's being lied to.

As for the direction I am seeking, there's been nothing more than a few positioning points. Working blind like this feels completely alien to me. When I DJ I can see and feel how a crowd responds. I can lift their mood and bring them back down. They vote with their eyes, their faces, and their feet. Here, there's no payoff, there's no one dancing around to your beat. It's like performing in a hermetically sealed box.

Halfway through the morning I'm also regretting being so upbeat about not using the harness, or so smug about my homespun fitness regimen. All the exercises I've done are to strengthen my back and shoulders, not my chest and arms where Isaac is now pulling on me. I'm strong, but I'm not *this* strong. *Paint me bright yellow and cover me with the letters* JCB, *why don't you?* I think. I hadn't banked on being used as a forklift!

But again, I don't feel it's my place to speak up—not on my second day, for God's sake! Brian means business, moving us on all the time. Moreover, unlike Alfie Allen, I am not a "principal cast" member in the great *Game of Thrones* hierarchy. Not even close. However much I ache like a bitch, I'm an untried, untested actor on the lowly rung of "featured artist." *Don't say a word, Kristian*, I think. *Do. Not. Complain.* There's also part of me that assumes all new actors are put through their paces like this— some kind of rite of passage. If I throw a wobbler now, I'm in danger of

not living up to my own hype. Yet as we continue, even Isaac realizes something is up.

"Are you okay, Kristian?" he whispers. He can feel my chest heaving against his body as I lift him for the umpteenth time.

"Don't worry, I'm fine," I say, arching my back to stretch out my muscles and relieve the pain. For all his leaping around and his Harry Potter spells, I'm starting to realize that Isaac is an intuitive child, sensitive to people. But the last thing I ever want him to feel is any guilt.

—

WE BREAK FOR LUNCH, WHICH, AS FAR AS I'M CONCERNED, cannot come soon enough. Afterwards we'll relocate to the Great Hall where Bran and I will enter to be met by Yoren, Tyrion, and Robb. The actor Donald Sumpter will also feature in this scene as Maester Luwin, the Stark children's tutor, and I'm looking forward to seeing him up close.

In truth, I cannot recall precisely what Donald has starred in—he's just one of those very recognizable faces. At Castle Ward, I found myself watching him with such curiosity. In and out of character, he has a manner that's Shakespearian, poised like he's about to deliver a soliloquy even when he's simply asking for a cup of coffee.

"Kristian, is it?" He approaches me just as I've made my way through the wasteland of technology between sets. The Great Hall sits in the middle of the Paint Hall, like its own island in a sea of cables. As the scene is being set up, we have a few moments to talk.

"Yes, Kristian, and you're Donald?" I reply. I figure honesty is the best policy, so I decide to take a tentative step into the unknown. Anything to feel authentically myself in this baffling environment.

"I'm so sorry, but I can't for the life of me remember what I've seen you in," I admit before I swallow hard.

Surprisingly, Donald doesn't flinch. In fact, he's only too happy to reel off a list of classic British TV he's starred in, plus some newer productions.

"And of course I was most recently Kemp in *Being Human*," he says.

I vaguely know *Being Human* is a werewolf-vampire-ghost epic, although I haven't watched it.

"And I'm big in Swedish noir," he adds.

"My Mum is glued to that," I reply, which makes Donald laugh.

"Wonderful! Glad to hear it," he booms before he takes his seat at the hall's top table.

Also present in the room is Peter Dinklage, who plays Tyrion Lannister, the Imp. Peter is as short as I am tall, and from the outset I feel there's an unspoken understanding between us. I know, and he knows, that we've both had demons to face to be here. And when I watch him at work, I'm quietly in awe. Peter has all the confidence and gravitas I can only dream of.

The scene takes a similar form as Bran's bedroom scene, only this time I'll arrive with Isaac in my arms. For Isaac to speak to Tyrion, I will have to set him on the ground so they are the same height. It's the first big close-up of my face on-screen and I become conscious of accentuating, but not overaccentuating, every expression.

"Okay, cut. Stand here. Move to the left. Then the right. But keep standing, then bend," Brian directs. It's these moments, when I have to hold Isaac for the longest, that kill me. Again, we repeat the scene, but no one tells me what I get right or get wrong.

"One more," Brian shouts.

One more. I exhale. There's a long afternoon ahead and I'm already in pieces from the morning's shoot. Plus, filming drags in the Great Hall like time has stood still. On each take Donald Sumpter tries something different from the last take. Whereas the younger actors follow the script and seem to deliver the same performance every time, Donald isn't afraid to shake things up.

"Let's do this another way," he suggests to Brian as if he owns the stage.

When he says his line "The boy has lost the use of his legs," it sounds different, a tiny shift in emphasis to the last time he said it.

"Thank you, Donald," says Brian, although I'm not sure he means it. Everyone behind the camera is always looking at their watches. It's difficult to know whether they want cookie-cutter acting or Donald Sumpter perfectionism. Whichever way, watching him feels like I'm getting a free acting master class.

In every short break we have, I move to the side and stretch out.

Soon, I hear a voice beside me.

"Are you okay?" When I look around, it is Peter Dinklage. He's noticed I'm in pain and he's come to check on me.

"Thanks, but I'm fine," I lie.

"I'm not sure how you're doing this, buddy. Are you not broken?" he continues.

"It is a little different to what I was expecting," I concede. "I did expect to be using the harness."

"So tell them," he says emphatically.

"Oh well, I . . . "

It's okay for you, I think. You're an A-lister. But I also think Peter understands my hesitancy, which is why he's made a point of coming over. People like us have been schooled in the art of self-apology, never putting ourselves forward or asking for what we need.

"Buddy. You're being worked like a heavy goods lorry. You're human, not superhuman! Don't be afraid to say that," he stresses before repositioning himself on set, ready for the next take. I'm thankful to Peter for noticing, but I don't speak up at any point during the afternoon. I don't want this to be my first and last acting job. I don't want to fail at what I've been cast to do. I don't know it then, but it's going to take some time before I find my voice.

BATTLE LINES

"HELLO," I SAY NERVOUSLY.

"Hello. Who is this?"

I don't recognize the voice on the other end of the line, even though she and I are blood-related.

"Granny. It's me, Kristian."

"Kristian?" The voice stops dead.

Shit, I think. *What do I say now?* I'm stuttering over my words. Regretting I ever made the call.

"I know you haven't heard from me in thirteen years, but . . . "

"Right."

There's a long pause while my father's mother fully digests who she is talking to.

"I'll pass you on to your aunt," she says abruptly.

My dad's family live in the coastal town of Carrickfergus. Ballads have been written about this town—the place where people leave their hearts.

I'm searching for a lost limb. At home, Mum and Nan are everything I need, but I'm missing something in the way that people miss an arm or a leg. I don't think it's love that I am searching for, it's validation. I'm not sure who I am or who I might be.

I hear muffled voices and then my aunt comes to the phone.

"Hello, Kristian," she says.

"I'd like to come and see my dad," I tell her. It's taken a hell of a lot of guts for me to make this call. I've searched through the phone directory to find his number and I've put off dialing several times.

"Can we call you back please, Kristian?" my aunt asks.

"Erm . . . okay . . . " I reply. *Isn't this a clear yes or no?* But they sound as though they've been ambushed, caught completely off guard. This is my fault and I replace the handset unsure of what I have unleashed.

My aunt does call back a couple of days later, and by now I've told Mum about the phone call. I'm not scared about her being angry. Mum has never dissuaded me from contacting my father, and she's always known where he and his family live. He has diligently paid towards my upkeep, too. Money drops into Mum's bank account every month. Yet for me, that makes his absence even harder to understand. I'm an outgoing transaction on a bank statement rather than a living, breathing person. Mum reassures me that she will support me in whatever I choose.

"Granny and I have been thinking. Would you like to come for dinner, Kristian?" my aunt asks.

"Will my dad be there?"

"Yes, he'll be there," she confirms.

"Yes, I'd like to," I say.

A date is set for Sunday, and Mum agrees to drive me to the suburban housing estate where Granny lives. Everything about the house feels beige, and when Mum drops me at the door, the reception I get is subdued, too. This is the moment I realize that it is as hard for Mum to be here as it is for me. She hasn't set eyes on these people for more than a decade.

Now that I'm at the door, I have a clearer vision of Mum, brought to life by the stories she's told me over the years. "If I could have said no, I

would have," Mum says of her marriage. She's described tears streaming down her cheeks before she stepped out of her wedding car and made her way through the arch of Drumbeg Parish Church near Lisburn.

"It's just nerves," Granda had said as he sat beside her. Then he warned her that if she didn't go through with the ceremony, all hell would break loose. "I've paid good money for this," he reminded her.

But Mum's outfit may have been a clearer window on her feelings. Apparently, she looked like a cross between a Las Vegas stripper and a member of ABBA: white fur miniskirt, white knee-length platform boots, and a fur stole draped around her tiny shoulders. Mum has no wedding photographs, but from the moment she described that outfit, she became my style icon. She wore tartan miniskirts, too. Elsewhere she may have blended in, but in rural Ireland in 1974, my hunch is she would have stuck out like dog's balls. The sheer audacity Mum had to dress like that on her wedding day. The Church of Ireland minister must have been mentally hosing her down with holy water when she walked down the aisle. Maybe my father knew he had a rebel on his hands, but as I've never heard his stories, I've never heard his side.

"Hello," Mum says to my aunt and strains a smile before turning to leave.

"You better come in, Kristian," my aunt says coldly.

I feel beyond anxious. Almost at hyperventilation stage. From memory, I don't know what my dad looks like, and he has no idea about me. The last time he saw me I was two years old. Now it's 1989 and I'm nearly fourteen. I'm in secondary school, studying for my GCSEs, and I've kissed a boy. A boy, for fuck's sake! That is a fact I will definitely keep to myself.

"Thanks," I say politely before being shown into the living room, where Granny is sitting. Dad is nowhere to be seen.

"We thought it better if we meet you first. Then you can come back and see your dad," Granny announces. I am speechless. I've thought about nothing else on the journey here. How he'll welcome me, what he'll say. I've even dreamed that, if this audition goes well, we can do this meeting regularly.

"Right," I say, puzzled.

"We thought you'd like to stay for something to eat, though," Granny says.

I stare down at my shoes. I feel utterly humiliated.

The TV is on in the corner of the room and Granny turns up the volume before turning towards the kitchen. Eventually a plate of fish fingers and baked beans appears, and she and my aunt sit in silence while we eat and watch the omnibus edition of the soap opera *EastEnders*. Both have thin, pinched faces and barely smile.

I have so many questions. There's so much I want to know about this half of my family that is a mystery to me, but all the curiosity I came armed with has vanished. Granny and my aunt ask me nothing about my life or Mum or anybody in her family. They ask me nothing about school or who my friends are, and by five o'clock Mum returns to pick me up.

"We'll be in touch," my aunt says, shooing me out of the front door.

"How did it go?" Mum asks as we pull off in the car.

"Dad didn't come."

"Why not?"

"Don't know, but he'll be there next time," I tell her.

Mum tuts angrily, knowing how deflated this will make me feel.

Over the next few days, I'm like a jack-in-the-box every time the phone rings. The invite back to Carrickfergus is due. Any day now, it will happen. Any. Day. Now. But days become weeks, and weeks become months. It never comes. Not one single call. Mum doesn't have an answer either.

Fuck you, I think. Fuck Granny, fuck my aunt, but most of all, fuck my father. As far as men are concerned, Lawrence is the only man in my family who I vaguely look up to as a father figure. Raymond is an uncle who is a bit more detached. We're biologically related, not properly connected.

Apparently, there were decent men. Nan's dad is someone who I would have loved to have met. She often talks about him. A gentle Irish man, she describes, while her mother, Tilly, was a rolling pin of force.

"He wasn't the fighting kind," Nan says. The story goes that he fought for the British in France during World War I but witnessed his brother

dying beside him in the same trench, shot down by enemy fire. It scarred him so badly that eventually he became a deserter. The men in our house loved him. Ordinarily that behavior in others may have been considered cowardly because all men should fight, but he fascinates me.

"He died so suddenly," Nan recalls wistfully, although I think it sounds like an idyllic way to shuffle off your mortal coil.

"These are amazing potatoes, Tilly," he is supposed to have uttered before keeling over and face-planting in his stew.

Granda is the other way. He comes from a family of hell-raisers. They are a fiery bunch who rarely come to our house. As for Granda, we've learned how to tolerate the old bastard.

"Even his sister died in the middle of an argument," Nan says with a look of resignation. He's a fighter, but underneath he's a coward. When Lawrence lived with us, he stayed clear of him, and so did Raymond, but the battle lines were drawn up way before my birth.

Before Mum's family moved to our farmhouse in Lisburn, they lived on another farm on the outskirts of a village called Drumbeg. Whenever we go to Belfast by car, Mum points out the house to me from the motorway. It's now an old stone shell. Part of the roof remains but its core lies in ruins.

"We stood up to him years ago," Mum tells me in a resolute voice. I don't know exactly what Granda said or did to Nan, but it must have been bad. Mum ran upstairs, fetched his shotgun, and when she found Granda outside, she pinned him up against the wall and held the muzzle against his neck.

"All bullies are cowards in the end," Mum says.

And I also know that men can do monstrous things. Mum has a secret of her own that rattles around in my head like a stone. It came out one day after I was being bullied on the school bus. She wanted me to know so that I could understand that bad things happen but people survive.

"I was raped," she confessed. I didn't know what to say. All I remember was the surge of love I felt for Mum as she put her comforting arm around me.

"What happened?" I asked her.

She was only nine years old at the time, playing with her friend on a stretch of parkland when two boys cornered them and dragged them to the ground. The boys were known locally. Apparently, Granda wanted to kill them, and they had to disappear for a while. But they never paid for their crimes, and she says she'll never repeat their names.

"Humans can be strong and resilient," Mum says, but it also explains a lot about Mum. She's loving, but she's not the gushy, hearts-and-flowers type. And she loses her shit badly if you ever corner her or stand in her way.

"All bullies are cowards in the end," Mum repeats.

I don't know who or what my dad is: whether he's a bully, a coward, or just useless at being a father. Maybe he's all of those things? Why else would he not turn up like that? Why else would no one phone me back unless he'd told them not to? Anyhow, something tells me he'd never accept me the way I am. I don't know if any of the men in my family will. I'm gay. There, I said it. It feels amazing to have a word for it, but it's not a word I use openly about myself. In school, it's not a word others use about themselves either, even though I know boys who must be gay. My friend Martin, with his love of lemon drizzle cakes and his merry band of female followers—he's gay. I'm sure of that, although he's never "come out," not even to me. And Rory *must* be gay, although he and I have never kissed since M block. I haven't breathed a word about that to anyone and I doubt he has either. I've not said the word "gay" to any other person bar one: my friend Nicky.

Nicky is a guy I know from outside of Methody. He goes to a different school, but we met on the bus home. He was listening to Megadeth so loudly on his headphones that I recognized the track and we made friends. He's become a distraction from the tedium of lessons. We share a love of heavy metal, and we mock each other like Bill and Ted on an Excellent Adventure. Mum warns me constantly that Nicky leads me astray, but the truth is we lead each other astray and I need little encouragement.

On some days I meet him in Sir Thomas and Lady Dixon Park, which is on the bus route to college. There's a café there called the Stables, and we nurse a coffee and a sausage roll on an outside bench like two old men and pass judgment on everyone who walks by.

"Jesus! Look at the state of him," Nicky says.

"Who?"

"Him. Over there. Two o'clock. With the checked shirt on. Gay."

Nicky spits out the word "gay" like you'd spit out a grape seed.

"Yeah, so gay!" I reply.

"Gay" is our diss for anyone we don't like the look of. It could be how they dress, or how they talk, or nothing in particular. If they're female, we call them "dyke."

"Absolute closet case," we agree simultaneously. I'm homophobic before I'm ever homosexual, stuck in my own ghetto of self-loathing. Yet, the more I play along with Nicky, the more I realize: the person who I'm dissing is *me*. I'm gay. I'm in the closet. And like a shaken soda bottle, I'm ready to burst.

Part of the problem is that "gay" feels like just another affliction to me. *I'm too tall and I'm too big. Nothing in this world fits me. Now I'm gay! Jesus fucking Christ! As if I don't have enough problems?* It's just another reason to put me in another box and segregate me. But there is only so long I can hold this in. And as I predict, I explode.

It happened when Nicky and I were on the swings near the café in the park. Other than ringing my dad, it feels like the biggest risk I've ever taken.

"See your man on the TV last night. He's definitely gay! Not even closet!"

Nicky had been talking about the British entertainer Julian Clary. He hosts a game show on Channel 4 called *Sticky Moments* where he appears in full makeup and brightly colored costumes. Sparkle on steroids. I think it's funny that Nicky only recognizes a properly gay man as this outrageous pantomime version, which means he hasn't got a clue about me.

"Yeah. So gay! Did you see him?" Nicky continued.

My body tensed, and the quiet rage flooded through me.

"You know what, I don't want to talk about this shit anymore," I snapped.

"What's wrong with you?" Nicky asked, surprised.

Ten minutes went by while Nicky quizzed me on why I'd suddenly become tetchy. Ten long minutes of me tripping over my words.

I didn't know what to say. I just felt sick. Eventually, I thought, *Fuck it.* I'll lose a friend, but that's better than lying to everyone, lying to myself. It's taken me enough time to find this path. Now that I'm on it, I'm not turning back.

And then it came out. I came out.

"There's someone we both know who's in the closet!" I said with a mixture of defiance and fear.

"What are you talking about?" Nicky's face looked blank.

"Me, Nicky! I'm gay! What the fuck are you going to do about that?"

Absolute silence. Nicky swung back and forth as the iron chains creaked. I'd carved out a piece of my heart and served it up to him, still beating, on a plate. I fully expected him to hop off the swing and say his goodbyes—"Nice knowing you, Kristian"—but he didn't.

Instead, he turned, open-mouthed, and asked:

"You're really gay?"

"Yeah, I am."

"Well. Right," he said, pausing again. "Have you heard the new Megadeth track?"

"Course I have, what kind of eejit do you take me for?"

"All right! Don't lose your shit. Fucking great, isn't it?"

"Yeah, it's fucking great," I say.

That day we left the park together exactly the same people we entered as. Next thing I know, Nicky's my number one fan. I could never have predicted that. He's even started to come to Limelight with me.

—

LIMELIGHT IS A CLUB IN BELFAST ONLY THE WEIRD KIDS AND goths from Methody go to. And since I've been at that school, Belfast has become my new playground. It's got a Pizza Hut restaurant now—the first in Northern Ireland. The all-you-can-eat salad bar is out of this world—vegetation like Tollymore Forest and coleslaw dribbling. We've also got a laser tag venue called Quasar where we hang out. We hold our fake rifles and skirmish. Virtual combat in a city where the bloodshed is real.

On the weekend, I get the train from Lisburn to Belfast, although, just like the school bus, it's another form of public transport I'm desperate to avoid. Complete strangers seem to have no filter when it comes to me.

"Hey, what's the weather like up there?" they shout out, thinking they're clever. I'm perpetually shocked that they think they're the first person to have thought of this jibe. *How original.* Yet however daft I know they are, I still feel like a criminal in wooden stocks, there to be kicked or spat at. Every comment sends me into a spin, so I leave home with my Walkman and my headphones and play my music at deafening levels to drown out the verbal assaults.

Only recently I was on my way into Belfast when I overheard a group of girls talking. I was walking through the carriage searching for an empty seat. There were three of them in short skirts and stilettos and makeup, probably only a little older than me. As I shuffled past, I heard them whispering loud enough for me to hear.

"Jesus, will you look at him?" one nudged the other.

"Who?" another asked.

"Oh, him, yeah. I know!" her friend said. "He's practically malformed!"

Practically malformed. A comment as throwaway as chewing gum. I could have died. I wanted to speak up, find my voice. *You have no clue how bad that makes me feel,* I wanted to say. But I know better than to say anything for fear of landing even more abuse. Instead, I put my head down and kept on walking, replaying those words over and over in my head.

Being this size does have some advantages, though. At Limelight I'm big enough to be ushered in by security without too much interrogation.

If anyone does ask, I carry fake ID, which I think is amazing but is basically a scratchy picture of my face and a date scribbled over in pencil. In Belfast in the late 1980s and early 1990s, no one is too vigilant. I'm also the designated cigarette and alcohol buyer, which does give me some kudos. Even the shopkeeper at the off-license knows I'm underage.

"I see you've been roped into this again!" he says while serving me a bottle of Malibu or the Rumple Minze peppermint schnapps we like to drink because it's cheap and very, very strong.

At Limelight, Tuesday through Saturday are "straight" nights, and it's on a Saturday when we usually go. I always bring a cassette tape and harass the DJ to put it on. If I'm lucky, he might play it. He's even indulged me in death metal band Deicide's "Dead by Dawn"—a brutal assault on every sense that leaves some in the crowd looking bemused and terrified. I love to watch people's faces contort as the track rages. Each Saturday, I'll go to the music exchange on Botanic Avenue called Dougie Knight's. He has racks of mainly secondhand vinyl and cassette tapes stacked up behind glass shelves—anything from Beethoven to Black Sabbath—so I'll bring in tapes and sell them for cash. Then, when Mum gives me my pocket money at the start of the week, I'll buy back all the tapes I regretted parting with. That way I have enough money for a Saturday night out.

We start in the Dome, which is the warm-up bar before we hit Limelight. There we drink purple nasties—beer, cider, and blackcurrant—before we start on the Malibu and pineapple. That's when things get messy. At Limelight, bands do play, but mainly it's DJs, so we pile in and listen to early Rage Against the Machine and Guns N' Roses and inhale the eternal smell of chips that wafts from the venue's kitchen. Chips always taste better when you're drunk. Better still if you can pinch them from somebody else's plate.

Monday night at Limelight is "gay" night, but I've only just started going. Before now, if anyone asked, I'd say: "I wouldn't be seen dead at Limelight on a Monday!" And the bouncers are the same on every night of the week. They know the faces that come and go, so I have a

pathological fear of word spreading. If I'm going to be loud-and-proud
"out," which I'm definitely not, then I want it to be on my terms. I lack
so much control about how the outside world perceives me, it's made me
weary about revealing myself to anyone. For that reason, I'm grateful to
have Nicky as company. Given that he was the most homophobic friend
I had, I still can't believe he's offered to come. And he's enjoying it, too.
Hanging out with me and a bunch of fruit flies.

"Fancy something different tonight?" The bouncer winked at us on the
first Monday night Nicky and I turned up.

"Yeah, definitely." I gave an embarrassed grin and stared at the
pavement.

And Monday night at Limelight is completely different to a Saturday.
It's as if someone's rocked up with a bucket of glitter, cleared away the
detritus of grunge, and slapped on some cheesy pop and happy hardcore.
There are men in checked lumberjack shirts and combat trousers who
look like Kurt Cobain, but out of the corner of an eye it's not unusual to
see a barman in drag whiz past on roller skates, balancing a tray of fruit
above his head while favorites like Madonna's "Like a Prayer" take flight
over the dance floor.

Other than the Crow's Nest in Skipper Street, which has the repu-
tation of being an old man's pub, there are no proper gay venues that I
know of in the city. For me, it feels like a wonderland—a place where I
can test out different versions of myself, try out new personas for size. On
this journey, I don't have any role models. Not everyone looks like me
or dresses like me, which is always the same black jeans and big baggy
T-shirt, but I know I'm with a tribe of like-minded people. Most of all,
Limelight feels safe.

That said, the vibe at Limelight is charged like a tinderbox. Everybody
is checking each other out. I'm far too unsure of myself to ask anyone out,
and if anyone did approach me, I would die. Instead, I prefer to observe
and there are boys there that do float my boat. As such, I don't have a
"type" other than someone who doesn't look like me. And other than the
personal ads at the back of *Sky Magazine*, which has celebrities like Tom

Cruise and Madonna on the front cover, Limelight is the only way for people of our age to meet.

Mum is still my regular taxi service. Whenever it gets too late to catch a bus or a train home, she'll make the half-hour journey into Belfast and wait for me on the roadside. Mum doesn't like me being in Belfast late on my own. She knows how boys can get caught up in the undercurrent of crime. Or how people find themselves in the wrong place at the wrong time.

"Belfast is dangerous," she still warns me. For me, though, it's become the only place where I can express myself, where I'm free to grow into my own skin. In Lisburn, there is no gay bar, no gay club, no gay anything. I don't even know if there are gay people. If there are, they keep themselves hidden.

But Mum has no idea that Limelight runs a gay night on a Monday night, and tonight she's faithfully waiting. As we spill out onto the pavement after midnight, I see her car but I'm distracted by two guys fighting.

"So that's it, then?" one is shouting.

"Yes, that's it!" the other spins round and yells.

I put my head down and continue walking towards Mum's car. The argument rages on and it's in full throttle when I open the passenger door.

Just as I do, one guy roars at the top of his voice:

"So, does that mean you're not going to sit on my face?"

If the ground could swallow me whole, I would be happy.

"Hi, Mum," I say, ducking in and banging the door extra hard to hide the din of the argument. But I also know that not much gets past Mum.

"What did he say?" she asks.

I can feel my heart pounding.

"Nothing," I reply. "Shall we just get going?"

"Did he just say what I thought he said?" Mum is frowning, searching my face quizzically.

"Kristian, is this a gay bar?"

It's so obvious, there isn't any point in lying.

"Yes, it is," I reply in a near whisper.

On the journey home, Mum is silent. She doesn't ask any more questions, but I know now that I have to tell her. She'll find out sooner or later, and part of me thinks that she probably already knows.

A couple of days later she and I are standing in the kitchen. *Just say it, Kristian*, I think. *What's the worst that can happen?* Mum has always been by my side. There's no way she'll let me down. I take a deep breath.

"Mum, I'm gay," I tell her.

Mum carries on making our cups of tea. She hands me mine, but when she does look up, there's a concerned expression on her face that I can't fathom.

"I know, Kristian," she says before pausing. "But you do know that involves anal sex, don't you?"

It takes a moment for the question to register, but when it does I almost spit out my tea. *Of course I know!* I want to shout, but I'm more taken aback by Mum's uncomplicated pragmatism. She seems more terrified I'll start a brush fire than she is worried about what being gay could mean for me as a boy.

"Yes, thanks, Mum," I say confusedly.

"I always thought you were," Mum concludes.

She carries on as if nothing has happened. *Was it my love of Wonder Woman?* I think. But if Mum did know, I'm glad she didn't say. Instead, she's left it to me to announce myself to the world. And I do. At school, I become one of the first boys to be openly "out." *Throw what you like at me*, I think. *I've heard so much worse.* What's more, there's nothing to lose. All the people that I love most in this world are still here.

"Mum, please don't tell Granda," I ask her finally.

"Don't worry. That secret's safe from him," Mum reassures me.

LANDING ON PLANET GEORGE

DURING THE FIRST SEASON OF *GAME OF THRONES*, I AM still working as a full-time DJ. Season regular status means I'm not required on set all day, every day, unlike many of the principal cast members. Besides, I still need a regular wage outside of the series. When I have a gig in a Dublin nightclub, David and Dan suggest I stay on and meet George R.R. Martin, who will be in the city at the same time to talk to fans as part of the city's annual book festival.

"Sure," I agree. Given that Mum is such a big fan, I'm fascinated to meet George, even though I still haven't read his books. The only communication we've had is the note he sent with my pewter replica. Among *Game of Thrones* executives, however, he holds an almost mythical status, especially for David and Dan, who are busy transforming his stories for the screen.

"Will anyone else be there?" I ask.

"As far as actors go, it's just you," David tells me. It's a mystery why I've been singled out, but I have to remind myself that however adrift I feel about my performance on set I should push myself, be proud that I've gotten this far, and embrace all the opportunities *Game of Thrones* throws at me. *Come on, Kristian, be the yes guy!* I tell myself.

The venue is the Camden Court Hotel in the south of the city. George will appear on a panel with the renowned Irish writer Peadar Ó Guilín, whose teenage fantasy and horror stories draw on all the Irish myths and legends I've loved as a boy, and I'll be there, too. Peadar also has some involvement with the unofficial *Game of Thrones* fan club, which I've heard about. It's called Brotherhood Without Banners—a loose affiliation of enthusiasts who follow George religiously and whom George himself is closely connected to. Alongside his wife, Parris McBride, they travel the world taking part in events and discussions. I've heard she's even hand-made banners for the fan club in anticipation of the show and in the absence of any official merchandise.

I'm expecting queues around the block, but when I get to the venue, I'm surprised at how few chairs are laid out. On set, there's a serious buzz around the production. We're only a couple of months into filming, but whenever I step inside the Paint Hall there's an adrenaline powering through it. It's so much more than its generators and cameras and cables—it's a life force of its own. By comparison, this gathering feels anemic. As fans drift in, there can't be more than fifteen people in the audience. They're difficult to pigeonhole, too: men and women of all ages sitting with their questions and books to sign. It's the first time I realize how dedicated George's fan base is. Small but knowledgeable—his happy hardcore. If I'm to do them any justice, I *have* to get Hodor right. These people will be poring over my every move. And at the back of my mind is always David and Dan's prediction that Hodor will become one of the series' best-loved characters. And while no one is talking about my character yet, it's been a shock to me how many blogs and forums appeared talking about the show before filming even started.

I'm also new to this world of fandom. Public speaking events or interviews are something I'm not prepared for. I've been given no media training, although thankfully no media has contacted me. The only missive I've come armed with from the powers that be at HBO is that I must not give anything away about the first season storyline.

Do you know how hard that's going to be for me? I thought as soon as they said it—it's like telling a child not to beg for sweets! I love spilling the beans. I love to watch people's reactions. Call me Mr. Instant Gratification! I also *really* hate lying—I want to be true to myself. It will take all my earthly might not to reveal a thing.

When I meet George, he instantly reminds me of a *Star Wars* Ewok. He's a short barrel of a man with a tufty fisherman's beard and a cap and when he greets me, it feels like he's greeting an old friend.

"Great to have you on board, Kristian." He smiles warmly before I'm treated to the first killer question of the evening.

"So, have you read the books?" he asks as we wait to take our seats.

Fuck. Is it bad form to lie to a god? I ask myself. When I study George's face, he's inscrutable. I pray he hasn't sensed my panic, but in that second, I make a decision: *He's a grown man, he can take it.* Besides, I've been astonished to find out that a few of the principal cast members haven't read the *Song of Ice and Fire* books either. Peter Dinklage, of all people!

"I don't want to know what happens to my character. I'm just living and breathing it," he told me during one of our breaks at the Paint Hall. Lena Headey feels the same. She doesn't want to lose the surprise element of how her character unfolds. To hear that has made me feel far more positive about my own half-baked strategy. I'd been carrying around the embarrassment of it like I carry around Isaac. Plus there are so many pages to get through!

"I'm really sorry, George, I haven't." I give an apologetic grimace.

"It's okay," he says with a shrug. However, I do feel I have to explain my reasons. As I talk, George's eyes flicker like an old light bulb. Without judgment, he's simply listening, taking it all in.

When the panel session starts, I begin to understand more of what it's like to land on Planet George. These fans may look different, but they are united in one passion—fantasy nerds who know every plot twist backwards, forwards, and inside out. For the first time, I also see the pressure an author like him is under. Everyone wants him to keep writing, to keep producing.

"When's the next book coming?" is a recurrent theme.

Four books have been published already, and he's just completed a fifth tome due to be published next year. He's not giving any spoilers away, despite the intense scrutiny.

"How does it feel having your vision adapted for the screen?" one fan asks.

"I have a lot of involvement," George explains.

"Are you happy with things so far?" another fan grills him.

"I'm really proud of the world that's been built. It's undoubtably mine," he replies.

Apparently, before David and Dan approached him, films had been mooted. But, George says, this wouldn't have done justice to the complexity of the *Game of Thrones* storyline. It was their enthusiasm for a long-running series and their commitment to staying faithful to the material that persuaded him. This builds on my respect for David and Dan: they're not just an abacus of box-office takings. They genuinely care, and this format has emerged from that desire. Characters have been altered and storylines have needed to deviate for the on-screen version, but none of the books' soul will be lost, George reassures the crowd.

When the attention turns to me, I feel I get off lightly—a sideshow to the main event, a starburst of intellect compared to George's galactic imagination. Fans seem to know me better than me, to know that I'm a newbie to the acting world. They want to hear about how the shoot is going, what it's like working with a star-studded cast.

"Intimidating and a great learning experience," I tell them.

I do not let on that I'm still rabbit-in-the-headlights terrified.

They also want to know how I feel about playing Hodor, to which I give the same diplomatic answer. I navigate each question, tiptoeing

around any incriminating detail. It's excruciatingly hard, but I can't give anything away.

There's a break between the panel session and the book signing, and George and I have a chance to chat further. Throughout the session there's one more observation I've had. George isn't superhuman. He isn't a god. He's a fantastically talented human being—but he is *very* human. And he's *very* funny, too. Bitingly funny, in fact. And although the series is set in a medieval kind of middle earth, his characters are just as human and flawed as all of us. *Game of Thrones* is spirited and dark, but it's George's gritty understanding of his characters that absorbs me. Today, however, his mind is also on more mundane concerns, which feels kind of wonderful.

"How's your hotel?" he asks me.

"Fine, other than the coffee. It's dreadful," I reply. As the on-set catering department is discovering, I can't start any day without rocket fuel, which their mass-catered vat of coffee most definitely isn't. I've started bringing in my own cans of Red Bull as a substitute in the hope they might get the hint.

"Yeah, don't you just hate it when the coffees sucks," George agrees. His body is in another time zone, he adds. He's not long come back from Australia and then he flew from his home in Santa Fe in New Mexico to Ireland only a couple of days ago. Cans of full-fat Coke are keeping him upright, he admits.

The conversation tickles me. We're sat like Statler and Waldorf from *The Muppet Show* carping from the sidelines.

"How's your hotel?" I return the question.

"The air-conditioning's too cold and the food is terrible," he moans.

I think that all this traveling and meeting of fans that George does must exhaust him.

"Don't you ever want to say no?" I wonder.

"Sometimes," he admits. "But without the fans I wouldn't be here, and they really are a lovely bunch of people—my tribe," he laughs.

I LOVE THE
NIGHTLIFE

"Go on!"

My friend Leigh is giggling and pushing me. We are at the top of the stairs in our farmhouse in Lisburn. It's 1995 and I am twenty years old. It's funny how your tribe can hide in plain sight until one day you find them, and Leigh is definitely one of my tribe.

"Go on!" she nudges me again. I am in full makeup with a black feather boa wrapped around my head, ready to make my grand entrance into the living room where Granda is reading his paper.

"Okay," I laugh back, knowing that what I'm doing is fraught with risk. Mostly, I don't care—I love that I'm pushing the boundaries, puncturing the established order of things. Even though, when it comes to me, Granda seems oblivious that he is the established order.

Before now, I vaguely knew of Leigh. She and I both attended Methody. We were in the same year in the same school, but we were never friends or shared the same friends. Weird that I didn't ever *see* her, especially as Leigh is the type of person who demands to be seen. She does not give a fuck. She looks like Courtney Love—bleached-blond bob, blackened roots, fur coat, and a miniskirt. She's fearless and unapologetic. But I guess back then I was too busy hiding myself.

Then, I bumped into her at a party after we left school and we've been friends ever since. Somehow we've gravitated towards each other. At heart, we're free spirits, and Leigh does bring out something in me that I can't explain. Not all of it is good. On our first night together, we picked a girl from school we'd both disliked and ordered twenty takeaways to be delivered to her house. It was a competition to see who could up the ante, which we both won and lost at the same time. We surpassed ourselves in badness, but I'm not exactly proud.

Now Leigh comes to my house regularly. On a Friday night we'll get a Chinese takeaway, watch *Roseanne* on TV, followed by *The Word*, which we love. It's a two-fingers-up-to-the-establishment entertainment show, filled with bands and interviews and outrageous pranks. For me, though, it's simply a reflection of what I'm going through. Yet it's hard to see people like me on TV. Gay is not "normal." Quite the opposite—we're blacklisted. More so now that the AIDS epidemic has ravaged through gay communities and spread the fear of God into righteous people. I'm not even legal yet. Not until I'm twenty-one years old. And in the south of Ireland, the ban on "gay" has only just been lifted. But on *The Word* it's barely questioned. "Gay" and gay culture just *is*. It's in-your-face without explanation.

On other nights, like tonight, Leigh turns up like a demented Avon lady with foundation as thick as modeling clay and white powder, plus a palette of eye shadows—blues, hot pinks, and silver shimmers. I also bring out my lime green, which is the only item I've ever shoplifted. I shoved it into my pocket at Miss Selfridge department store to avoid being shamed at the checkout—a six-foot, ten-inch man buying eye

shadow! We huddle into the upstairs bathroom where there's a mirror and shut the door tight. I become Leigh's canvas. She applies a base layer, then the rest, topped off with thick black eye pencil to shape my eyebrows and a brush of cheap mascara to my lashes. She has an array of lipsticks, too—metallic reds and frosted corals.

Leigh also brings accessories—a punk Mary Poppins with her bottomless carpetbag of mirrors and plants and hat stands, only Leigh pulls out sparkly sunglasses and feather boas. There's fake diamanté necklaces, hair bands embedded with glitter, multicolored plastic bangles. I'm like a magpie. If something sparkles in the light, I swoop on it. And when she's happy with my finished look, we giggle in the upstairs hallway before she pushes me downstairs.

The only thing that's let tonight's outfit down is my black sweater. Mum knitted it, the same way she makes so many of my clothes. It's baggy and long and it almost reaches my knees. Leigh's so disgusted by it she's written a poem:

> Sweater from hell, sweater from hell,
> Go back from where you came,
> Sweater from hell, sweater from hell,
> You truly are a shame,
> You're full of holes and rips and tears,
> And smell of grizzly grizzle bears,
> Sweater from hell, on my nerves you are grating,
> You are the crochet work of Satan.

Tonight, Granda is grunting like a Rottweiler enveloped in his own pungent aroma. Mum and Nan are in the kitchen.

I poke my head around the door.

"Mmmm," I hear him mutter.

The stereo sits not far from the TV and it's also an item of furniture in its own right with its wooden cabinet. I would *love* to have the balls to march in, drop the needle of the record player onto vinyl plucked from

Mum's collection, and dance around the living room, fist clenched against my chin in the shape of a microphone and mouthing every word.

Mum's got T. Rex and David Bowie, Kate Bush, *Rock Follies*, Gary Numan, and much, much more. When I was younger, I had no clue that some of these records were classics, I just loved the sound—Kate Bush's ethereal voice and Gary Numan's synth-pop especially. Both bend and stretch and take me on a journey far more spiky than cheesy pop, even though I love that, too, in the same way that I love frothy coffee.

I'm *bursting* to shove that in Granda's face, but I know I can't. Instead, I flirt with danger. When I reach the bottom of the stairs, I turn and catch eyes with Leigh one last time. Then I strut in, hands on my hips, head up, chest out. I'm Linda Evangelista circa 1990 catwalking down a Milan runway. I'm head-to-toe cool defiance, but as I double back and strut past again, it takes Granda a while to even register.

At first, his head remains buried in his pages. And when he does finally lower his *Belfast Telegraph* and peer over the top of his glasses, it's not a look of shock he gives me. Instead, it seems to lightly tickle him.

"Haha," he gives a little chuckle as I flick my head from left to right and work my look harder before I make my way through to the kitchen.

When I look back at him, his eyes are following me and he's shaking his head, almost affectionately. "Honest to God, that boy . . . what's he up to now?" he's saying behind his dry smile.

What's he thinking? I wonder. *What does he understand of this? Does he know what I am?* I know for sure that he's never been told. As it happens, I don't think Mum's officially told Nan either, although I'm sure Nan does know, or at the very least she knows that I'm "different."

In the kitchen, Mum and Nan look up.

"Hi there!" I call out breezily, reaching into the fridge to grab some cans of Coke to take back upstairs for Leigh and me. They do not bat an eyelid. They've seen it all before.

Strangely, when I'm dressed like this in front of Mum and Nan I don't feel like a woman, or even think that I'm pretending to be a woman. I'm just delirious. This embryonic creation of Leigh's is so powerful in my

mind that I wish I could feel like this all of the time. And the best thing is, no one here—not even Granda—asks me to explain it. If they did, I doubt I would have an answer. This is an expression, a feeling, not yet an actual "thing."

Even so, it's not an expression I could ever have outside of this house. On the streets of Lisburn, I'd be lynched. Home is my safe place and Leigh intuitively knows that. Whenever she's here it's as if she's giving me permission to take one more evolutionary step. For these few hours I forget about the boundaries that constrict me in the real world, and I let go.

Back upstairs in my bedroom is where I shift up a gear. That's when the music blares out from my stereo and I perform. I mime all the words to every song with my imaginary microphone. And I dance. Fuck me, I dance. There's disco classics: Alicia Bridges's "I Love the Nightlife," or Tina Turner's "What's Love Got to Do with It." Leigh sits on my single bed with her feet up and her back pressed against the wall, enthralled by the spectacle. And when I finish, she whoops and erupts into applause.

These are all songs from the film *The Adventures of Priscilla, Queen of the Desert*, which I've seen so many times I practically know it off by heart. It came out last year and I'm obsessed with it. The only drag queens I've ever known are those I've seen at Limelight. They're old-style acts who snarl at the audience, picking out punters and humiliating them.

"Look at the state of you! What are you wearing?" they'll shout while some poor person sinks farther into their seat. But what I've seen in *Priscilla* is different. Behind the over-the-top act and behind the makeup, there's humanity. There's love. It's shown me that there's kindness. I know I have kindness in me, too. I don't want to be bitter. But before *Priscilla*, I didn't know that I could show it. It's opened me up to a different way of being—a way that's kind of beautiful. *I could do this*, I reckon whenever Leigh is here.

When the music eventually goes off, I help Leigh pack up her treasure trove. But at the end of the night, it's not just a bag that I'm handing over to her. It feels as though I'm handing her ownership of part of me.

"Maybe see you next week?" I say hopefully.

When Leigh leaves, this creation leaves with her. Back in the bathroom, I wet a cotton wool ball and begin to take off my makeup. Immediately, I can feel my shoulders hunch and I slink back into my shell as I look at myself in the mirror. I don't know how to reconcile these conflicting parts of me.

———

HOWEVER SCRAMBLED A PERSONA THIS CREATION OF LEIGH'S is, it's only through her that I'm forging it. It's strange to me that it feels so right because in the outside world I haven't found any clear path to who I want to be. In fact, mine has been a potholed existence ever since I left Methody, which was almost five years ago. Surprisingly, I came away with enough qualifications to count on two hands, but continuing in education was never part of my calculation.

Mum was disappointed, I think. She put so much energy into sending me there. And I never did get to join the school choir or the orchestra or make the most of the legendary music department. My face just didn't fit.

Instead, I've been at technical college, where I started on a course in travel and tourism. That lasted all of a year. My friend Nicky left school at the same time as me and started on his own course. But the two of us remained glued together. Whenever he was truant from lectures, I would meet him. And whenever I couldn't be bothered turning up, I'd suck him into whatever I was doing, which was never very much. We were like a merry-go-round of knuckle-dragging apathy. We continued to meet at the Stables for coffee and a sausage roll. Anything but sit in a classroom feeling the life force drain from us. Besides, hospitality didn't exactly tickle my pickle.

Next, in a last-ditch attempt to do something, I went back to Methody. Lucky they agreed to have me, Mum said, and I should have made the most of it. But that lasted all of two months. The death knell was a teacher approaching me in the corridor.

"Nairn, you need to cut your hair. It's hitting your collar. And tuck your shirt in like everybody else," she said. *This is definitely not for me*, I thought, as if I didn't know that already. *I'm just discovering who I am. I'm not conforming for anyone!*

Then, a foray into hairdressing, which to date is my shortest-lived career—shorter than a crew cut. That lasted all of two days. In my head, I was wafting my way to Vidal Sassoon in a cloud of L'Oréal hairspray to fashion asymmetric bobs. Imagine the disappointment when I spent ten hours sweeping hair from the floor and scraping dead skin from old ladies' scalps at Paul Shappiro salon. The glamour of it! On day three I didn't turn up. I still give the salon a wide berth if I'm ever on that Belfast street.

I've also been a trainee chef. That was at the College of Business Studies, but that came and went. I love food. I always have. I've grown up with Nan, who still dreams about having one of those big double-fronted Aga stoves—the kind you find in posh farmhouse kitchens—but has had to make do with the same beat-up electric cooker she's always had. Despite this, the assembly line of food she creates is remarkable.

Our kitchen at home has always smelled of freshly baked soda bread, potato bread, and scones. To me it's the smell of pure comfort, but training for a commercial kitchen was like a boot camp in a war zone. The pressure was unbearable. After a year, I gave up on that, too.

And I even made the bold move of leaving Belfast for the mainland UK. I thought I would like it there. I've always enjoyed visiting my great-aunt and -uncle in Newcastle. And I did enjoy it, for a while. A college in Belfast put me in touch with a new course starting in Stoke-on-Trent—the first of its kind to combine music and performance. There were modules in recording software, music promotion, music, and acting. I don't even know that I want to perform, I just know I want to share something that I love with the world, though how I make a living from music, I have no idea.

As for Stoke-on-Trent, it's a gritty, industrial, brawler town in the Midlands. The house I got allocated was a two-up two-down worker's cottage

with a steel security shutter on the door and a housemate called Daniel, who turned up twice the entire time I was there. He seemed lovely, though. I could still claim government help, but I've discovered I'm a disaster zone when it comes to money. As soon as I picked up my welfare check, I went to the corner shop and bought a bag of frozen fish fingers, a loaf of white bread, and a Toblerone as big as a walking stick to last me the whole week. The remainder I spent on dyeing my hair a new color of the rainbow.

I would have stayed and finished the course, but the abuse I get in England is just a different shade on the spectrum. No one on my course cares that I'm gay. But a giant? I haven't jettisoned that curse. Worse than that, I'm an Irish giant. And to people in England, there's only one kind of Irish.

One night, I was in the phone box at the end of the street talking to Mum when an object smashed right through the window.

"What the hell was that?" she cried.

"I'll call you back, Mum."

Outside in the darkness a group of kids on bikes were hurling stones at me. They couldn't have been more than twelve years old, with faces scrunched up like angry wasps.

"Freak!" one of them called out.

"IRA freak!" another shouted.

Word must have gotten round that I was not one of them.

"Yeah, fucking IRA. What you gonna do, bomb us?" I heard.

Jesus. IRA? I thought. Well, of course, I *am* Irish, so bovine logic would dictate that I can only be a Republican paramilitary here on a killing spree. There was no point explaining the finer details of the Troubles to them. I endured three more months before I realized my welcome was truly over. And now I'm here, back home with Mum, Nan, and Granda in Lisburn and still finding my way.

I do have a job, though. It's with the communications company British Telecom. I am the voice of fax telesales.

"Hi, my name is Kristian Nairn. I'm from BT. Would you like to hear about our new product Fax Minder?"

Fax Minder is a service for people to leave messages.

I say this day in, day out. I dress in a smart shirt and trousers and sit in a cubicle in a call center, watching others who have been here far longer than me claw their way up to become the shining knights of telecommunications. To be honored with a permanent contract here is quite something. They will die here, I'm sure of it, but I have so much untapped energy tearing around me that I just furiously call people until my shift ends.

To stop myself imploding I've enrolled on a sign language course. Having had hearing problems all my life, I know I have something to give in this world. Besides, the Minicom system I've learned to use is so cool. It's a communication tool for deaf people and people with speech difficulties—a teletypewriter that sends electronic messages to its recipients.

I've signed up to do a counseling course, too. I don't want to spend my life connecting people to products via the BT switchboard. Instead, I want to bring people together in other ways. Leigh's taught me that I need to get whatever is in my heart out. She's taught me that I have love to give even if I don't know how to love myself. And if I can't do that through music or performance, then maybe this is my only hope.

Slowly, I can feel myself changing, and since I've been home Belfast is changing, too. There's a new permanent gay venue that's not just a token Monday night at Limelight. It's called the Parliament. It took me a while to switch allegiances. Limelight is where my loyalty lay since I first stepped into it as a terrified fourteen-year-old, not even "out." But Parliament is gay every night of the week. It's grotty and seedy with carpeted floors that your feet stick to. It's got dancers in cages and downstairs it has the largest horseshoe-shaped bar and a staircase that leads to a room that feels like Santa's grotto. It's filled with fairy lights and neon triangles hanging from the ceiling, and sometimes when it's early I go there alone and stand beside the bass bins. I watch the DJ in the booth spin track after track and feel the beat reverberate through my chest. Parliament smells of sweat and poppers, cigarette smoke, sex, and possibility. It feels electric and I feel alive.

But it's taken me a while to find my place there, too. I still have my mullet of long hair. I still wear my black jeans and baggy T-shirt. The world has moved on to grunge and I remain in a glam metal haze. I don't care what people think about that, but I do care about everything else. I care that someone will find me attractive enough to make their way through the smoke to ask me out. I care that I'm safe here—that I'm with my tribe. I care that I'll be accepted the way that Mum and Leigh and my handful of friends accept me.

But my first night at Parliament reminded me never to have blind faith in any new order. I was standing by the bar when one guy approached me.

"You new here?" he asked.

"Yeah," I replied, looking hopeful.

"I know a great diet," he said before turning on his heels and walking away.

In that moment, I felt agonizingly exposed. Honestly, I still do.

THE DRAFT EXCLUDER

"Okay, Kristian, could you take your robe off now, please?"

Paul says this softly but matter-of-factly. Can *I*? It's being presented as a choice, but he knows and I know that it isn't a choice at all. *Can I?* I pause. Paul is the head makeup artist in our Raven unit. He looks at me with a sympathetic half smile. *I know this is going to hurt, but it's my job,* he's saying without saying anything. I have agreed to this, after all. David and Dan *did* run through this with me at the Fitzwilliam Hotel. *Why the hell did I say yes?* I think. But the nude scene has been signed and sealed: the scene where Hodor emerges from bathing pools completely naked for ten, maybe fifteen, seconds. I will be undressed for less time than it would take me to text a friend, yet it has played on my mind for weeks. *Come on, Kristian,* I think. *Just get this over and done with.*

By now it's around 10 a.m. and the trailers have been buzzing for hours. Base camp, we call it whenever we are on location. Today's base camp is a little market town called Carryduff, just south of Belfast. A cluster of trucks are parked up where the Saturday farmer's market usually runs. *How apt*, I think. Fresh meat served up to a baying clientele. The prover- bial lamb to the slaughter. Last night I even debated whether to have a "tidy up downstairs." *Maybe I should give myself a shave? Make it all look a bit more presentable?* Then I remembered it has been explained to me, sev- eral times now, that the prosthetic penis I've requested for this scene will be attached to my own bits and bobs. Apparently, it will be plaited into my existing pubic hair even though I can't fathom how it's going to work. Best not shave, I concluded. It's *Game of Thrones*, for God's sake. We're in fantasyland 298 AC, whenever that is. Be kind and give the makeup guys something to work with. Let the forest run free!

The crew has been arriving in dribs and drabs. I'm familiar with this because, being among the first on set, I am always here to greet them. Normally a car collects me from home at 4 a.m. I've opted for a pickup because I don't trust myself to wake up and get here under my own steam. Besides, it's lovely to have someone else drive. I've been allocated a maroon Jaguar, which apparently was once the car used by the heroine of the Northern Ireland peace process, UK politician Mo Mowlam. She must have been tiny. The only way I can fit into it is to stretch out on the back seat. On the journey I sleep, or sit half-awake watching the sun rise as we wind through the countryside. When I took on this role, I never factored in an early start. I am *not* a morning person and I assumed Hodor would have very little makeup—at most a sweep of grease in my hair and a dust over with a powder puff. But, other than the characters like the White Walkers who are imprisoned in makeup from 2 a.m., my preparation takes the longest. Tattoos are the culprit, and I have several.

First are the five blue stars tattooed on my right temple. After lengthy discussion, Hodor has been given a facial scar to cover them. By chance this ties in nicely with my imagined backstory about Hodor being kicked in the head, but the process is uncomfortable. As a former drag queen, I'm

used to the makeup, but now I must sit expressionless while red blocker is applied to neutralize the blue. Then, it's painted over with foundation, spirit gum, and scar wax. A scalpel is used to carefully make the shape of the scar. It pulls like a face mask and often peels off under a bright-light sweat.

More troublesome is the depiction of Thor that covers my shoulder, plus a nuclear sign tattooed onto my inside wrist—a black trefoil on a yellow background and the first tattoo I ever had done—a humorous nod to the person I used to be.

At some point in my past when strangers asked, "How can you be that tall?" I ditched the credible, polite explanation that I'd used for so many years: "Oh, there's a tall gene in my family." Instead, I dressed my reply up in double-plated battle armor: "Because I grew up next to a radioactive power plant!" I hoped they got the subtext: *I get asked that by everyone, you stupid wee prick, so you're going to get a stupid wee answer.*

—

PAUL HAS ALREADY DABBED ON DIFFERENT SHADES OF FOUN-dation over Thor for around an hour. Setting spray has also been applied, which thins and wrinkles my skin like an octogenarian's. Now it's going to be applied to my nether regions and I shudder at the thought.

By now a few more members of the makeup crew have arrived, along with the actress Esmé Bianco. We've never met before but she's playing the part of Ros, a prostitute working in Winterfell.

"Hi, nice to meet you," I nod politely as she slumps down in the makeup chair next to me with her morning coffee. It feels as though I may be in good company—she has to take her clothes off all the time.

"So, Kristian. Dressing gown off?" Paul is now waiting.

"Yes, sorry . . . " I stand up and start to untie the cord and slowly peel the toweling robe from my shoulder. I pull a glum face.

"Feeling okay?" he asks. *Oh, you do not want to know the answer to that one, Paul.* "No. Not really," I want to say. My insides are knotted like you

wouldn't believe. This is me. Kristian. The guy who never wants to take his clothes off in front of anyone, let alone a trailerful of people, some of whom are strangers. I've been body-shamed enough with my clothes on!

Paul wants an answer, but in that split second, I'm transported back to my fourteen-year-old self in the carriage on the Lisburn-to-Belfast train. I can still picture those girls dressed up for a night out. I can still hear them whispering: "Jesus, will you look at him? He's practically malformed."

I wonder, would any of them know that I'd be here more than twenty years later—a thirty-five-year-old man on the production set of one of HBO's biggest series since *The Sopranos* or *The Wire* with those words still emblazoned on me like a branding mark? *I don't need to feel this exposed*, I think.

But there's another voice in my head, too. It's the voice I've been working on for so many years. The voice I am *still* working on to this day. Yes, I *am* feeling okay, Paul. Yes, I *do* want to do this. I *need* to do it, even. *The days of the Hollywood trope are over, bitches. I might not be Brad Pitt, but who the hell is? I have as much right as anyone to be proud of my body!* "Erm . . . I'm nervous," I reply. It seems so much easier to say.

Suddenly, a shout interrupts my thoughts.

"Go on! Don't worry, I've seen it all before!"

The roar is Esmé's, and when I turn to her, she is grinning from ear to ear. She's a burlesque dancer outside of *Game of Thrones*, she explains, and she's already had to give a full-on flash of her bits to Theon Greyjoy, aka Alfie Allen, in episode 6.

"Nothing shocks me. Literally nothing," she beams. Immediately I can feel my tension soften.

I take my robe off, but I can still sense myself standing as stiff as a sentry guard. All I need now is for Isaac to stampede in with his *SpongeBob SquarePants* earworm and his "Morning, Kristian!" cheeriness. I would die. Not to mention be reminded of the irritating fact that Isaac gets to turn up to set later than me every single day. Comparatively, he needs little makeup.

Next comes the hard part. Paul turns to fetch the prosthesis. I've had the pleasure of seeing it twice already, but its size has grown in my imagination in the intervening weeks, like a looming obelisk. The first time it got presented to me was several weeks after Paul asked if he could take a picture for the special effects department. Apparently, they needed some dimensions to work with. It was just me and him in a room with a camera and my pants down. On any other day, that would sound like a come-on, but it *really* wasn't. And the thought of my Polaroid penis being passed among people analyzing closely my length and girth to work out how this gargantuan contraption would fit over my real dick made me squirm.

I'd only just gotten over the embarrassment when the props department called me in.

"Kristian, we need to make a decision about which prosthesis to use," they said.

Jesus, there's more than one? In fact, there were two: one a slightly lighter shade of burnished oak complete with thick, dark, afro-curl pubes. *Is someone having a joke?* I thought. Surely they'd know by now that with a surname like Nairn I'd be half Irish, half Scottish with a hue verging on Arctic blue. Thankfully, the one Paul now has in his hand is a closer match—much paler but still not quite pale enough.

The moment I saw its size, though, I'd said to Paul: "I could use it as a fucking draft excluder!" Sixteen inches of hard, weird plastic that looks like a hollowed-out dildo.

"And it doesn't even match my coloring!" I protested.

"Don't worry, Kristian. Makeup will sort that. We'll match it to your skin tone once it's on," he explained.

The second time the prosthesis got an outing was not long after we started filming. I turned up at work to find the actor Richard Madden, who plays Robb Stark, dancing around the car park at the Paint Hall studios like a naughty goblin. He was gripping it with both hands and shaking it enthusiastically like a garden hose. Apparently, he'd stolen it from the special effects department.

"Holy God, look at the size of it!" he was shouting to the small assembled crowd of assistant directors and runners, all pissing themselves laughing. "This is yours!" he yelled to me as I walked over.

"Thanks, Richard," I smiled. I took it in the humor it was intended. And I've gotten to know Richard better since then. I like him. He's a joker who never fails to make me laugh. But that morning when I looked at everyone's faces, they were laughing *with* him, not *at* him. Or that's how it seemed to me. I don't know if people will be as kind. I'm dreading finding out. *Really* dreading it.

The prosthesis is attached with a thin twine—a kind of undignified G-string that secures around my back and bum before it's plaited in. Sometime down the line some poor sod in postproduction will have to airbrush that out, too. My arse cheeks will probably be in their face for hours. Not a thought I want to dwell on too long either.

Now a pot of glue and a paintbrush appear.

"I thought it just needs plaiting in?" I say to Paul worriedly. In the endless conversations I've had about this prosthetic, no one has mentioned anything about glue.

"It's going to be on for a long time. It needs to be secure," Paul replies. I can tell by the way he's softened his voice that he's treading carefully. *Right. Don't make a fuss, Kristian*, I think, but fuck me, it's painful. The glue gets applied in blobs that stubbornly pull at my pubic hair before it gets worked into the surrounding area. I need more Red Bull, and fast. Thankfully, a can has been delivered. It's the only thing so far I've put my foot down over. I reached my limit with the canteen coffee, and catering have kindly begun stocking energy drinks for me. They've nicknamed me "the Red Bull Guy." I'm alternating sips with shoving a lukewarm bacon sandwich into my mouth.

With my pubic hair plaited and the glue applied it's now time for the painting of the prosthesis. This seems to take forever. From my vantage point, all I can see is the top of Paul's head and his brush and powder puff working away below. Periodically, he stands back with his hands on his hips for a good eyeful before rummaging around on the countertop for a

different shade of foundation. Down he goes again. *This is a day of indignity, get used to it, Kristian*, I think.

"Okay, we're done. Ready to move to set." Paul finishes off with a dramatic curtsy and hands me back my dressing gown.

"Not so bad, was it?" he says.

"Erm . . . fine," I reply shakily.

Set. Shit. The time has come.

—

TODAY'S SET IS A DENSE GLADE NOT FAR OUTSIDE OF CARRY-duff. The woodland here is beautiful. It's exactly the countryside I grew up in: between the fields and rolling hills there are wooded dells and secluded fern-covered clearings, places where supernatural beings would naturally find a home. Perfect territory for what has been sold to me as "a magical scene."

It's a scene I've rehearsed in my head many times, and I dredge it up again on the short ride there. In the *Game of Thrones* story, the pools are near Winterfell. I visit them with Bran and a wildling called Osha who, in a previous episode, has been spared death at the hands of Robb Stark. Now she is a servant for House Stark and part of our entourage.

Bran has come to pray by the sacred heart tree. He and Osha will be talking together when I interrupt them by rushing out from the location's hot pools, where Hodor loves to bathe. Only I've forgotten to dress myself. *What would Hodor do in that scenario?* To me, there's only one way to play this. Hodor would run out so haplessly, so innocently. Nothing in Hodor's brain would register that it isn't the "done" thing—like a baby trundling out in its nappy to find its mother. That's it. A baby. I'll play Hodor like a giant baby, I've decided.

When we arrive, I find myself looking out for Isaac. I haven't seen him yet today and I need him more than ever as my anchoring force. This feeling is surprising. It's crept up on me, but whenever I see Isaac, I feel an unexpected surge of protectiveness. It's because of him that I've asked for

the prosthesis in the first place. I don't begrudge him that. Better to have the draft excluder than scar the wee fella for life. But I have a feeling that if anyone can distract me from the mind gremlins, it's him.

As we start to trek across the field, I try to focus on the positives. It's not like I'm going to be exposing myself to lots of people. I've been promised a closed set: just the three of us, the camera operators, lighting crew, makeup, and the director for this shoot. I've already Googled him. His name is Daniel Minahan and he's got the US TV series *Six Feet Under*, *Deadwood*, and *True Blood* under his belt. I think I'll be in good hands.

I can see the light balloons swaying high in the air as we approach, but if this is what's called a closed set then I'm the pope. It's about as closed as one of my DJ sets. Swarming around the glade is a large semicircle of around two hundred people: a small army of runners, more crew, production staff, assistant directors, cameramen, lighting, sound, and scene dressers. Everyone is here. I gulp hard. *Don't make a fuss, Kristian*, I tell myself. *They've forgotten. It's okay. Be professional. This is a first-world problem. Just get over yourself.*

I barely notice an even more pressing problem. Rain. It's not torrential, just that relentless drizzle that we get in Ireland that slides from the fingers of branches and makes the landscape misty. Perfect for atmosphere but disastrous for my prosthesis, even if I'm only out in it for a short while.

"There's going be quite a bit of retouching today," Paul warns me.

Retouching? I don't want to be touched, let alone retouched! I think.

As we set up in our tent and prepare, I spot Natalia Tena, who plays Osha, walking towards me. I've bumped into Natalia around Winterfell, and we've shared a car from set together. I don't know her well and I'm not sure what to make of her. Natalia seems to take free-spiriting to a whole different level. On one of our car journeys, she was even telling the driver intimate details of her sex life! She's played the character Nymphadora Tonks in the *Harry Potter* films, and outside of acting she lives on a houseboat in London and tours the world with her band, Molotov Jukebox, a kind of tropical gypsy, funk, ska, dubstep ensemble, a genre they've named Gypstep. She is lead singer and plays accordion.

As Natalia gets closer, she is grinning wildly. I'm huddled in a small group with the makeup artists who are making last checks to my prosthesis.

"Phwoaaaaaaar!" Natalia says. Her eyes widen like comical saucers.

I titter nervously, but Natalia goes one step further. She bends down and yanks the prosthesis up and down.

"Phwoaaaaaaar! You're a big boy!" she repeats and collapses into laughter.

Out of the corner of my eye, I can see Helen and Isaac arrive on set. *Fuck. This is beyond horrendous.*

When we move to the edge of the glade to run through our positioning, the familiar sickly smell of "atmos" hits my nostrils. It's dank, but not dank enough and the machine is pumping out dry ice. While it does so, I'm hoping for a few words before filming starts. Maybe the director or another of the executives might take me aside. I know I'm not in the top tier of actors, but this is a terrifying scene for me. At the very least I'm hoping for a "We understand this could be a hard day, Kristian. We'll do our best to make it comfortable" reassurance. There's nothing.

Instead, the director launches straight in, we run through the scene, and then I move back and wait on the sidelines de-robed.

"Sound . . . picture . . . " he calls.

Now my heart is racing. I can hear Natalia and Isaac talking. Osha is telling Bran about the Old Gods of the Forest, the gods of nature people worshipped before the Seven Kingdoms of Westeros came into existence.

Yet all I can think of is the crew standing in a semicircle and the moment that I run in. *What if I'm distracted by them? What if someone laughs? What if I look in their direction and someone is grimacing?*

I hear my cue and the assistant director beside me silently signals.

When I run in from the bushes, I try to emphasize the lurch and shuffle of a baby. I stop. I gaze. I watch Natalia's face smiling up at me and her eyes staring at my dick before I hear her line: "He has giant's blood in him." I run back. I haven't heard any sniggers, but I can't be sure.

"And cut," the director shouts.

"Okay, good start but you haven't quite hit your mark, Kristian," he tells me. "Let's reset."

I'm not sure what he wants me to do differently, and he doesn't say either. Paul is waiting on the sidelines with his brush and powder puff. The set dressers are now on their hands and knees reapplying the fallen leaves on the ground in the place where I've scuffed them. If there's one thing I've noticed about *Game of Thrones*, it's this minute attention to detail. I find it staggering every time I'm on set.

While I'm being retouched, I make a mental note. I can barely look at Isaac—all I keep thinking about is me naked in front of a ten-year-old boy—but if I keep my eyes fixated on Natalia, then her expression will give me confidence.

"Sound . . . picture . . . " the director calls again.

When I lurch in this time, I try to accentuate it a little more. I roll my shoulder while my legs woodenly move from side to side. I have my baby-in-a-nappy in the front of my mind.

"And cut," the director shouts.

What now? I think. I'm staring at him, begging for guidance.

"Okay, Kristian, could you banana slightly when you emerge from the pools?" Banana. Yes. I do know this word. It makes me laugh every time. He means veer to the right slightly in a bow line.

How much banana does everyone need? I think. I'm still completely naked.

"Sure," I say through tight lips.

We redo the scene three more times. Each time my prosthesis needs to be retouched, and the rain is also getting heavier, which makes the ground muddier underfoot.

When I run in this time, I hear Daniel Minahan tut loudly.

"Cut . . . Okay, Kristian. Not quite hit your mark there. It's the expression. We need more expression."

What expression, I'm not sure, but I need a new strategy. Time to play the game of opposites. It's a technique I've learned as a drag queen. What's the opposite of how I'm feeling? Terrified? Insecure? Serious?

Okay . . . what would Hodor be feeling? Not weird—Hodor doesn't have the intelligence to feel weird. Happy. Definitely happy. He loves bathing and he wants to share what's in his heart with the world. But he's also shy. Vulnerable. Scared. *I've got this*, I think.

However, before take six can even happen there's another problem on set. The continuous background whir of the generator has stopped. Bang! The lights shut down and the camera operators groan as they get up from their perches and lift off their headphones. The rain halting filming was not in the script and I'm left hovering on the sidelines without my dressing gown.

No one knows how long it's going to take for the power to restart and I stand there naked not knowing what to do. After around five minutes, I feel Paul at my side.

"There's really no need for Kristian to be naked all this time. Can someone get this man his dressing gown?" he shouts.

Thank God. In a quiet, unassuming way Paul has become my protector-in-chief. There's another man in the costume department called Gwyne who's also been quietly fighting my cause and making sure that I'm not naked for too long in between takes.

And in the intervening twenty minutes it takes to get the generator working, I don't know if someone has had a word, but I notice that as soon as it's up and running the director and his assistants are now communicating through the makeup and costume department.

"Erm . . . is Kristian ready yet?"

I do not reply. The pressure feels too intense. Without thinking, I hand ownership of myself to Paul and the others.

"Not yet! He needs another retouch. We'll tell you when he is," I hear Paul shouting back indignantly.

"Leaving you naked is completely unacceptable. We'll deal with them," he says with a shrug that in the same breath means: "Welcome to the world of film."

"Thanks," I say.

We move on to take seven.

"Sound . . . picture . . . "

Swwwaaaaakkkkk. A noise pierces the air, followed by a low drumming sound and a rustling from the undergrowth on the far side of the glade.

"Jesus Christ, what the hell is that?" Daniel Minahan looks very pissed off now as one of the crew jogs over to see what the noise is.

I am left standing naked once again.

"It's pheasants!" we hear a voice shout over. "Erm . . . pheasants having sex!"

This seems to break the unease and there's a ripple of laughter that runs around the semicircle. I wonder if it isn't polite to wait until they are finished but everyone is keen to move on before the light fades.

"Can someone shoo off the fucking pheasants?" I hear. When they eventually emerge from the bushes, the male is staring us down and I can't help feeling some sympathy.

"Okay, let's reset! Is Kristian ready?"

We go again and again until the director calls it a day midafternoon.

"Time to move on," he shouts, and the crew start to disperse. There's no thank you. No niceties. But in my little circle, I feel there's an unspoken understanding that today has been sheer torture for me. I've gotten through it and I'm proud of that. In fact, I feel surprisingly empowered. However, I do want someone other than the makeup crew to tell me I've done a great job. That I'm on the right track with Hodor. Yet it doesn't come.

The path to acceptance never does run smoothly, I remind myself on the journey home.

CHAPTER 9

OUR RAINBOW COALITION

"DON'T YOU LOOK FAMILIAR? YOUR FACE. HAVEN'T WE MET before?"

A police officer is standing opposite me outside Parliament bar in Belfast. It's a Friday night in May 1997 and I am twenty-two years old.

"I don't think so," I reply, studying her eyes.

"Your face. It's so . . . familiar," she continues.

"Sorry, no."

"You look like . . . you look like . . . "

She's clicking her fingers now trying to locate whoever it is I remind her of. I can see the cogs in her brain working overtime.

"That's it!" she shouts like she's just hit the jackpot. "It's David Nairn!"

David Nairn? Fuck. My father. The man I've never met and who's never called me back since that Sunday I tried to see him ten years ago.

"I'm his son," I say. "Do you know him?"

"We've been friends for years," she smiles.

"I've never met him," I say with some venom.

Secretly in that moment I'd like word to get back to David Nairn that I'm here, that I clearly look like him, and that he's never bothered to see me. I want her to know that the man she thinks she knows has a son he's probably never mentioned. I wonder if he's told any of his friends about me. More than that, I want him to know that his son is gay and that she's standing with his gay son outside a gay bar in gay Belfast.

There's an awkward silence.

"Oh right," she says, frowning confusedly. "I'm sorry."

She moves rapidly back to the reason why we are here. Her question has thrown me, but in many ways it's just added to the surrealness of the evening. I have no idea what time it is now. Maybe 11 p.m., maybe later. I'm still running on adrenaline, trying to process what has just happened.

She clicks her ballpoint pen and carries on.

"So, you say you were in the corner?" she asks.

"That's right," I agree.

"And you came here at around 8 p.m.?"

"That's right."

"And your friends are . . . "

"David and Sean . . . " I reply.

She writes all of this down in her notebook. David and Sean are friends I've had in Belfast for a while now. They go to Queen's University Belfast and we met in Parliament. They are part of the lesbian, gay, and bisexual group at the university and, even though I've never been to university, they've welcomed me in. Sometimes I go to their group socials in the university's Students' Union bar, and on other occasions we meet in town. Tonight we met early for a few drinks.

"We were just talking and then it happened," I continue.

"Okay, let's rewind a bit," she corrects me. "You were talking and . . . what did you see then?"

"This guy, he just walked in," I say.

I go on to explain how we were sat in the bar downstairs when a guy came through the door. The bar wasn't as rammed as Parliament usually gets on a Friday night, so maybe that's why I noticed him. He also looked very shifty.

"Shifty in what way?" she asks.

"Like he was wearing some kind of disguise."

In fact, as soon as I'd seen him, I'd made a joke to the others: "Who does that guy think he is? George Michael?" When David and Sean turned around to look, they exploded into laughter. He did look just like George Michael—but a weird, painted-on version. It was as if he'd gotten a makeup sponge and dabbed brown hair dye all around his mouth and chin. He also had strange eye makeup on that I couldn't quite make out in the dim light. And his hair poking out around his ears didn't look real at all. It was thick and solid. I've seen some bizarre sights in gay bars in my time, but never that bizarre.

"And was he wearing anything distinctive?" she asks.

"Yes. A baseball cap," I reply.

He was also moving very quickly, I tell her. He darted in from the door to around the bar area. There was something about that guy that made me feel nervous, something dark and intense about him.

"And then what?" She keeps writing.

"Three shots," I say. "There were definitely three shots."

Those three shots were so clear they're still ringing around my head. *Bang. Bang. Bang.*

"That must have been shocking," she says.

"Yes," I agree, even though I don't really feel anything.

"And what did you see then?" she asks.

"I heard a thump and when I looked again a guy was laid out on the floor. Then there was a loud scream. The barmaid definitely screamed," I say.

And that's exactly what happened. I don't know the name of the guy at the bar, but I've seen him in Parliament many times before. He's a regular. A friendly guy, young with a shaved head who I always say hi to. He

was sitting and chatting with a friend in a lumberjack shirt before he was shot in the back three times—gunned down in cold blood.

"People started screaming, and running. There were people covered in blood and people crowding around the guy on the floor," I tell the officer.

"And the gunman?" she asks.

"He ran out as fast as he came in. I made eye contact with him. We all did," I say. "But it happened so fast."

I talk to the officer for another fifteen minutes or so before she moves on to others to get more eyewitness accounts. It's odd, but as I continue talking to my friends, I feel a sense of stillness. All of us do. In fact, we're so calm that instead of going home, we decide to carry on the evening at the Crow's Nest, a pub not far away. It's not a pub we ever go to, but it does have a gay clientele and Parliament is now shut for the evening. As we leave, the blue lights of the emergency service vehicles are still flashing, and police are guarding the club's front door. Officers in forensic suits are marching in and out of the building. Journalists and camera crews have also now arrived on the scene, which makes people nervous and is probably the reason why many people have left. If you're gay in Belfast, it's likely members of your own family don't even know, just like Granda doesn't know about me.

—▬

DAYS LATER, THE RUMOR GOING AROUND IS THAT THE DEAD man is an off-duty police officer called Darren Bradshaw. He was twenty-four years old and a Protestant, gay policeman. I wonder how many of his colleagues knew he was gay. The police, like the church in Northern Ireland, is not exactly known for its tolerance. As for the gunman, the Irish National Liberation Army, a Republican splinter group, say they carried out the killing, although no one knows why they targeted Darren.

And that's when it smacks me. The whiplash of delayed trauma lasts for days—nothing but calm and then waves of nausea flood my body, as if I'm only just getting feeling back into it. I think about what this means

for me as a gay man. An officer shot in Belfast's only gay bar is not just a tragedy for him and his family, it's shaken all of us in the gay community. Parliament is the one safe place that we go to and now that safety has been shattered.

It's not the first time the Troubles have affected me like this, but it is the most direct and the most horrifying. I've known Mum's mantra, "Belfast is dangerous," since I was a wee fella, and over the years I've gotten used to the armored vehicles and the army checkpoints. Growing up I've also endured the bag and body searches and the under-the-car-seat inspections in the city center whenever we go shopping. The soldiers stand at either end of the main street while others walk down the traffic jam snaking into the shopping center to pick at random who they want to search. We call it the ring of steel. But in Lisburn, the war has always seemed farther away.

Now I can count on one hand the times in the past when the Troubles got too close, even though I wasn't always old enough to understand it. The first time was when I was around eight years old and still at Hillhall Primary School. It's the only time I ever saw Mrs. Duffy's armor crumble. We were in class when a teacher interrupted the lesson.

"Excuse me. There's an urgent phone call for you," she said.

Mrs. Duffy stepped into the cupboard where she kept her canes, and where a phone sat on a desk. As we waited, a shriek pierced the silence like the cry of a maimed animal. Then there was sobbing, the kind that comes from the pit of someone's belly. And when Mrs. Duffy hurried back through the classroom, tears were rolling from her chin. I'd never seen an adult cry like that before, and never thought it possible of Mrs. Duffy—the Iron Lady.

"Mrs. Duffy has to leave," the teacher announced. As I remember, there was no sugarcoating of the news. "Her niece is a police officer and she's just been killed by a bomb in Newry," the teacher continued matter-of-factly.

Newry is on the border, an hour away. There were always bombs there. I'd seen it on the news, but it never seemed real. Besides, we were never

taught about the Troubles in school. The war between the Republicans and the Loyalists always remained on the periphery of my world.

Another time was several years ago, when I was around twelve. Then it got one step closer. Far too close, Mum and Nan said at the time. It was lunchtime and Nan and I were in the kitchen making cheese and onion sandwiches when we heard the screech of car brakes from the motorway. Two men jumped over the roadside barrier and were bolting straight towards us. Then we heard the *crump, crump* of gunfire in the distance and the men stumbled forward onto the grassy bank. Pursuing them were officers with rifles. When they reached them, the men were writhing around on the ground and kicking their legs out—more so when the police placed bags over their heads and dragged them back. Nan and I stood frozen, watching the drama unfold from the kitchen window.

Later, when an officer knocked at our door, he said if those men had made it as far as our house, they probably would have taken us hostage. *My wee Nan! Hostage?* I recall thinking. It didn't feel possible. *How can complete strangers take us hostage?* I thought. *They don't even know us!* And we never did find out which side those men were fighting for. All we knew was that they were paramilitaries—not the real army, Nan explained, the unofficial one.

"Did those men die?" I recall asking Nan later.

"No, Kristian, they were brought down with plastic bullets. They're not real," she reassured me. But by then I did know that people do die in Northern Ireland, even when the bullets are pretend.

And the Troubles did bleed into my daily existence for the year that I attended catering college in Belfast. The college is right next to the Europa Hotel, at the time the most bombed hotel in Europe. All the journalists covering the war stayed there and so the IRA knew they'd get maximum publicity if they launched an attack.

On the upper floor of the college, where the catering department is, it became so normal to feel the floor shake, for utensils to clatter off worktops, and to be knocked off your feet that the explosions became an inconvenience more than anything. Once I remember Madonna's *Erotica*

playing on my Walkman when one blast hit. I felt so pissed off at it interrupting the track that I rolled my eyes and rewound the chorus.

How dare the IRA come between me and Madonna's new album? I thought before eventually grabbing my jacket and heading outside to the familiar sight of glass shattered across the pavement. Gathered in the street were groups of bystanders who'd been evacuated from buildings. We got evacuated so many times that often I didn't even go back to class and caught the train home.

As for ever being lured into the Troubles, I knew that path was never for me. One boy I vaguely knew from Lisburn did join the Loyalist paramilitaries. I found that out at the only bonfire I ever went to when I was around fifteen. I went out of curiosity more than anything else, and because friends from home were going. July 11 is the day each year when Protestants celebrate the Battle of the Boyne when William of Orange defeated the Catholic King James II so many centuries before. They pile pyres with wooden pallets and burn flags and effigies and march through the streets with their drums and penny whistles and orange sashes draped across their shoulders.

We were standing on the sidelines when a friend nudged me.

"He's just killed someone," he said, pointing discreetly at the boy we knew.

"Are you sure?"

"One hundred percent," he nodded.

As I stood there, I tried to imagine that boy killing someone. Someone of my age with his face covered in a balaclava and dressed in military fatigues with a gun in his hand. Then I tried to imagine him actually pulling the trigger. I knew it was probably true, but I just couldn't picture it.

All I remember feeling in that moment was like a fish out of water. *This is not for me*, I thought. *I have enough battles of my own to fight without becoming embroiled in a war that people seem hell-bent on, even though I think some of them don't know what it is they are fighting for.* Maybe that boy had a clear vision of the man he wanted to become. I still have no

perfect vision for myself, but there is one thing I do know. And I knew it back then, too: I do not want to be that. I do not want to fight somebody else's war, or be part of any mob bewitched by bloodlust on either side of the divide.

More than that, I truly don't understand how, one day, someone can buy a loaf of bread from a shop assistant and talk about how lovely the weather is, then hate them the next day because they found out they practiced a different religion. It happens here all the time. Friends, acquaintances, and families become sworn enemies overnight. The Troubles have made both sides numb to brutality. But Mum has taught me to respect everyone. And she's drummed into me that the dead are always somebody's husband or wife, mother or father, son or daughter, niece or nephew, or even just a neighbor. She's also taught me never to take sides, only to see the human collateral, so I'd rather navigate my own path and find some kind of lasting happiness.

And until now, I don't recall the Troubles ever preventing me from doing anything, from going anywhere, or ever thinking that I couldn't. When war is woven into the fabric of everyday life, there's no such thing as "rained off." And I think that's why what's happened in Parliament has hit me so hard. There, every night it felt as though we were forging a new way. People I know who turn up are sworn Catholics and sworn Protestants, but in Parliament they put their differences aside on the dance floor. Nobody cares. There's no Union Jacks or Irish tricolors. The only flag flying is that of our rainbow coalition. We're united by music and dancing and the promise of a new beginning—a feeling that has been growing in this city.

For three years now there's been an official cease-fire even though there are still sporadic attacks. And two years ago Bill and Hillary Clinton stayed at the Europa Hotel to show the world how Belfast and Northern Ireland are changing. To see that presidential cavalcade wind its way to the Europa was a big, big deal for this city. In his speech, Bill Clinton called the terrorists "yesterday's men." And there's talk of bringing the violence to an end for good. Real negotiations, not just

endless hot air. Martin McGuiness of the IRA and Gerry Adams of its political wing Sinn Fein say they've committed to a political solution, and in the UK there's a new government that's been elected, headed by Tony Blair, who says that, more than anything, he wants an end to the Troubles. But at the nightclub Parliament we were already doing it—we had an unspoken truce. Now it feels as though the hatred of the past has blown that apart.

And now because of the shooting of Darren Bradshaw, a new front line has opened up in the war, this time at home. Apparently Granda got talking to someone on his weekly outing to the pub. I'm not sure how, but he knows I witnessed the shooting at Parliament. Maybe one of the TV cameras picked me up standing outside, or Mum or Nan told him.

Whichever way, Granda is furious.

"Kristian was at that shooting," he'd told his drinking pal.

"Alfie, are you sure? That officer was shot in a gay bar."

"What?"

"It's a gay bar, Alfie."

"Kristian . . . at a gay bar?"

From this information, Granda has put two and two together. Unbelievable that it's such a shock to him. After all, I've been parading up and down the living room in full makeup in front of him for two years. It's made me wonder more than ever what goes on in that man's mind.

Mum says he came home like a thunderhead, storm clouds trailing him. Thank God I wasn't there, but she's told me how he was ranting about how much I've embarrassed him. How he's been shamed in front of all of his farmer friends. How I've been under his roof for all these years but that I'm gay, and now that he knows that I'm gay he doesn't want to speak to me ever again. *But I'm still the same person*, I think. Because of that, Mum's warned me it's better if I stay away for a while, so I've come to Belfast and I'm sleeping on my friend David's sofa.

We've talked endlessly. We've replayed the events of that night in Parliament over and over. We've talked about how Parliament brought everyone together and how we can't let what's happened knock our community

off course. It's not that long ago that the city staged its first ever Pride march. Years ago, that would have been unthinkable. We've traveled too far in a hostile world to ever turn back.

I talk to Mum on the phone every day. Granda is softening, she says. Besides, she's threatened to kill him if he doesn't let me come home soon. I want to go back, too. I miss Mum and Nan and all the things that make me safe, and I hope that Granda can find his way to understanding that there is a better way, and that peace between us can thrive.

JEDI JOHN

As MY FIRST SEASON ON *GAME OF THRONES* DRAWS TO A close, I am beginning to understand more about how magical the characters Bran and Hodor are. It makes me think Mum's notion that Hodor is special could be right. As I see it, Bran and I are navigating our own unique path through a war-torn kingdom.

Until now I've not thought about the parallels with my own country: how people can turn in on themselves and tear apart a tiny island. But so far, I've not felt so connected to the conflict or brutality in *Game of Thrones*. I do know, however, that the story is loosely based on the Wars of the Roses—a series of bloody civil wars that raged in England for the most part of the fifteenth century. It's made me consider that history rarely changes and that generations make the same mistakes over and over.

Partly I haven't felt too connected because in our Raven unit we are our own splinter group. Isaac and I have been based in and around Winterfell

for months now, where the threat of war is ever present but the onslaught of battle has not yet arrived. I hear of other cast members, like Lena Headey and Peter Dinklage, flying off to Croatia to film scenes, but we've remained in Ireland, either on location or at the Paint Hall. Maybe our story feels different because we're not at the heart of the overwhelming machinery of Dragon and Wolf units.

Even though I've gotten more used to the daily rhythm of a production set, I still don't feel I own Hodor. I'm getting to know Isaac better every day. Now that Osha has joined us, I'm also getting to know Natalia and the lovely whirlwind of chaos that surrounds her. But as far as my acting ability goes, I've found the last six months nerve-wracking, fun at times, but frustrating. With less direction from the executives than I had hoped for, I don't feel confident that I understand Hodor in the way that I should. He doesn't yet feel mine.

When filming finishes for the season in mid-December I book a flight to Santa Monica near Los Angeles. I've heard about the Ruskin School of Acting through an agent in the States and I've enrolled in a series of workshops the following year. An American friend, Jake, who I know through playing *World of Warcraft* online, also wants to join me. He's based in Utah and is also an aspiring actor, so we combine a holiday with attending classes.

When I reach Los Angeles International Airport, it's the first time I've visited America's West Coast. Immediately, I love it. It's around the end of February 2011 when I land. Back home it's cold and blustery, but here it feels like summer all year round. Everything appears light and breezy.

The drive to Burbank, where Jake and I are staying, takes around two hours. That blows my mind. Whenever we turn a corner in this sedate and residential neighborhood there's a new landmark. The MGM studios loom into view. On another road there's the Paramount studios. I get the same buzz I had when I first visited New York—I know these places intimately but only as part of a celluloid skyline. I've never actually been to them and now they're within reach. When we take a drive through

Beverly Hills, I wonder whose house is whose. *Holy shit, this is where it all happens*, I think.

So far in Belfast there's still been surprisingly little hype around *Game of Thrones*: maybe a couple of billboards advertising the show, which is due to air on Sky Atlantic from April. But here, it's everywhere. You can't turn a corner without seeing Sean Bean on the Iron Throne. And when we turn up at the Ruskin School for our first evening workshop, its founder, John Ruskin, knows all about me and my role.

"I've known George for years," he tells me, plus he's read the *A Song of Ice and Fire* books, which again I'm ashamed to admit I haven't. John also knows most of the directors on the show. It dawns on me that Hollywood is just as incestuous as Ireland is.

The Ruskin School is in Santa Monica Airport, housed within an air hangar that has been converted into a theater. When John greets us in the waiting room, we are sat with around twenty others.

"Pleased to meet everyone," he says and his eyes sparkle.

Surprisingly, John looks like an accountant—balding head, white shirt, cardigan, corduroy trousers—but he also exudes a hippie calm. I can see and smell Birkenstock sandals, and the beads around his neck make me think he's far more than just a bean counter.

When he eventually leads us through to the studio theater, I have to do a double take. *Jesus fucking Christ.* Casually sitting in the small auditorium is the unmistakable figure of Sir Anthony Hopkins. I've heard that John does know everyone who's everyone in the acting world, but this feels surreal. I didn't expect them to be turning up on our first day. Or ever.

The first fifteen minutes feels like an endless icebreaker. John wants us to introduce ourselves and talk a little about our lives.

"Hi, I'm Monica. I'm from LA and my favorite food is cheese sandwiches," one girl says in a rather self-satisfied voice.

Normally in these situations I have an uncontrollable urge to let my inner drag queen rip—my defense against opening up to any stranger.

Well, I'm Kristian. I'm from Northern Ireland and every morning I like to chow down on a chihuahua on toast.

When another guy tells the group he's starred as an extra in some high-profile show and he's happily married, I want to counter with: "Well, I'm Kristian. I've been a drag queen and I take it up the arse." I don't know why I have to fire with both barrels. Maybe it's nerves: here's my brain-dump, deal with it. But, I like to think I'm just generous with my humor.

Thankfully, the presence of Sir Anthony Hopkins acts as a necessary restraint. When it comes to my turn, I feel an overwhelming urge to say my name, shake Anthony's hand, and squeak out: "I bloody adored you in *Silence of the Lambs*."

Instead, I clear my throat.

"Hi, I'm Kristian. I'm from Northern Ireland and I play Hodor on *Game of Thrones*. I like strong coffee and very loud music," I grin politely.

In the first part of the session, Anthony sits on the sidelines as we run through some breathing exercises. Then, some loosening-up techniques.

"Okay, I want you all to make a noise like a monkey," John instructs us.

A monkey? Momentarily I'm transported back to school drama lessons, about to piss myself at the thought of standing like a tree.

You've chosen to be here, Kristian, I remind myself before I contort my face into the shape of a baboon. "Whoo, whoo, whoo," I breathe in and out rapidly, followed by a few grunts for good measure. I feel ridiculous.

"In these sessions, we're really going to be learning how to let go," John continues. *Speak for yourself,* I think. *I'll not be letting go of anything.* In truth, what I've come for is a pat on the back. Someone to tell me I'm doing a good job, maybe learn a bit more technique that I can apply to Hodor. The online blurb didn't mention anything about morphing into a primate.

However, as we continue, I begin to think that John may be a Jedi disguised as an accountant. In his presence, I feel unnaturally calm. Effortlessly, he seems to take on the mantle of father figure to the whole group, yet there's nothing overbearing about him. John is curious, listening to

every word I say. In his company I feel heard. And the weird thing is, whenever I look at him it's as if he can see right through me, the way Mum can see through me. It's disarming and threatening in equal measure. Does he know how insecure I am? I'm terrified, yet at the same time I don't feel scared.

In this first workshop, Jake and I haven't come with anything prepared. Others who have been to the class before have brought scripts or have memorized monologues, and that's where Anthony Hopkins steps in. He sits quietly resting his hands on his paunch while they perform. Then, he offers his critique. I'm surprised by how harsh he is, albeit delivered with wit and kindness. He says things like: "Okay, good, but I was starting to think that character was missing a pulse."

Other times, he gets the students to think around the character. "Wouldn't it be better to approach her this way?" he suggests. Or: "In that moment do you *really* think that character would have pulled that face?"

As I listen to him, it strikes me that there is no right or wrong way to play a character. It's all a matter of doing it until it's natural, until you feel immersed, until it feels authentic. This is definitely not the answer I've been searching for, but as the session ticks on I become more intrigued by this. For the first time, I realize it's me in the driving seat.

One of the last exercises of the day is also one Jake and I sit out. Some students have come with a prewritten letter to themselves which they read aloud. One guy's letter is heart-wrenching, and as he reads it, I can feel the emotion rising in my chest. He talks about how he was beaten as a child, how his life has been shaped by fear. When I look around the room, members of the group have tears streaming down their cheeks. So does he. He gulps, barely able to speak. *How can this guy be so open with strangers?* I think. Every line brings a more horrifying revelation.

Then, an unnerving thing happens. The second he draws his monologue to a close, he sits back and snaps out of it in a heartbeat. He bursts out laughing and takes a mock bow.

"Thanks, that was a really great performance to end the day on," John says. We give a shaky round of applause. We are all utterly broken.

"I thought that letter *was* that guy's life," I say to Jake on the way home. Inside I feel a mixture of jealousy and admiration—*could I ever be that good? Could I ever inhabit a character that convincingly?* I ask myself.

When Jake and I attend the next evening, I feel myself opening up despite my initial resistance. In particular, the school is renowned for an approach called the Meisner Technique. To introduce it, John talks about how he trained with its original practitioner, Sanford Meisner. His stories are mesmeric: how Meisner spent forty years developing this method of improvisation, and how he passed it on to John.

"It changed me profoundly," John says before we set to work.

The technique doesn't focus on the actor. Instead it's reactive, where actors respond to what's going on around them or what's being said. It's about developing a character's deep emotional life so that when the action happens in the moment, the response comes from a place of empathy. It's a way to build authenticity, John explains.

As Hodor has no words to play with and little backstory to draw on, I think that the practice may help me more than anything. Hodor is only ever reactive, and if I am to get to the heart of him, then I need to understand that.

As part of the practice, we are assigned a partner to work with. I have Chun, a young Asian American girl, an aspiring actor rather than someone who's landed any roles yet.

"Hi," she introduces herself before we small-talk a little.

"Why did you choose this course?" I'm interested to know.

"I've heard it's the best and I really want it to launch my career," she tells me.

"Have you had many auditions?"

"A few, but lots of rejections," she admits, pulling a sad face.

Suddenly, I feel an overwhelming pang of guilt. I'm here as a jobbing actor, about to debut on a prime-time TV series. Yet less than a year ago I could barely be arsed to turn up to audition for the part. Lunch with Jim and my growling stomach seemed far more important than hauling myself to South Belfast. So much has changed since then that I feel

ashamed by my past indifference. And when Chun speaks, it reminds me that people would give their right leg to be in my position. For that reason, I want to give it my all in the exercise so that I can give her some confidence to do what I've done, however false my confidence truly is.

As the exercise starts, we sit facing one another. It's based around a series of repetitive tasks where words and feelings are reflected by each actor in a call-and-response format.

"You're looking at me," she says.

"You're looking at me," I reply.

"Your T-shirt is black," she says.

"Your T-shirt is black," I reply.

We each bat back and forth until John wants us to step up the exercise to become more complex. This time, we put ourselves in the frame.

"I'm bored," I say.

"You're bored," she says.

"I'm happy," I say.

"You're happy," she replies.

As we continue, I start to notice more the expression in her eyes, the tone of her voice. Sometimes she sounds happy, other times irritated. We're getting faster now, batting to and fro more quickly, and I feel my own moods and expressions shape-shifting, too.

"You're incredulous," I say.

"I'm incredulous," she fires back, laughing.

"You're cheeky!" I say with an affectionate twinkle.

At that moment the smile drops off Chun's face. I don't know what to do. It's like I've just announced that I've strangled her pet poodle. Then her eyebrows buckle in an expression that looks like anger. I'm trying to read her, but I'm confused. *What have I done?* I step in before she can respond.

"You're . . . annoyed with me?" I say hesitantly.

"I'm . . . " she says, but she can't get the words out.

At that moment, there's a shout from John, who's been wandering around each pair, listening in and offering some pointers.

"Okay, well done everyone. If we can wrap up for this session," he says.

Thank God for that, I think. Chun doesn't say thanks. She spins out of her seat and yanks it back to the edge of the room, almost slamming it down.

Jake has been next to me with his partner, and I give an embarrassed shrug.

"What was her problem?" I mouth to him.

"What did you say?" he frowns.

"All I said was that she was cheeky!"

Jake's mouth drops open.

What the hell is wrong with cheeky? I think.

"We don't say that here, Kristian . . . " he says, looking red-faced on my behalf.

"Say what? Cheeky?" I repeat, at which Jake flinches.

"Keep your voice down, Kristian. We don't call Asian people Chinky here. It's racist."

Jesus fucking Christ. I am mortified. Chun has clearly misheard the word over my thick Belfast accent. I feel more insignificant than an amoeba.

"Cheeky!" I say defensively. "As in irreverent! How long have you known me, Jake? I am not a racist!"

Now I am scouring the room looking for Chun so I can apologize, but she's already picked up her jacket and left. I can't imagine what she's thinking: Hodor's a repulsive bigot! I'm still squirming when I get home to Burbank that evening.

—

JAKE AND I ATTEND THREE MORE TWO-HOUR WORKSHOPS AT the Ruskin School of Acting. Sadly, I don't see Chun again. It takes me a few days but my intense embarrassment fades. Every lesson keeps getting better.

During one, John picks out a scene for me to read. It's from the film *American Beauty*.

"I thought this would be perfect for you, Kristian," he tells me, handing me a script. I wonder how he could ever know how much I love this film.

"Can you read it out loud?" he asks softly.

The passage is one where Ricky, the school outcast, shows one of his films to Jane, the object of his desires. He loves to film simple things around him that he finds beautiful, like dead birds and plastic bags floating in the wind.

I take a deep breath and begin to read:

You want to see the most beautiful thing I've ever filmed? It was one of those days when it's a minute away from snowing. And there's this electricity in the air. You can almost hear it . . . right? And this bag was just . . . dancing with me. Like a little kid begging me to play with it. For fifteen minutes. That's the day I realized that there was this entire life behind things, and this incredibly benevolent force that wanted me to know that there was no reason to be afraid. Ever . . .

As I continue reading, I can feel the separation between me and the words narrowing. I'm not reading from the page, I'm in the page, feeling the words rather than repeating them, feeling the meaning of it and the beauty of the passage. By the end of it, I'm almost choking with emotion. *This is me. This passage is me*, I think, and I wonder why I've never had that conscious thought before.

"Wonderful, Kristian. Thank you," John says before there is a round of applause from the group.

That day John takes me aside to talk to me about how I can improve. In every conversation I've had with him, I feel like the wayward Will Hunting, gently being guided by the therapist Dr. Sean Maguire in the film *Good Will Hunting*.

"You have everything that you need inside you, Kristian," he tells me. "What you think you've come here for is detrimental to the development of your part. The secret is not to overthink your character. If you keep trying to deconstruct Hodor, you'll destroy him," he adds.

Instead, John convinces me that the strategy I started out with was right, and I am still on the right course. I just need to keep practicing what I am doing. He says I just have to keep going, and that what I'm going through, all the doubt and the insecurity, is what all actors go through.

"All your creativity is there," he says. "You just need to commit to whoever Hodor is and believe in him. The more you commit to one path, the more you'll truly feel it."

When Mum asks about John when I get home, I'm struggling to find one adequate word to describe him. "Being with him is joyful," I say. "Joyful" is the best word that I can find; John is such a joyful man.

FREAK MAGNET

I AM STANDING IN FRONT OF THE BATHROOM MIRROR AT home in Lisburn. So far, the only makeup techniques I know are the ones taught to me by Leigh. When she's not here it takes me far longer, but I've been practicing on my own and I want to get it perfect.

First, I shave my face satin smooth. Then I apply scar wax and spirit gum to accentuate my eyebrows. This gives them more lift: a more feminine arc than a man's naturally heavy brow. Next I smear on the foundation so thick it feels like a mask eating at my skin, but I don't care. It's all part of becoming who I want to be. On top I brush over a thick matte powder before I move on to my eyebrows and eyes, which are my favorite feature to paint. I always shape my eyebrows thick at the bottom and tapering to become elvishly thin—goth-style like Patricia Morrison from Sisters of Mercy. Towards the bridge of my nose, I brush in bold colors, as if to give myself a false eye socket. I use ABBA blue or Ziggy Stardust red. On my cheeks I rub in a pinky-orange blusher before I finish

with my lips. These are ridiculous and overexaggerated. I use lip pencil to extend my Cupid's bow into a heart shape and fill in the color with a deep ruby red.

I've called myself Revvlon Miguel, a decadent combination of lipstick and lager. The name popped into my head one day and it's stuck, and I've spelled Revvlon with two *V*s so that nobody can accuse me of copying the makeup brand, though I doubt that would ever stand up in a court of law. I have a lot to thank Leigh for because she's been instrumental in Revvlon's genesis. Every time she's here she gives me the confidence to carry on.

This is especially so since the shooting of Darren Bradshaw at Parliament—a setback for all of us in Belfast's gay community. Contrary to my fears, though, it's made me more determined to be seen as a gay man, not to hide myself away. At home, it's different. Granda allowed me back, but me being gay or me being at Parliament bar that night has never been mentioned. Not once. I've come to the conclusion that the only way he can deal with me is to pretend that part of me doesn't exist. But I do exist, even if I don't have the balls to exist in his house as Revvlon Miguel. A few months after the shooting, I moved out and into my own flat, but I go back home often.

Revvlon has had a few public outings, but not in Belfast. Instead, I've taken an early version of her to London. I hoped that no one would recognize me, but it turns out that London is a gay refuge for everyone who can't express themselves at home. To date, there's no permanent venue for drag here, and in London I saw a few faces I knew. Some were performing, but I don't feel ready to. My only performance still happens within the four walls of my bedroom, belting out songs from *Priscilla*.

In London, Revvlon Miguel works as a door whore at the gay superclub Heaven: handing out leaflets, welcoming people in and directing them to whichever floor they want to go. At Heaven there are two, and a labyrinth of different bars and rooms playing anything from electronic hardbag to garage and acid house. Compared to others, Revvlon's not a stereotypical London drag queen. Some of their outfits are magnificent. One guy I know walks up the main shopping area, Oxford Street, half-naked and

with a crown of thorns. No one bothers him. *He must have balls of steel*, I think, which I definitely don't. I try to blend in more—as much as a man as big as me can blend in. Besides, I don't have a lot of money to spend on an outfit. Off-the-peg boob tubes or miniskirts are never going to work for me. For any women's clothing to fit, I'd have to have it custom made. And custom-made is way out of my budget.

Instead, I've patched together an outfit that is far more do-it-yourself. Tank Girl has been my influence. Leigh and I love her, and I use her cartoon persona as my shield. She's a brazen postapocalyptic warrior far more in-your-face than my childhood Wonder Woman. Tank Girl drinks and farts and fucks and is so edgy she falls off the clifftop of decency. She also ticks a lot of practical boxes. Wigs made of real hair are too expensive, so I have a thick blond synthetic hairpiece. The only way I can keep it on Revvlon's head for the whole night is by securing it with Tank Girl–inspired aviator goggles—only Revvlon's are ski goggles sourced from a sports shop.

From the outset, though, I chose to make Revvlon Miguel appear bigger. However I hunch my shoulders or push down my spine, the reality is that I cannot alter my size. Revvlon gives me permission to amplify everything about myself. She demands that I stand up straight. She doesn't have heels yet, but she does have clothes that are never nipped or tucked at the waist to give the illusion of small. She wears black capes, feather shawls, and bright orange smocks. Anything I can find that will fit me. Revvlon fills a person's whole frame of vision. *I* fill a person's whole frame of vision: a complex paradox of wanting to be seen but at the same time not wanting to be seen. Each step on this journey is incremental and slow.

—

IN BELFAST, I'M TWENTY-THREE YEARS OLD WHEN THERE IS A rumor of a new club opening, which it does in 1999. It's called Kremlin. Unlike Parliament, which is a gay club run by straight management, Kremlin is the city's first club managed by gay owners. It's an

underground bunker of cool: tsarist opulence combined with Cold War brutalism—there's a long bar and an area called Red Square where DJs play and there are live performances. It's out of this world, like stepping through the wardrobe to find yourself in Narnia. And we joke that whatever happens in Kremlin, stays in Kremlin.

Even though the barriers are coming down and there's a spirit of glasnost in the air, Kremlin's new rule has not been welcomed by everyone. On its opening night, I am on the dance floor with hundreds of others when the music stops abruptly and the lights smack on.

"Can everyone please make their way to the exit," a voice booms out over the sound system. Reluctantly, everyone files out onto the pavement. But once you let the genie out of the bottle, it's impossible to put it back. The party spills out across Donegall Street and we carry on dancing to the background wail of police sirens and the engine roar of armored Saracen vehicles, making their way down the street like rhinos ready to lock horns. When I look again, one drag queen, Titti von Tramp, is spread-eagled over the bonnet of one Saracen dressed in nothing but a buckled black leather corset, a leather bra, and six-inch heels. She looks amazing, like a twisted Cinderella. The Royal Ulster Constabulary are trying to pretend it isn't happening. Later we hear there's been a bomb scare at the club.

"Fuck them," we say to each other. "No one's going to stop the party."

Around three weeks into the club opening, Aaron, the club's entertainment manager, approaches me.

"I hear you do drag," he says.

I'm taken aback at this. I've never performed here so I don't know how Aaron knows.

"I do dress up in drag, but I don't do it in Belfast," I reply defensively. It feels intrusive, like he's found out something about me and he may take aim.

"How do you know?" I ask.

"People have seen you in Heaven," he tells me.

Aaron says he wants me to perform drag in Kremlin, but initially I'm not keen. In London I'm less inhibited, able to test out Revvlon Miguel in all of her guises. If ever I do perform drag, I know I want it to be with heart, I'm just not sure what form that takes yet. Revvlon doesn't feel authentically mine.

I'm also not sure that Aaron is serious. No one's asked me to do anything like this before. *What the hell does he see in me?*

"We're looking for something different at Kremlin," he continues. "Something a bit more avant-garde. I think you'd be perfect."

Now I'm interested. Avant-garde has my name written all over it. I can definitely pull off "different." After all, I'm the guy who stood in Parliament like a glam metal reject while everyone loitered in Nirvana grunge, but it still feels like a monumental step.

"I don't know," I hesitate.

If Leigh were here, she'd be poking me and pulling a thumbs-up face, but she isn't.

"We've got a drag ball coming up. Maybe you could introduce yourself there?" Aaron tries to convince me.

"I'll let you know," I say.

I think about the offer. I do want this, but I'm scared. I also still have a job at BT even though, technically, I've been off sick for weeks. Staring at a telesales screen gave me cluster headaches for which I've been mainlining codeine painkillers. Coincidentally, the headaches struck just at the moment my line manager said the gods at BT Tower were about to bestow on me a permanent contract so I, too, could become a shining knight of telecommunications. The regular salary was tempting, but it filled me with horror. Since then, I've moved to being the voice of directory inquiries.

"Hi, who would you like to be connected to?" I say. And I've moved offices, to a building so uninspiring it's nicknamed Castle Grayskull. But I'm no Master of the Universe. I hate my job, and my headaches have only intensified, meaning more time off sick. Even so . . . customer service

agent turns local drag queen. It feels like there's a lot at stake if people find out who I really am.

Adverts have started appearing in the *Belfast Telegraph* for more jobs at Kremlin—gay DJs and drag queens wanted. This is also a first for the city. No business has been this brazen before. *People do drag as a full-time job*, I think. It's probably not a respectable job, not a job they can tell their grandparents about, but it's a job nonetheless. Seeing those adverts jolts me into a different mindset. *What if Aaron offers that drag spot to someone else? What if I don't take this chance? Does my opportunity disappear? Can I contemplate gasping my last breath at BT?*

Then I do the stupidest, craziest thing I've probably ever done. The next day, I wake up knowing that I must *never* go back to the day job. I decide that when my sick leave ends, I won't set foot in Castle Grayskull ever again. Instead, that day I head to the Ulster Bank and sit in the queue for an appointment to secure a £2,000 loan. I tell the bank manager I'm an up-and-coming artist and the money is for music equipment. Not one molecule in my brain considers how I'm ever going to pay it back.

Then, I head home to my flat. As well as Leigh, who's been with me on this journey, I have another friend called Nadine who I know through some goth metal friends. She lives with her boyfriend five doors down. They're arty types and I reckon that if anyone can help me put an outfit together it's her.

"Sure, I'll help you," she agrees when I call her. "I could go with you to B&Q tomorrow."

"B&Q?" I ask, puzzled. It's a chain of DIY and hardware shops.

"Yeah, I can do you some tiling shoes," she says casually.

I have no idea what Nadine has in mind, but I've seen other creations of hers. She's into what I'd call homemade cyberpunk style, which I love. Edgy, futuristic goth clothes. I've seen similar at Heaven in London, although I don't have the same money to spend on the real cyberpunk outfits on display there, which are as fantastical as something out of *Blade Runner*.

What I do want is an outfit that's going to make me stand out. The opening ball has a competition element to it which I've decided I'm going all out to win. Already I've started obsessing over the details. It's the same perfectionism I have whenever I play music, but this feels overblown, like the event has mushroomed in my mind. Only in my course at Stoke-on-Trent did I ever dabble in "performance." This feels like a different ball game.

At B&Q Nadine and I wheel around a large trolley. We fill it with sheets of cork floor tiling, spray paint, and industrial-strength rubber band. Back at her flat I watch her as she glues layer upon layer of cork tiles together. Then, when these are dry, she takes out what looks like an electric turkey carver.

Drr. The sound is industrial, and Nadine precision-slices through the tiles and sculpts an outline of my foot that she's marked in black pen. A few more floor tiles are attached on top to secure the rubber band, which acts as a strap.

"Ta-da," she says when she's finally finished spray-painting the pair black.

I don't know what to say. Part of me is ecstatic: my very own size 16 women's wedge heels. I never thought I'd see the day. But when I force my feet into them, the elastic strap cuts into my skin and I wobble unsteadily. A night in these and I'm going to need crutches.

"Thanks!" I say enthusiastically.

Days after she's taken my measurements, Nadine appears at my flat with a handmade two-piece ensemble. It's jaw-dropping: a black stretch miniskirt covered in lines of latex spike nipples. The top is black velour with matching spikes running from each shoulder to the sleeve collar. And the best part about it is that it fits! To set it off I already have a huge black fake-fur coat that belonged to a friend's mother, recently deceased. Revvlon can wear it to make her entrance.

Before the big night, I turn my attention elsewhere. I've never self-tanned my legs, so I spend ages reading the instructions. In the bathroom, I'm careful to apply the lotion evenly to my freshly shaved legs.

At first it looks fantastic, but by day two it's faded and uneven, like a sun-parched grass lawn. Stubble is starting to poke through, and the orange color is blotchy. It's too late to redo it. *The only way to salvage anything is for my makeup to be knockout*, I think. As I've lost faith in myself, I ask my friends Colin and Shane, who I know from Kremlin, if they'll apply it that evening, which they do in their apartment so nothing gets ruined.

And for my performance I've gone high-octane avant-garde. Others will be twirling around to anthems like Gloria Gaynor's "I Will Survive" or the Village People's "Y.M.C.A." Not me. I've moved left of left field. *Give the crowd precisely what they won't expect*, I think. I've mixed "Calling Occupants of Interplanetary Craft" by the Carpenters with "Freak Magnet" by L7: Sunset Strip sweetness meets kick-ass girl punk. Somehow, positioned back-to-back, they encapsulate both my need to connect with people and my inner loathing of anyone who violates me or my personal space—the same push-and-pull that consumes me most of the time.

I've also dropped the surname Miguel. It doesn't feel iconic enough. *Madonna and Cher don't need a surname, so why do I?* I figure. From now on I simply want to be known as Revvlon.

On the night, as my slot rolls around, the experience becomes overwhelming. I've practiced my routine over and over, but the noise of the crowd—probably a couple hundred people packed onto the Kremlin's dance floor—sends me into a spin. I'm obsessing about my stubbly legs, my hair, my makeup, myself.

"You're up next." Aaron pokes his head around the backstage door to give me my cue. He winks in a "you'll be fine" kind of way.

"Thanks," I smile weakly. My nerves are rattling. Belfast crowds are not known for their politeness—in fact, they're uncompromising.

What if people despise me? I think. *What if they're not ready for my "act"? Maybe they want crowd-pleasers? Maybe they don't want some in-your-face lip-syncing ladyboy pushing their buttons.* Then, I try to gee myself up: *Revvlon's a part of you that needs to come out*, I think. *Come on, Kristian: commit to her. Commit. Commit. Commit.*

As I walk out onto the stage, a feeling possesses me. What I do next has not been in my master plan. It's nothing that I've rehearsed. At the sight of the sea of faces staring up at me, I snarl my lip like curled leather. My chest is thumping, and the longer I'm here, the more my lip curls. I place my hand on my hip, thrust my chest forward: "Come on, have a go," I'm saying. Then, a surprising thing happens. Applause starts. Applause ricochets around the room. *Surprise them, Kristian*, I think. *Make friends with the audience.* So I give the crowd a tongue-in-cheek smile. I haven't the faintest clue what I'm doing. I'm making it up as I go along, but the crowd is loving it. They are whooping and cheering. I'm loving it. We're bouncing off one another, connecting, and I feel myself standing tall.

"We are observing your earth . . . " the alien intro to the Carpenters' song lights up before its schmaltzy keyboard and string section twinkles over the dance floor. Everyone is smiling and swaying. They have no idea yet how I'm going to disarm them with L7's epic guitar-riff intro, but when that kicks in, the audience magically come with me on that journey, too. It's the most empowering thing I have ever done. In that moment, I feel in control. I feel in control of myself and in control of the audience. And that night I win. I win the competition. I win a shitty Amstrad stereo, but I don't care. I win a whole lot more. I commit to Revvlon and I don't want it to end.

HODOR, YOUR POUCH IS RINGING . . .

"KRISTIAN! KRISTIAN!" ISAAC IS HURTLING TOWARDS ME AT the Paint Hall in Belfast. He launches himself at my chest like I'm a bouncy castle. Ba-doof!

"Hi, Kristian," Helen smiles.

"Great to see you," I say. Helen and I have been in regular touch during the break, and I have managed to catch up with her and Isaac a couple of times. When Isaac has been in Belfast on the odd publicity trip, we've met at Deanes—a restaurant in the city center. But I've missed him and it's great to give him a big hug and feel his energy back on set.

Before filming starts, however, we have to digest some bad news. Margaret John, who plays the part of Old Nan, has passed away in the

intervening months. When I hear this, I feel rather broken. In my first ever scenes in *Game of Thrones* Margaret helped me so much—a wonderfully warm and funny woman and a person I looked forward to working with again. As a mark of respect, it's been decided that no one will replace her and instead her part will be written out completely.

"Do you feel sad?" I ask Isaac, mindful that he and Margaret starred in many scenes together. Margaret often sat by Bran's bedside and told him stories.

"Yeah, I'm sad," he says, but Isaac also has that childlike ability not to dwell on sadness. In those first few days, he snaps me out my mournful gloom.

As well as my trip to Santa Monica, I've continued DJing at Kremlin. I did so throughout the first season, as well as in between filming. This season I plan to carry on. As we tend to work in blocks with days or weeks of filming before time off, it suits the schedule. Plus, my regular slot not only provides me with supplementary income, it's also my insurance policy. During season 1 no one knew whether a second season would be commissioned, plus when I first read to the end of the script and the shocking realization that a central character, Sean Bean aka Lord Eddard Stark, was to be executed, I knew that no one was safe. All the actors know it—no one is sentimentally spared in *Game of Thrones*.

"Did you get 'the Call' this season?" is a new tension running around set. Apparently, "the Call" is from David or Dan. It's the "Really sorry we'll be losing you this season, but thanks for your contribution" call.

I've been so anxious about how long Hodor is going to last that when the latest script of each episode for season 2 drops into my inbox I don't read it. Instead, I lazily type the name "Hodor" into the Find tool and jump straight to my sequences. Episode 3: not dead yet . . . Episode 6: not dead yet . . . Episode 10: I've made it through the whole of the second season. Hallelujah! The relief has made me realize how invested I've become, and how I don't want the experience to end.

Surprising to me, viewers have also shown themselves to be invested. Far from *Game of Thrones* remaining the preserve of the sci-fi and fantasy

genre which I, and many on the show, had assumed, it's already made a crossover into the mainstream. *This is going to be big*, it dawned on me for the first time when I watched the buildup online to its April 2011 debut. The reception on forums and in the wider media in the US has been epic. Apparently, it's big in Brazil, too, although in the UK it's slower to catch on.

Admittedly, I haven't watched every episode. When it began airing three months ago, I did tune in to a couple. But watching myself on-screen became too cringeworthy, especially the close-ups of myself in the Great Hall in Winterfell. I don't see Hodor, the character, at all. All I see is what I remember thinking at the time: *My back is killing me. I'm hungry. I want this to end. Do I really have to do one more take?*

Worse than that, close-up screenshots of my prosthetic penis have been landing in my Instagram feed ever since episode 8 aired in June. Fans seem to think it's an image I want to revisit. Truly, I don't. I haven't watched that episode at all. Months after filming it, it continues to turn my stomach. As for people sending images, I wonder whether this is something I'm going to have to get used to. Despite my desire to feel in control, I realize that I have no control over how people perceive Hodor, or me. And I have to keep reminding myself: *Do. Not. Check. Social. Media.* It's the sage advice David and Dan gave me from the outset, and I know they're right, but it's hard not to get caught up in its weird cycle of self-punishment.

Already, I've started shopping in the twenty-four-hour supermarket in the early hours. Because I'm so visible over the shelves, I've caught wind of the name "Hodor" being called out several times. On other occasions onlookers have hovered by the checkouts while I bag up my groceries. Although my instinct is to say something, I've decided not to respond to the name "Hodor." It's not my name and I don't want people to confuse my character with Kristian, the person.

At the same time, I can understand the impulse—how people assume ownership of characters and, by extension, you. It reminds me of when I was younger and a big fan of the Australian drama *Prisoner: Cell Block H.*

The actress Val Lehman, who played tough-nut Bea Smith, was performing in a theater production of *Misery* in Belfast and signaled to me just as I was passing her at the stage door.

"Excuse me, do you know where I can get a takeaway coffee?" she called out.

I was so starstruck that I shouted gleefully in her face, "Hi, Bea!" only to feel crestfallen when she didn't respond with a rapturous "Hi there!" back. I didn't see her as a person at all. Now that I'm somewhere on the other side of that, I do feel an empathy.

—

ON SET, THERE ARE POSITIVE DEVELOPMENTS AND I NOTICE myself feeling more at ease. Instead of me carrying Bran like a baby in my arms, it's been decided that throughout this season we will use the harness that's been custom made. Isaac is eleven years old now and he's gotten bigger and heavier over the holidays. Thankfully, without any prompting from me, executives have noticed and spared me from impending back surgery.

When we first try it out, it's near the same wooded area in Carryduff where the prosthesis scene was filmed. In the *Game of Thrones* story, Osha and I take Bran back to the pools. In a dream, Bran has had a vision of his pet dire wolf, Summer, reflected back at him in the water, but when he checks his refection again, it's his outline.

"Are you okay?" I hear Isaac whisper to me as we walk up and down beside our trailer so I can get more used to the contraption. It's got leather straps and a wicker holdall at the back that cradles him as we walk.

"Yes, I'm okay," I whisper back.

"Are you sure I can't do anything to make things better?" he asks.

"No, it's fine," I tell him.

Just as in the previous season, the last thing I want is Isaac to worry about me. After all, I'm supposed to be protecting him. Besides, the harness feels amazing—not just physically but emotionally, too. *This is how*

it's supposed to be, I think. This is the Hodor and Bran that Mum reckons are so special. The inseparable duo—one iconic unit, like a virtuous Master Blaster from *Mad Max Beyond Thunderdome*.

When the filming of the scene starts proper, I can feel Isaac's fingers pulling on the leather strap at the top of the harness as we trudge through the wood to the pool. Quietly, I realize that despite my assurances, he is attempting to redistribute his weight to my shoulders to make it more bearable. I'm struck by his kindness and secretly thankful of the tiny adjustments he is making.

Bran's dire wolf, Summer, is also an interesting adaptation. In season 1 I got so used to seeing real dogs bounding around off set in Winterfell—beautiful shaggy Northern Inuit dogs with shiny silver coats that look like a cross between a German shepherd and a husky and bear the most resemblance to the now extinct dire wolves.

This time around, however, the real dogs and their trainers are nowhere to be seen. Apparently, obedient Inuits are rare and the dogs needed too much looking after on set. From now on, they'll be superimposed into the scene using CGI at the postproduction stage. That way they can also be augmented as they grow in age and size throughout the series. But it does add a bizarre element to filming.

In Carryduff it's almost comical. Bran's dream scene is filmed at the same time as our pool scene, and I can't help breaking into laughter at the sight of it. Instead of a dog and a trainer on hand, there's now a middle-aged assistant director, dressed head to toe in all-weather gear, on her hands and knees, brandishing two sticks with tennis balls attached to either end.

When it comes to filming a scene in Bran's bedroom at the Paint Hall that same week—a scene where Summer wakes him from another dream—I'm faced with either peering around an invisible dire wolf or being confronted with a large, fuzzy soft toy called Stuffy—half dog, half teddy bear—who sits in for the more complicated scenes.

"I'm so sorry. It's just so funny," I apologize to the director as we retake scenes for the umpteenth time. I've never experienced corpsing but now

I can't stop. To compose myself I desperately try to think of something somber. Once I erupt, I know Isaac will follow. Or he'll smirk at me as his bedcovers are being relaid and my body will start to shake. *I need to be professional*, I keep telling myself.

This, however, goes completely out of the window when it comes to Winterfell's ravens. Mostly the ravens on set are real, although some will be added in with CGI, along with each bird sound. But the real birds are surprisingly large, and we've been warned that they can be very unpredictable. Whenever I pass one, even if it's in its cage, I send out subliminal hate messages. The bird's eyes are inky-black and beady, and I have visions of my own eyes being plucked out like I'm in an Alfred Hitchcock horror film.

Already one raven has landed on my head during filming, if only briefly. Embarrassingly, I dropped everything and immediately ran around Winterfell screaming "Help! Help!" like a hysterical Penelope Pitstop being chased by the Hooded Claw—precisely the opposite of the instructions given to us by the falconer.

"If a raven lands on you, do not move. Stand still and cover your eyes because they will go for you" were his words. All great advice in theory but when it came to it, I abandoned all common sense and flapped around like an inflatable roadside air dancer.

Most incredible to me, though, is Winterfell itself. During our time away, its exterior and the inner courtyard has been rebuilt fake brick by fake brick on a hillside northwest of Belfast near the town of Ballymena. It seems that the royal cart scuffing the castle on our first-ever day's filming at Old Castle Ward was not greeted kindly by the National Trust, who look after the building's heritage, and HBO got its marching orders.

I'd heard the rumors of the rebuild, but I couldn't imagine how the medieval ambience of Old Castle Ward could be replicated by a prefabricated set. Easily, it seems. When we arrive to film there, it looks no different to a real castle perched on a hillside in the distance. Inside, its courtyard also feels exactly the same, even though I know that its walls aren't real and segments of it are held up by scaffolds.

But the biggest change I notice is in me. I've come back with a renewed momentum to launch myself into Hodor and get him right. In part I feel buoyed by John Ruskin's encouragement and his confidence that I already possess everything I need. I just need to commit to the character.

I also feel far more at home on the production set, and it's lovely to see familiar faces. Even the canteen staff greet me with a "Hi, Kristian! We've got the Red Bulls in." These are faces I didn't know a year ago and I feel genuinely delighted to reconnect with them.

I'm also learning that film sets can be very fluid places. Sadly, some of the costume and makeup crew have moved on to other productions. When I ask after Gwyne, who was an anchor and one of my staunch defenders during my prosthesis scene, I hear he's no longer working on *Game of Thrones*.

"He got a job on *Downton Abbey*," Paul tells me. *Was it the top-to-tail wardrobe that lured him?* I worry. Maybe shielding my naked body from the rain was the day he decided that *Game of Thrones* was the worst career move ever. I can't help thinking he's sought refuge in an Edwardian costume drama.

However, being local, there are other members of the crew I've bumped into around Belfast between seasons. Some of them have become regulars in Kremlin; during season 1 word slowly spread that Kremlin is the place to party at the end of a hard week's filming.

This season, I've noticed more crew and cast members showing up. Mainly actors have been staying at the Fitzwilliam Hotel, less than a ten-minute taxi ride away. Being a gay bar, many say that if they are recognized they feel safer there than in any other venues. For me this feels both reassuring and disorientating. While the performer in me is loving that people choose Kremlin and are having a great night there, it also feels like two separate worlds colliding. Kremlin is a venue I have a twelve-year history with. It's been both my savior and my undoing at times, and I'm not sure I'm ready for these past and present lives to meet. But I have to keep reminding myself that no one on *Game of Thrones* knew me in a previous life and so none of it matters. *You can be who you want to*

be, Kristian, I think. But old baggage can be hard to let go of, and there are times when it feels as though everyone who comes through Kremlin's doors knows something about me that I haven't yet felt comfortable sharing about myself.

At other times, I can't help but see the funny side. Some cast members are unmistakable on the dance floor. Recently I was in the DJ booth on a Friday night when I looked out to see one woman with bleached-blond hair towering above everyone else. *I'm sure I recognize her*, I was thinking. When I peered again through the heavy smoke, it was the unmistakable figure of Gwendoline Christie, who plays Brienne of Tarth. Gwendoline has always been very friendly to me on set, but it was weird to see her there, completely lost in her own world, dancing and swinging her handbag around her head to some hard-rave techno. *Respect*, I thought.

One night, though, I don't see the warning signs until it's too late. It's around midnight when Richard Madden taps on the DJ booth door.

"Hi, Kristian!" he mouths and waves. Richard is a person I'm genuinely pleased to see at Kremlin. He's one of the principal cast I've really gelled with ever since I found him dancing around the Paint Hall car park waving my prosthesis. He's warm and funny and definitely one of the more sensible younger actors when it comes to behaving himself on a night out.

Standing beside him is Kit Harrington and Alfie Allen. In and around Winterfell, Alfie has also made me laugh. Mobile phones are strictly forbidden on set, but from early on Alfie sussed that I hide mine in a pouch in my costume. It means I can check my messages if there's a lull in filming so long as no one catches me. He is always asking me to stash his in my pouch, too, and others have followed suit. Already there's been a few close shaves when iPhones have gone off.

"Hodor, your pouch is ringing" has become a bit of an in joke.

However, this is the first time I've ever seen Alfie in Kremlin.

"Hi!" he and Kit both shout over the music before signaling that they are heading to the bar to get some drinks. My set has some time to run and I'm also DJing for that night's act, a drag queen I've known for years

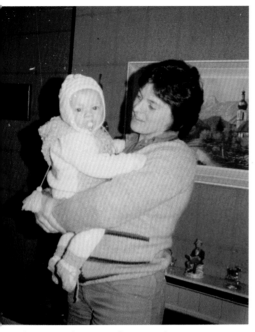

in the arms of my guardian angel, my mum.

My first school photo, taken under duress at age six. I hated having my picture taken.

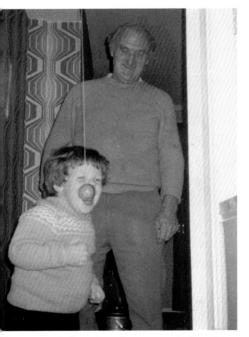

lloween with Granda and a rare smile from him. eck out the psychedelic seventies wallpaper!

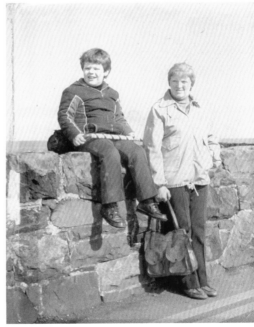

Nan and I at the harbor in Donaghadee, near Belfast.

Is it Meatloaf? Or Mother Teresa? Me at eighteen cradling my first Fender Stratocaster.

Me and a DJ friend terrorizing the countryside in promo shot.

Early Revvlon promoting a vodka brand in Kremli

Mum and me in the family kitchen in Lisburn. I still have those vases.

as a warped version of Supergirl with added tan.

Sweating on stage with drag queens Titti von Tramp and Chloe Shagalot in my custom rubber X-Man outfit.

ersonating Nana Mouskouri without having aintest clue who she is.

The final evolution of Revvlon to date—hosting and DJing in Dublin.

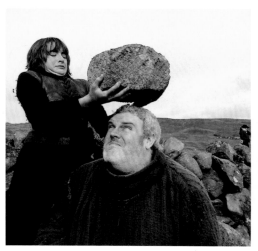

Getting well and truly stoned with Issac!

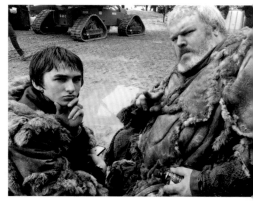

A serious face for one of my final days on set for *G*
of Thrones.

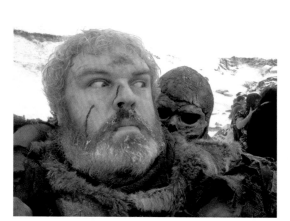

An unwanted embrace from a wight—not a real actor,
of course, just a backpack strapped on.

Me and my buddy, Finn Jones, at a conven
somewhere on the planet.

... and Gemma Whelan showcasing our mus-
... in Paris.

Campaigning for gay marriage in my hometown in
2017—unbelievable I even had to!

... and Issac enjoying some downtime in one of our
...rite Belfast hangouts.

Finally, I got to meet the real Supergirl, Helen
Slater. I almost imploded.

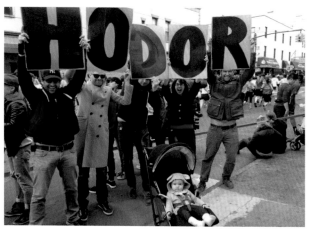

All roads lead to In-N-Out Burger LA—and that day I bumped into Al Allen (aka Theon Greyjoy).

Sent to me from Hodor's lovely fans on America's East Coast.

Preparing for a guest spot on Wil Wheaton's cable show.

Playing Innuendo Bingo at the BBC. I made t mistake of swearing live on air. Oops!

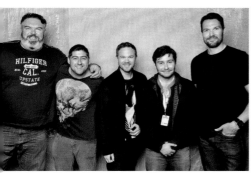

...ne of Thrones meets the X-Men in Australia: me ...n Laurence Wreford (second from left); Shawn ...more (middle); Dan Portman (second from right); ...Daniel Cudmore (right).

Studiously knob-twisting behind the decks some-where in the world.

...ing with lasers at *Rave of Thrones* in Phoenix, Arizona.

Holding a Mini-Me at a San Francisco premiere.

Mum's first time in America. I took her to Las Vegas, and she loved it.

Cuddling producer Deadmau5's cat, Meowingt (RIP little fella)—never mind my allergy, I had give him a squeeze.

An overwhelming crowd in Delhi—who knew Hodor would be so popular in India?

When someone hands you a Hodor mug screening in Toronto, you have to make the r of the shot.

called Felicity B Wilde. She's gorgeous with her blond spiky hair and her elaborate costumes. She also draws in the crowds. Her Kylie tribute act complete with dancers is legendary.

Some way into my set, Richard snaps me back into consciousness. He's turned up at the DJ booth again and is trying to grab my attention.

"Help!" he's mouthing to me and pretending to garrote himself.

Momentarily I take off my headphones to try to hear what he's saying. "What?"

"Kristian, everyone is so drunk!" he says. Apparently, Kit is at the bar talking to random strangers while Alfie keeps threatening to take his clothes off.

"I don't know what's happening!" he shouts. This makes me smile. *That's what Kremlin has always been about*, I think. Letting go.

I promise to join Richard when I have a break and watch him disappear into the crowd. But when Felicity B Wilde's set kicks in and I look down onto the stage, I realize he *really* isn't joking. Something is afoot. *Jesus fucking Christ.* Alfie is clambering up onto the stage. Felicity has no idea who he is. As he stumbles around grinning madly at the crowd, she deftly maneuvers around him. He is steaming drunk. Then he clumsily muscles into the group of backing singers she has performing alongside her and begins to dance. He's swaying his hips, shimmying his shoulders. In the crowd I can see Richard, mouth agape as Alfie drunkenly sways from side to side and starts to unbutton his shirt.

Oh. God. No, I think. I have a terrible feeling about this. Now Alfie's shirt is coming off. It's off and he's twirling it around his head like a bad striptease. Then, I clock two bouncers wading through the crowd, talking into their headsets. When they finally reach the stage, Alfie looks as though he's poised to unbutton his trousers. Felicity is still weaving around him, signaling to get him off the stage. Finally, he's stopped in his tracks. Both bouncers grab him by either arm and drag him off.

"What the fuck?!" I can see Alfie protesting as he is hauled towards the exit. I can't help chuckling. As we always say, what happens in Kremlin, stays in Kremlin. Besides, no one wants to attract the tabloids.

STOP MELTING MY UNICORN, BITCHES!

I LOVE BIG EMOTIONS. I LOVE THE BIG EMOTIONS THAT SOUND creates. I love to feel a tsunami of joy followed by the crash of despair, knowing that I'll be lifted up again. I don't do states of equilibrium. All of this seems to feed my newfound love of performing. Now this never happens in the privacy of my own bedroom but in front of hundreds. It's as if all my life I've been working up to this. I love being absorbed in the moment, reaching out to people—that nonverbal connection that helps me translate the pain of everything that has made me different—a two-fingered salute to the haters. But I also know that I have a lot in my heart that I want to share. Still, the only way I can do this is through Revvlon. She's my millennium superhero.

Since I won the drag ball at Kremlin, I've been a regular onstage on Friday and Saturday nights. It's taken Revvlon some months to find her groove, but I've run with the lip curl and the spit-in-the-crowd expression whenever I appear. I'm always nervous. A sharp intake of breath before I stagger forward in my cork-tiled wedge heels. Then, I lean in with the full weight of my body and announce myself to the world.

"Fab . . . " I shout sarcastically and wait for the crowd to explode into whoops and applause. It's become a catchphrase that raises the roof.

The more disdainful and ferocious I look, the more the crowd get behind me, before I break the intensity of the moment with a joke or a wink that lets them know that this is pure pantomime. I don't know what people love about Revvlon, but I think it's her honesty. If I'm having a bad day, Revvlon doesn't pretend. She's genuine in that way.

On Tuesday nights I'm meaner. I dress in a ginger wig like the TV host Anne Robinson and spin my own version of the quiz show *The Weakest Link*. I fire round after round of ammunition at contestants.

"With a brain so small, why did you bother getting out of bed today?"

"Really, that's your answer? Surely you can do better than that?"

One of Kremlin's DJs has nicknamed me Princess of Darkness, which is how I'm introduced before I make my entrance onstage, but there's always an underlying compassion to my act.

I'm also the perfect counterpoint to Titti von Tramp, who works Kremlin's door. Whereas she's long-legged and ultra-feminine, I've kept my look androgynous. Other queens wear fake breasts, but I don't. Titti could wear a handkerchief and heels and still look amazing, and she can work a room like a pocket rocket. But I don't want to appear ladylike. For me, drag has never been a sexual act. I've never even had the urge to pull someone in drag. Not long after I started at Kremlin, one guy I vaguely knew groped my arse. "Hiya, Revv," he said as I was climbing the stairs. Instead of feeling flattered, I felt ready to vomit.

"What are you doing?" I spun around and barked at him. Whenever I saw him after that, I could feel my body language shift. Revvlon disappeared and Kristian found it impossible to look him in the eye.

But Revvlon makes her own rules, and I've realized precision is not in her rule book. I take care over my makeup—at first it takes me a couple of hours, but I'm getting quicker—but I've abandoned the routine of painting my toenails. Wearing Nadine's open-toed shoes means I bash them off everything. Some nights my feet look more wolverine than human. I don't wear false fingernails either. The size of my fingers means that I'd have to have nails custom made, but that would also get in the way of my guitar playing. Revvlon's my imperfect chrysalis from where I feel I can grow.

A FEW MONTHS INTO MY SLOT AT KREMLIN, REVVLON GIVES me the balls to take one further step. I travel to Brighton on England's south coast. I've lined myself up to help judge a fancy dress ball in the city's best-known gay club, Revenge. If I can't openly gender-fuck in Brighton, then I can't do it anywhere. Brighton is the unofficial gay capital of the UK.

I book a cheap hotel room and get ready there. There are no dressing rooms at Revenge, but also by doing so I've added an extra level of danger to the evening. To get to the venue I'm going to have to walk though Brighton's cobbled lanes in full drag-queen garb. It's a gauntlet I'm willing to run—a kind of test. When I set off, I'm dressed in my wedge heels and latex spike outfit and carrying a little red heart handbag, which I grip tightly just in case I need to use it as a weapon. I've also brought with me a small suitcase on wheels packed with jeans and a T-shirt. If I do have to make a quick exit during the evening, I'll need to blend into Brighton's nighttime crowd.

I make it down one street. So far, so good. But then I sense company. As I approach the first junction I look briefly over my shoulder. *Fuck.* I have a small crowd following me.

"Sally!" one guy shouts.

Sally? I'm confused. *Head up, Kristian*, I tell myself. *Keep walking.*

"Yeah, it's Sally Solomon!" his friend laughs.

Haha, okay, I get it. It's a step up from "practically malformed." Sally Solomon is the tall, blond extraterrestrial in the TV comedy *3rd Rock from the Sun*: a military commander on a mission turned earthling housewife in disguise. It's one of my favorite comedy series. *At least on my own planet I'm a decorated war hero*, I think. I want to spin around with a killer blow stolen straight from Sally Solomon's mouth: "Stop melting my unicorn, bitches," but I just keep walking. If I was in Belfast, I'd already have had a brick thrown at me from a moving car. Thank God for small mercies.

"Yeah, its Sally Solomon!" he repeats, but when I listen again his voice doesn't sound hostile. Now when I turn around there's ten more people and they're not angry. They're beaming up at me. There are people dressed as Willy Wonka; there's a *Wizard of Oz* Dorothy; there's ABBA luminaries and even a 1970s Elton John complete with jumpsuit and sparkling sunglasses.

"Going to the Revenge Ball?" one asks.

"Yeah . . . "

"Us too. You look amazing!"

"Thanks!" I say shakily.

Suddenly I feel like the Pied Piper of Hamelin tottering through the streets with my flute and coat of many colors. By the time I reach the next junction, around five more people have joined the procession.

"Sally!" they continue shouting all the way until we see the black exterior and neon lights of Club Revenge. I'm safe. It's such an alien feeling.

The Revenge Ball goes well, and with Brighton under my belt I feel I've reached another milestone. Not only have I survived as Revvlon at the club, but I've also survived on the street in a city that's not my own. A couple of months later it's Revvlon who gives me the strength to say yes when Aaron at Kremlin suggests I take part in the Alternative Miss Ireland competition.

The pageant takes place each year in Dublin around St. Patrick's Day. I'd never heard of it, but apparently it's run by a drag queen called Panti Bliss, real name Rory O'Neill, who kick-started it as a regular event

around four years ago in 1996. It's a charity ball raising money for HIV/ AIDS organizations. A six-foot redhead, Panti puts the alternative into drag—far more gender-bending, edgier, and angrier than traditional drag, and the event is a tongue-in-cheek take on the Miss World competition.

"People will take notice of you, Kristian. Revvlon's different," Aaron says.

Normally there's an application process to get through but Aaron knows Panti well and he secures me a place.

As I am being paid peanuts to perform drag at Kremlin, and my £2,000 loan from the Ulster Bank is running down fast, I ask an artist friend of a friend to create three costumes for me for the night.

"I'm sorry, I can't pay you up front," I tell her, but I do promise that I will pay her back. Just like my bank loan, I have no idea how. I'm living day-to-day but I'm so focused on my new path that reality becomes the first casualty, especially when it comes to money.

Even so, I have no regrets about giving up a steady job and a regular wage for this. I don't miss the nine-to-five clock-watching. I don't miss Castle Grayskull. I miss nothing about my previous existence. Mum isn't telling me I've made a mistake either, although she doesn't know the half of it, especially that I'm struggling to pay the rent on my flat in Belfast.

"If it's what you want to do, Kristian," she says. And I do know Mum is behind me all the way, not just in words but in deeds.

She was sitting in the audience at the drag ball I won at Kremlin. *I love you for that*, I think. And she's promised to accompany me to the Alternative Miss Ireland pageant in Dublin, too.

When my outfits arrive, I pore over them. Aside from the shoes and latex two-piece Nadine made me, I've never had anything custom-made before. Instantly, I forget about how much these cost to make. Each outfit is like a dark fairy tale—far more in-your-face than I could have imagined.

Just like at any Miss World, the competition has three elements to it. For day wear I have a pair of silver lamé flared trousers. There's no back to them, just two circles cut out and my bare bum cheeks on show. I love

them. This is topped off with a bubble-wrap boob tube and a thick rain-coat made from PVC. As an accessory I'll carry a silver umbrella.

For swimwear, I've taken my inspiration from the movie *Jaws*. I have a shark's tail jutting out from the back of a gray PVC dress, fins on either side, and teeth sewn into the A-line skirt to give the illusion that I'm being swallowed whole by the shark's bright white teeth and red salivating mouth.

Evening wear is my favorite. A Japanese funeral outfit makes me look like an ambisexual sumo queen: an amorphous black-and-silver ankle-length kimono smock with bat sleeves.

"You'll be sweating in that under theater lights, Kristian," Mum's voice of concern kicks as soon as she sees the outfit, and she's offered to sew in a thin lining to stop the material from sticking against my skin. I also have a large white lily for my hair and a veil hanging from the back. But the cherry on top is the red-tint contact lenses I've bought. They give the ensemble a far more menacing feel.

On the day of the pageant, Mum, Leigh, and I drive across the border in Mum's Citroën 2CV. I've asked Leigh if she'll accompany me so she can apply my makeup. I need a far more polished look than the one I rock at Kremlin.

When we finally arrive at the Olympia Theatre near Dublin's Ha'penny Bridge, there's already a queue snaking around the block. Inside, there's an assortment of traditional drag queens; alternative drag queens like me; hyper queens—women dressed in Barbie-feminine drag; and a handful of drag kings—mainly women dressed in male drag. There's transexual, transgender, all kinds of transformative people under one roof. There are bauble dresses, chandelier hats, glitter tops, and sequined feather boas: more shimmer than a Christmas tree. Leigh is in her element as we make our way through this beautiful mayhem of audacity and originality.

Suddenly, the pressure hits me. I can barely speak. I'm faffing at which dressing room I'm in, which is so far up in the gods I swear I'll get a nose-bleed. Mum and Leigh feel the brunt of my mood.

"Listen, Mariah Carey, don't get diva with me!" Leigh snaps. I've never known myself to behave like this before, but I can't pull it back. I've a face like thunder as we make our way upstairs. Mum takes the hint and gives me a wide berth.

"I'll wait for you downstairs," she says tactfully.

Later, inside the red velvet auditorium, there's outsized glitter balls twirling from the ceiling. Rory stands with his clipboard and runs through the running order with all the finalists, which number thirteen. While he talks, I size up the competition. Every performer has gone to a lot of effort. My routine has also been meticulously choreographed, but I worry it's too scrappy, too alternative. I'm used to performing in a night-club but now I'll be in front of a thousand in a professional theater in a city where I'm a complete stranger. And while Dublin is a far more cosmopolitan city than Belfast, I don't know if it's ready for Revvlon.

In the day wear category, I'll lip-sync to the funky house tune Sunkids' "Rescue Me," while I take aim at a line of Barbie dolls with my umbrella-turned-golf-club. In my mind I'm knocking the head off each rival and sending it hurtling into the auditorium. I joke to Leigh that I have a lot of pent-up anger—Revvlon is my only chance to exorcise my demons with some humor.

In the swimwear category there's an interview during which I probably won't be calling for world peace. And in evening wear I'll finish by lip-syncing to PJ Harvey's "Down by the Water," which is far less razzmatazz than I suspect any of my fellow contestants will dare.

When the show starts, Panti Bliss is the hostess extraordinaire with her checked ra-ra skirt and bikini top. Then there's Dizzy and Dolly Dyin'forit, also part of the entertainment, who sit like two gossiping aunties on an onstage chaise lounge and cheer the contestants on and off. I watch from the wings. There's one queen whose dress resembles a table complete with fruit and candles; there's another trapped inside a TV set; a third is brandishing a pet snake. And then there's Miss Siobhán Broadway, whose cabaret routine comes with four puppet minstrels dancing in

synchronicity to her steps. I notice that everyone has an array of props to help them. I don't. I'm mainly just Revvlon and I feel very exposed.

"Miss Revvlon, you're up next." I get the call. And when I'm ushered out, I have to catch my breath. I'm overcome by the enormity of the event. I try to tune out the noise of the crowd by focusing on Mum and Leigh, who have seats in the front row.

When I look down, Mum is giving me the thumbs-up. Leigh looks about to burst, surrounded by frills and glitter and an audience dressed to the nines. I swallow hard, wait for the thumping beat to kick in, and begin. The song has Aretha Franklin attitude and I stomp out to it. I'm trying to look angry, but I can't help but smile. I'm shaking my hips with the silver lamé trousers on, and I thrust myself forward. When I look down, I can see Mum's expression changing. She's seen the trousers at home and she can't quite believe what I'm about to do.

"Don't turn around, Kristian," I can hear her saying. "For God's sake, don't turn around."

"Sorry, Mum!" I shrug as I spin around with my bare arse hanging out and parade myself in front of the crowd. They go wild. When I look down again Mum is peeking out from behind her fingers and Leigh is laughing her head off. Even Mum has her limits, but underneath I know she's proud of me. She's proud of me being up here, doing what she knows is inside of me to do. She's also the one person who knows what it's taken for me to be here—she truly understands that this is not the Kristian of old. This is not the Kristian who couldn't even get on a school bus for fear of being bullied.

I don't win, but I get close. Very close. Even the judges say I lose by a whisker to Siobhán Broadway with her life-size tap-dancing puppets. It's second place and I am *so* disappointed.

"Don't worry, Kristian, there's next year," Mum tells me when we finally meet in the foyer. And Mum is right. The score is close enough for me to know that I can *do* this. I have talent. I didn't go out there with all those props, and the audience still loved me.

"You were fucking brilliant, Kristian," Leigh pep-talks me all the way home.

And when I get back to Kremlin, there's another offer waiting. After one night's drag act as Revvlon, I am approached by a guy who's interested in representing me.

"You're going to be famous," he tells me. "There's something about you," he says. His name is Connor, a local talent agent.

"Thanks," I say. Instinctively, though, I'm not at all convinced.

"If there's any acting roles that come my way, I'll put you forward for them," he continues.

Acting? I guess Revvlon is an act, but I've never thought seriously about acting. I don't see myself as having the ability for it. *I'd rather stick to what I know*, I think, which is drag.

"Sure," I say, doubting I'll hear back from Connor anytime soon.

Then two perfect worlds collide. One resident Kremlin DJ is sick, and when he doesn't show, I spot an opportunity.

I overhear Aaron talking about what to do and I catch his attention.

"If you need someone to take over, let me know," I say, explaining that I have a massive music collection and that he can trust me behind the decks.

"I know my music," I persuade him.

Aaron raises an eyebrow and nods slowly.

"It's a warm-up slot, so I'll give you a go," he agrees hesitantly.

He won't pay me for the tryout, he adds, but if I do well and the absent DJ turns into a permanent no-show, then he'll consider handing me a regular slot. But there's one problem. I don't tell Aaron, but I can't do this as Kristian. I need to be Revvlon. But at Kremlin only drag queens do drag acts, and DJs play music. *Fuck it*, I think. I'm bringing Revvlon with me alongside my two folders packed with CDs. And when Revvlon shows up, no one says a word. I launch into my first Thursday night 10 p.m. slot with the same lip curl and look of disdain that the crowd has come to love.

"Welcome to the Kremlin on a Thursday night," I shout before I take my place in the DJ booth. With Revvlon as my shield, I'm not terrified.

At the end of the night, Aaron arrives to shake my hand.

"Kristian. If you want a regular slot, you can play again," he tells me.

"As Revvlon?"

"Yeah, as Revvlon. I've got faith in you."

FAITH IN ME

I STINK. THE SMELL OF SWEAT AND MANURE HITS MY NOS-trils every time I move. I've been wearing this costume for several weeks now, and in the *Game of Thrones* rule book there's an edict that twenty-first-century washing machines are an aberration of the future.

When I first got fitted for my costume, I loved the novelty of it. "As heavy as fifteen sheep," I joked with Helen and Isaac, and that was only my outer tunic. Underneath the tunic, Hodor wears a base layer—a shirt made from burlap cloth and what can only be described as old-fashioned breeches hand-stitched in a rough woolen material. But two seasons in, it scratches like cockroaches against my skin. Modern, breathable fabric is hard to find in any *Game of Thrones* wardrobe. Instead, all its costumes have been made to accurately reflect a bygone period. In Winterfell, many of the servants wear farm clothes modeled on clothing worn in the North of England during the Middle Ages. As for the real-time wear and tear, the reason is for continuity. But the unwashed smell is disgusting.

On the sly, I've smuggled in CK One perfume, which I've been spraying on each layer at the start of every day. Not that it's made much difference—now I just smell like a pig rolled in shit mixed with top notes of citrus and jasmine. It doesn't help that I have a lot of moving around to do. Plus, there's a new man at the helm to navigate on a couple of key episodes, so I feel there's a lot to sweat over: he's a director called David Nutter who I feel intimidated at the mere thought of.

David's reputation precedes him. He's known in the business as "the pilot whisperer." He started out directing *The X-Files*, but it's also lore that any TV pilot that David makes gets commissioned. He's a Hollywood grandee, and I'm expecting a dose of the same businesslike manner and sparing direction that I've gotten used to on *Game of Thrones*.

Yet when we meet, David seems different, although I can't fully explain why. He has the look of a teddy bear and he talks as fast as I think his brain works, which is very, very fast. Each word rolls into the next in a stream-of-consciousness babble and you have to be alert to keep up. But he also asks questions of me and asks questions of my character.

The first scene I film with David is the beheading of Ser Rodrik Cassel, played by the wonderful Ron Donachie.

"Okay, there's a camera here, here, here, and here, so when Ser Rodrik is dragged into the courtyard, then all eyes should be turned this way," he says. "Kristian, you'll be standing with Maester Luwin and Rickon Stark. Bran will be seated a meter to the left. How's Hodor going to react in this scene?"

This is the first time a director has asked me how I envisage playing Hodor, and as we discuss it, I feel myself warming to David's highly collaborative style. I watch him do the same with other actors. He has faith in their understanding of their own character, and I also feel he's a director who has faith in me. Without question, he's seeing me as a bona fide actor, not someone pretending to be an actor as I've felt inside up until now.

David's camerawork is also a departure from other directors. Ordinarily during filming, we are used to one or two cameras, but David sets up at least six. He films from every conceivable angle, which, by

comparison, speeds up the process. Scenes that would normally be reshot fifteen or twenty times, he finishes in five—a technique that would have been bliss when I needed to carry Isaac over and over in season 1, almost putting myself in traction.

For this scene, his fast direction is a relief for different reasons. We've known about Ron's departure from the series for a while—he's had "the Call." I'm dreading him leaving and I want to get it over and done with. Ron is someone I've grown to like a lot, as has Isaac. He and I have shared dinners after long filming days, and I could listen to Ron's stories forever. He's a proud Scotsman and a stalwart family man whose crazy acting career has taken him to every corner of the globe. But it's Ron's turns of phrase that I love the most. He's lyrical in the way that he speaks—flowery, like listening to an endless Robert Burns poem.

Whenever I turn up to set and he and Donald Sumpter are in the waiting tent, I know it's going to be a great day. I've learned so much about the craft of acting from these two old hands, and I've also enjoyed their company in the breaks between filming.

I'm also dreading Ron's death because fresh in my mind is Donald Sumpter's death as Maester Luwin. Because almost nothing is filmed in sequence during *Game of Thrones*, that particular scene, which will air during this season's final episode, was in reality filmed back in July. We are now in October. On the day itself, I sensed a quiet fury in Donald, which is very uncharacteristic. I've come to know Donald as a suave and charming man, always regaling us with snippets of his lovely bohemian-sounding life, of his wife and family and of him sailing his boat to France.

"Is Donald okay? He seems pissed off," I'd asked Ron that morning.

"What he's being asked to do is really hard," Ron explained, and not at all usual. Fresh from a holiday between seasons, Donald not only had to die, but then rewind and play out his journey leading up to that moment for a whole ten episodes.

"It's hard to summon up that depth of emotion and then backtrack," Ron explained further.

When I think about it, everything you do following your on-screen death must seem like a massive anticlimax, as if you're just going through the motions.

And on the day of Maester Luwin's death, all of us who witnessed it shed a real-life tear. Donald did summon up something remarkable. We acted out the scene in the glade in Carryduff. Maester Luwin said a stoic farewell to Bran and Rickon as he lay dying under the heart tree before I led them both away. Then, he asked Osha to sacrifice him before we left Winterfell to head north. As soon as we'd disappeared off set, Isaac and I stood together and watched on as Donald and Natalia wrapped up the dialogue. Already, during filming, I'd had to swallow hard to stop myself from filling up. But the minute I was off camera, I couldn't control the tears that trickled down my cheeks. Donald was so convincing. I sensed Isaac's sadness, too, so I put my arm around his shoulder and gave it a squeeze. Both Ron and Donald have been like surrogate parents to him on set.

Ron's death, on the other hand, is far more high-octane and gruesome. It's an equally big scene and also a turning point in the story. Over the next two days of filming, Ron will be dragged back to Winterfell and beheaded in the courtyard by a treacherous Theon Greyjoy. His death represents Theon severing ties with the Starks. And, as a loyal servant of the Stark household, both Bran and Rickon are distraught at his death, which foreshadows the depths to which Theon will descend during the series.

On the first day of filming, the rain is pouring down when we arrive in Ballymena. And when it's this wet, my costume gets unbearably heavy and also stinks to high heaven. I'm also worrying about my shoes. During season 1 I was allowed to use my Dr. Martens boots because my custom-made shoes hadn't arrived yet from Italy. Now they're here, but the soft Italian leather feels flimsy in the rain, and I also keep slipping in the mud. I hate all these uncomfortable distractions when all I want to do is give it my all.

To create the right emotion for the scene, I feel I have fair few of my own memories to draw on to summon up feelings of horror, anxiety, and sadness. To this extent, I've gotten better at the process of reaching into

my own internal experiences, then channeling them through Hodor. But I wonder what Isaac, an eleven-year-old, has to draw on. Rickon, played by Art Parkinson, is of a similar age. *What do they think about?* They've hardly got much life experience at all. Off set I've heard Helen discuss with Isaac how he might approach this scene. What if one of Isaac's pet dogs was to die? How would he feel? And through his kind, symbiotic style I've also heard David talk with the children about how they might portray their distress.

As we begin filming, I don't feel overly worried about Isaac, but I notice a strange shift is occurring. Throughout filming, David has handed me so much ownership of Hodor that when we do the initial run-through, I find myself truly feeling what Hodor is feeling: such togetherness with Bran and protectiveness towards him that Bran's begging of Theon not to drop his sword on Ser Rodrik's neck cuts right through me. As Bran cries out, my chest lurches forward. All I want to do is walk over, shield his eyes from what is about to happen, and give him a big hug.

When it comes to the second and third takes, I'm even more in the zone. However, what I haven't factored in is Art, who is standing directly in front of me and constantly distracting me. As each scene is set up and I'm composing myself, he fires out a salvo of the most random questions.

"Kristian, do you like bananas?"

"Kristian, have you ever been to Morocco?"

Be patient, Kristian, Art is a child, I think. I'm full of understanding for the kids on set—these are long, difficult sequences to be filmed—but I'm also concentrating so hard on getting my own performance right that I can't help wanting to swat Art like a fly.

"Shhhhhhh," I try to silence him before we have to compose ourselves again.

"But Kristian . . . "

"Art, we need to focus now. Filming is about to start."

In an instant, I have to snap from irritated, distracted Kristian to sad-faced and distressed Hodor. *Summon the sad emotion, Kristian*, I tell myself.

During filming I also notice that Art can only keep still for a short while. As his body presses against me I can feel his leg gyrate restlessly as the scene unfolds. Ser Rodrik is being dragged through the courtyard, bloodied and unrepentant. Bran is yelling and crying and begging Theon not to kill him. There's a clap from the assistant director, which is supposed to signal the sound of the first sword swipe on Ser Rodrik's neck. Someone is waiting at the side ready to throw in a rubber replica severed head onto the muddy courtyard floor . . .

"And cut," David shouts.

Immediately, Art turns to me.

"Kristian, what do you keep in your pouch?"

For fuck's sake. I conclude that it's the only way that Art can control his nerves. And when I think about it, maybe I'd have been a nightmare at his age, too.

When we arrive on set the following day to retake parts of the scene, the weather is glorious: shining, beautiful blue sky has replaced yesterday's grumbling clouds.

"Hurrah! We won't get soaked today, Kristian!" Isaac shouts as he leaps around the trailer at base camp. I, too, am delighted by this. I've come to loathe standing out in the rain inhaling my own body odor. In the rain my scar makeup also constantly falls off and needs to be retouched. Mostly, though, bad weather makes my stomach growl harder and my mind fixate on what's for lunch.

However, our optimism is quickly crushed when we arrive into Winterfell. To maintain continuity, rain machines have been brought in and loom over the courtyard. Isaac's face drops as he looks at me and points. One rain tower and sprinkler is poised not far from the barrel on which he will be sitting. And as filming begins, I can see Isaac becoming more agitated. As we retake again, droplets pour down his tunic. His hair is soaking, and the wetness is dripping from his nose. On the other hand, I am as dry as a bone. Given the angle of the machine, I manage to avoid the shower and I also figure out that if I hover slightly under the castle arch, it gives me added protection. The water lands only on my shoes.

"I'm soooooo dry," I tease Isaac in between takes, hoping that some fun might distract him from the intensity of the action.

"Shut up, Kristian," he spins around and shouts.

"I've never been dryer. I'm soooo, soooo dry . . . " I continue poking fun at him.

"I said shut up, Kristian," he snaps back and stamps his foot.

Actually, this is the first time ever during filming that Isaac has been moody with me. I've seen him pissed off that he's being called off set for lessons with his school tutor. Or pissed off that he's been told off for dancing and singing when filming is about to start. But pissed off with me? Never. In truth, I'm a little taken aback by it. I don't voice it openly to Isaac, but in that moment I realize that despite his outward confidence and resilience, this scene may be hard for him. Maybe the emotion is overwhelming and, like me, he's also dreading missing Ron when he departs the series. Plus, Isaac really is soaked to the skin. I quit pulling his leg and give his hair a friendly ruffle. Barney the Dinosaur back in the room.

It's during today's filming that I also realize what a good actor Alfie Allen is. Off set he's been surprisingly unsure about his abilities, always rehearsing and re-rehearsing his lines in the waiting areas, always asking for reassurance about how well he's performed. But I also sense he's building a lot of confidence under David Nutter's direction. He's beginning to fully inhabit the dark places Theon Greyjoy will go to throughout *Game of Thrones*, which already looks like a very lonely place. In fact, under David's directorship, everyone seems to shine. As well as being the pilot whisperer, I think David may also be the actor whisperer. While he's demanding and focused and knows exactly what he wants, he balances this with some kind of magic touch when it comes to summoning the best performance out of everyone.

—

IN THE NEXT SCENE I FILM WITH DAVID SOME DAYS LATER, MY enjoyment of working with him grows even further. The scene is twofold:

having secretly escaped from Winterfell after Ser Rodrik's death, Bran, Rickon, Osha, and Hodor leave by dead of night before doubling back to hide in Winterfell's crypts. After sunrise, our group walks over fields around Winterfell. I am carrying Isaac in the harness while cracking walnuts (already pre-cracked by the crew) that I've kept in my pouch to feed Bran and Rickon as we travel. It's supposed to be another signifier of Hodor's strength.

In the run-through, David and I discuss how Hodor is going to react, especially when Osha calls him a "sweet giant." Ever since I've read the script, I have been thinking about this line, so when David asks me about it, I feel another transformation happening. For the first time on *Game of Thrones*, I make a suggestion. By doing so, I surprise myself. I've never made a suggestion before, but I do feel 100 percent certain of what Hodor would do. More than that, I feel David may be open enough to listen to my thoughts.

"David, could I suggest something?" I say tentatively.

"Sure. Go ahead."

"When Natalia says the line 'We've been walking since before sunrise, even Hodor will tire. . . . Even you, sweet giant,' I think Hodor would be really flattered. I think he'd love being called 'sweet giant,'" I say.

I'm half expecting my thoughts to be shot down and for David to direct me in another way. Inside, I'm recoiling, but David listens carefully and smiles.

"Okay, you know your character better than anyone," he replies. "How are you going to express that feeling?"

I think for a few moments.

"I think Hodor would giggle but in a shy, bashful way," I say. "And he'd repeat the word 'Hodor' while he's laughing."

"Okay, let's try that out," David says.

When we finish the first take, I look over at David. His eyes narrow thoughtfully before he speaks.

"Great. That really works," he says.

"You think so?" I can't quite believe what I've heard. In that moment David is telling me that I'm acting the part well, but he's also telling me that my understanding of Hodor is deepening. I, too, feel that I am starting to give Hodor an emotional texture that's been absent in any previous portrayal of him. It's what I've wanted to do from the outset—to move Hodor away from the lumbering half-wit that people assume he is.

"You think it works?" I ask again, just to make sure.

"Yeah, I really think it works," David repeats. "Let's give it one more take . . .

"Sound, picture . . . and go."

CHAPTER 15

ON THE RUN

As I grow into my own skin, life seems to be getting harder. I hadn't predicted this at all. Developing from the uncomfortable, awkward child that I was into the person I want to be is a far more jagged and unsteady journey than I could have imagined. It's 2004 and I am twenty-nine years old.

Now I don't feel that I can ever shed Revvlon. In fact, I cling on to her by my fingernails for dear life. She is the only barrier I have between me and the outside world, but I've come to understand that it's crepe-paper thin. Up onstage in drag, I feel invincible. Behind the decks at Kremlin, I can shake a dance floor all night. But every step I take towards becoming Kristian feels painful—my emotions burn like a comet ball of fire all of the time.

To stop this feeling, I am running faster and faster, working more and more. I'm working insane hours to blot out everything, to not feel anything. I've gone from playing once a week at Kremlin to taking every DJ

149

shift offered to me. For those few hours when I'm performing, when I'm completely in control, when I'm good at what I do, it feels like the perfect escape. And at £60 per set, I need all the money I can get.

Every Thursday, I go to Mixmaster Records—a music shop in Queen Street in Belfast. It's an underground emporium where Belfast's magic circle of DJs gather and exchange notes on the latest dance tracks.

DJ Roddy is the music buyer there and the assistants also know the tastes of every DJ in every club throughout the city.

"Have you heard this, Kristian? You'll love it," they tell me. Before hanging out there, I'd never heard of Greek DJ Danny Tenaglia or DJ Sasha.

They feed our habits. As well as my two folders of CDs, I've added two boxes of vinyl, which will soon expand to three. Each week I exit bleary-eyed from the basement into the daylight clutching a £100 stack of records.

But those moments of routine hide a different story. In between shifts, that's where my stability ends. I'm rent-hopping: moving from flat to flat, leaving behind a minefield of arrears, praying hard that no one hunts me down and demands back their lost earnings. I never did pay back my loan from the Ulster Bank. As for the designer friend of a friend who made my costumes for the Alternative Miss Ireland competition, she came round and asked for them back. Honestly, I don't blame her. I still feel so ashamed. And in between flats I'm sofa-surfing with friends, some of whom I've met at Kremlin. There's a handful of people there I'd call close friends, but my friend Jim is probably my closest. He always talks about the day we met.

"All I heard was thump, thump, thump," he laughs.

"Yeah, all right, Jim." I roll my eyes.

"I was convinced it was the tyrannosaurus from *Jurassic Park*," he continues.

Jim had been upstairs at Kremlin when he heard me climb the stairs in my wedge heels. My thick black eyeliner was smudged way down my cheeks—Christina Aguilera meets the exorcist.

"Want to play bingo?" I'd asked.

Once a week between 10 p.m. and 11 p.m. Kremlin runs a bingo night, with yours truly as its most unenthusiastic host. I give the same surly delivery that the crowd has come to expect from Revvlon: "88—two fat who gives a fuck . . . " That kind of call makes everybody cheer.

"I thought I must be dreaming," Jim says incredulously whenever he's telling his story. "A gigantic drag queen turning up and asking me if I wanted to play bingo? As if we were ever going to be friends!" But from then on, Jim and I are the best of friends. At eighteen years old, he's working as a glass collector at Kremlin, but he's like my nerdy little brother: eight years younger, short, dark-haired, and dependable. Jim looks up to me, but more than that he looks out for me. He seems to intuitively understand that I need both.

As well as DJing at Kremlin, I've also joined a band called Daddy's Little Princess. It's fronted by the Dublin drag queen Veda, who I met through Panti Bliss. Veda is as avant-garde as I am but far more demure—David Bowie to my Chili Peppers' Flea. She's been a previous winner of Alternative Miss Ireland as Miss Veda Beaux Reves, but Daddy's Little Princess is a grungy, punky rock band. I first saw them play support for the Scissor Sisters at Limelight in Belfast and I remember thinking then what a cool motherfucker Veda is: elegantly tall with a black bob, lashings of attitude, and a full-bellied voice that flows like caramel. And while my Mum is at home chained to a sewing machine with a bobbin and thread and a meter of PVC crafting my outfits, Veda's clothes are always custom made by some artisan designer she's plucked from her Rolodex.

I'd love to be part of that, I remember thinking as I watched the band perform. But at the start of this year, I didn't have the balls. Six months later Veda needed a bass player and heard that I play lead guitar. Bass is a different beast of an instrument, but I could make the transition easily.

"Want to start rehearsing with us?" she'd asked.

I said yes without a second thought.

The band is Dublin-based, though, so this means traveling back and forth across the border at weekends. We rehearse all day before I head

back to work at Kremlin, playing until the early hours of the morning. I'm dog-tired, running on empty most of the time, but I have to keep moving.

Nights at Kremlin have gotten wilder. I've graduated to being the venue's best DJ, bringing in the biggest crowds. Usually, I'm lost in my cocoon of sound. I focus on the music and I love to see bodies rising and falling on the dance floor, like a pulsating jigsaw. But I'm so lost in the moment that one night I don't even notice what's happening until a shoe is lobbed straight at my head. A horrible cheap stiletto ricochets off my face and lands in the DJ booth. It hits the spinning vinyl, which screeches to a halt.

"Whoa!" I shout. In that split second the wall that I've created between Revvlon and Kristian takes an almighty tumble. It's far less solid than I think, and I'm catapulted back to defense mode. *That's aimed at me*, I think. *Fuck. Get back in your box, Kristian.* I've gotten away with being accepted here for too long. Loved, even. Kremlin is my safe place, but something was always going to shatter that—it was never a question of if, only a question of when.

When I look up, though, it turns out the commotion is far bigger than me. There's a riot going on. Management has made the mistake of letting in a private party of girls fresh from their high school prom. They've brought their boyfriends with them and there's a tangled mass of ball gowns and tuxedos writhing around in Red Square. As the carnage unfolds, bar stools fly like a scene from the Wild West. Some of the rabble have jumped behind the bar and they're drinking straight from the beer pumps. It's not funny, but at the same time it's hilariously funny. *Holy crap*, I think. *Please don't let me die in a black PVC trench coat, full makeup, and a blond wig.*

The madness lasts until we hear police sirens aboveground and a swarm of officers enter the building. By now, I've rescued my CDs and vinyl from the DJ booth and stashed them in the back office for safe-keeping. I've also grabbed a candelabra, closed the door, and barricaded myself in with a handful of bar staff, who are terrified. But I'm also so

angry at my set being interrupted that I threaten to bust out brandishing my weapon like Brigitte Nielsen in *Red Sonja*. Probably for the best, but the manager persuades me that going on the rampage is not a good idea. Instead, after a while we creep out and watch as the last dregs of the club are finally cleared. At the exit some of the rioters are flaunting their spoils of war. One is carrying the cash register above his head, ripped from the bar. Another is waving a stool. Later, we hear the orgy of destruction has continued onward throughout Belfast city center.

—

THE CHAOS OF NIGHTS LIKE THAT MAKES IT MORE DIFFICULT when it comes to persuading Kremlin's management to run an all-nighter. But I, alongside my friend Graham, am determined. Graham doesn't work at Kremlin. Instead, he sells and installs gig equipment like smoke machines and stages. He's the guy you'll find forty feet high in the air scaling a lighting rig with the ease of a child on a climbing frame. We've tried for months to get it off the ground. No clubs in Belfast run legal all-nighters, but in the early 2000s the house music scene is exploding. As my DJ sets are already pulling in hundreds, Graham and I are convinced we can attract even more devotees. Kremlin is also the only club in the city to hold a twenty-four-hour license.

I feel consumed by the idea. It's all part of the treadmill I've placed myself on, which is hardcore. I can't see it, but there's a part of me that's spiraling out of control. The more I take on, the less conscious I am of what I'm doing or why I'm even doing it. All I know is that I have a new appetite for getting out of my head. Total oblivion. Music has always done that for me but now it's not enough. Now cocaine hits that spot.

Until the age of twenty-eight I've never taken drugs. I've never even smoked a spliff, never had the inclination. But cocaine is different. I *love* cocaine. Whether or not I *like* it is a different question: it gives me mad heart palpitations and white-knuckle anxiety. But I love that line after line feels like a grenade detonating in my head. *Boom!* And I feel lucky,

too. Really lucky. The person I'm in love with, the person who's introduced me to cocaine, also loves taking it with me.

He's a guy called Liam. We met at Mixmaster one Thursday afternoon. We got chatting and one thing led to another. And when I think about it, he's only the second person I've ever been in love with. Random one-nighters? Loads. Hopeless crushes? Countless. But properly in love? Happens rarely. Lee, the first guy I fell in love with, I met at Kremlin, but I know now that I was wearing the thickest rose-tinted specs on the planet. At first, he refused to let me pay for anything, which made me feel special. But I soon found out he was the dodgiest person—bouncing checks like basketballs. After a couple of months, I woke up and realized it was all a front, but I will admit to being a bit heartbroken.

On the other hand, Liam and I have a lot in common. He's a DJ like me. He's tall and blond. He never says it, but I believe he does love me for me, which means he loves everything about me, including my physicality. I'm flattered in an innocent, childlike way. *Me? Attractive? Wow. Someone likes me. Someone thinks I'm attractive.*

But there's something about Liam that's also unreachable. I have to work hard for his attention, which only makes me want him more. I'm hooked on that candy. I've noticed that if someone likes me back too quickly, I'll push them away. It's as if I'm disappointed that it's all been too easy. But Liam isn't like that. He's far more distant, more aloof. Getting out of our heads together is one way that I can feel closer to him.

At the moment I'm living in a rented house which I share on and off with Jim, but Liam comes over a lot. He spends money like it's going out of fashion, so there's always drugs at home. I'm snorting so much coke that when I lift my head off the pillow, usually past midday, it's still encrusted into the cotton like cardboard. This only gets worse when, back at Kremlin, Graham and I finally get our all-nighter off the ground.

We call it Event Horizon after the 1990s sci-fi film, which we adore. We're excited that Kremlin has agreed, but in the lead-up to our launch night, we're paralyzed by fear. We've boasted that we'll fill the dance

floor twice over but as the night draws closer, we panic that no one is going to turn up, like the paranoia of organizing a birthday party you'll end up sitting at alone. So we go all out to sell it. Brightly colored flyers and posters flood the city, the design of which shouts "amphetamine high" from the rafters: The *E* in Event Horizon is shaped like a giant smiley-faced ecstasy tab.

And our efforts pay off because after that first night, we're the talk of Belfast. When we pull open the front doors and peer nervously around the corner, the queue for Kremlin lines Donegall Street. *Thank fuck*, we exhale. And when everyone piles in, there isn't riot-like chaos. Instead, we realize we've brought together the most discerning group of hedonistic house heads you could ever wish for under one roof. Ravers who understand the music, who understand us.

For Graham and me, it feels like one big dream—a psychedelic carpet rolled out for our guests to trip down. We share the love. For the first time, I also dress as Kristian. When it comes to a serious music night, I want a separation between Revvlon and me. Now I wear my amphetamine high as my shield. And when the music ends and we step out after 6 a.m., there are bodies littering the street like survivors from *Dawn of the Dead*. "We've done something brilliant here," we congratulate one another before heading home, and all I can feel is warmth and satisfaction spreading through me.

From then on, I play my usual slots of 10 p.m. until 3 a.m. as Revvlon, take a break, and then DJ in my own name right through until 6 a.m. In this life I barely see sunlight. In fact, it hurts my eyes. But that's okay because I'm loving it. Really loving it. The Wurlitzer spins me from bed to cocaine, sometimes to ecstasy, to the DJ booth and back again. And on a weekend, Liam often drives me to Dublin to rehearse with Daddy's Little Princess before I return to play an all-nighter and start on the week's treadmill once again.

I've spread my wings and traveled, too: I've been a guest DJ at Dublin's newly opened SEX club, I've played at Heaven in London, Poptastic in Manchester, and at Birmingham's DV8. Mainly, though, I'm at Kremlin.

As soon as I'm paid, which is always cash in hand, there's a plentiful supply of drugs. I'm a monster. I go hard on whatever I can get my hands on. Not long ago I hoofed half a kilo of coke up my nose. Half a fucking kilo. Liam couldn't believe it, especially as he'd bought it—thousands of pounds' worth of white powder delivered to the door in a shoebox. But Liam made the big mistake of going out and leaving me to make friends with it. By the time he came back, I'd almost plowed through the whole lot.

"What the fuck?" he was shouting.

It took a while for his boiling rage to turn to concern.

"Kristian, how are you not dead?"

I don't have an answer to that question. I'm drinking heavily, too. I'm drinking like I've never drunk before. At Event Horizon we serve up Red Bull with wings—energy drinks laced with vodka, which I neck shot after shot to keep me upright. On one night I made my way through as many as thirty lined up around the DJ booth. Most mornings, when I eventually get home I use the same industrial-strength codeine painkillers that I've taken ever since I worked at the BT call center. Codeine feels like a soft-blanket soother. It's the only drug that can bring me down and stop my nerves from jangling. I buy them over the counter but I have to make a special request, so I work my way around several pharmacies before I land back at the first. That way no one suspects I have a problem.

All of this makes sharing a house with Jim strained, so he comes and goes. As far as drugs are concerned, Jim disapproves. When I surface from binges, he has to watch as I sit at the kitchen table with coke snot down my cheek and a face like war.

"Jesus, Kristian . . . the state of you," he says when I refuse a cup of tea, all the time wanting to disappear to my room and do a line the size of a road marking.

When it comes to housework, we both share the same chaotic energy, which means we argue. Together, we're slobs. Zero cleaning gets done, which becomes the focus of many fallouts, even though there's a far bigger problem at play that I can't see. Not long ago he and I fashioned

hazmat suits from black plastic garbage bags and gaffer tape to tackle a fly infestation that had engulfed the kitchen. We each armed ourselves with two cans of fly spray and decimated clouds of insects. And when we finally located the problem, we traced it to a bag of decaying potatoes that had fallen down the side of a kitchen cabinet.

Our filthy living habits aside, Jim tells me more and more that he's worried about me and that I'm going too far.

"Kristian, you have a problem," he says.

"I'm fine," I tell him. "I don't have a problem." And I don't have a problem. I'm loving my life. I'm doing everything I've ever wanted to do. I'm a DJ, I'm playing guitar in a band—all my boyhood fantasies right there. And I'm with someone I love. And it doesn't matter that I don't always feel that Liam loves me back because it's perfect. He's perfect, even if I'm not.

—

MONTHS GO BY AND MY HABIT SPIRALS FURTHER. DADDY'S Little Princess support Scissor Sisters again both in Dublin and in Belfast, this time with me up onstage. The rush of playing to an arena of thousands feels amazing and overwhelming—a stratospheric high—but behind the scenes I've barely been able to make rehearsals. Not long after, the band falls apart.

Even Mum is worried about me. Granda passed away not long ago and she's still living with Nan in Lisburn, although Nan is very frail now. When I go home for Sunday lunch one weekend, I make the mistake of asking her to grab my wallet from my bag in the kitchen, and when she does, she accidentally pulls out a bag of white powder.

"What's this?" she asks.

"Erm . . . it's cocaine, Mum," I admit. I feel a hot flush of embarrassment, but I know there's no point in lying to Mum. She'll find out soon enough.

"Are you being careful?" she asks concernedly.

"Of course, Mum," I lie.

"Don't forget who you are, Kristian. Don't get lost in this world," Mum warns.

But I'm so lost that when she goes on to ask me how I even take cocaine, I say: "I'll show you." I bring out a £5 note from my wallet, roll it, cut out a line on top of a CD case, and snort it right in front of her.

"I'm shocked, Kristian," she says.

"It's fine, Mum. Honestly," I reply.

Yet in my heart I know it's not fine. I'm a proud person. Missing band rehearsals, missing life—it's not the person I am or the person I want to be. I want to be that boy playing guitar in his bedroom and loving every minute of it. *You've come too far to destroy this*, I think in my more lucid moments.

Tied up in all of this is Liam, too. For months I've been wanting him to tell me that he loves me, to commit to something more than the casual drug-fueled relationship that we have. But he won't. Even Mum says that my obsession with him is sapping the life force from me, that I'm not myself when I'm around him. It's as if I've disappeared in him. And when our relationship ends, I'm devastated. I've been chasing him like a puppy dog, thinking he was aloof, but all this time he's been with someone else.

"I'm sorry, Kristian," he says. "We're moving in together."

Now that I know the truth, that this love was always unrequited, I find it hard to accept and I feel myself falling further.

That week I go out with friends, and at the end of an evening a taxi drops me home. I've taken God knows how much coke and a fair helping of ecstasy in some random toilet somewhere I don't even remember. As I stumble through the front door, I turn to walk down the hallway. Suddenly, my heart jumps from my chest. I'm not alone.

"Hello?" I call out, but there's no answer, just an eerie silence.

"Jim? Are you in?" I shout, but there's no reply.

I can't quite make out who this person is, but there's someone at the other end of the hallway walking towards me. When I stop dead, so does he. When I thud forward unsteadily on my feet, so does he. And then I

realize . . . it's my own reflection in the mirror on the wall at the far end. As I move closer, I peer in. It's so absurd I'm almost laughing. My eyes are dark and wide. My teeth are grinding. I'm chewing on the skin on the insides of my cheeks. My nose is caked in white powder and my gums are so numb there's saliva dribbling down my chin. I barely recognize myself. I'm not Kristian. I'm not even Revvlon. There's nothing of me, just debris of the person I want to be. I'm a mess. I'm gone.

THE DOPPELGÄNGER

"HI." THE GUY IN FRONT OF ME IS HOLDING OUT HIS HAND to shake. I have no desire to shake his, but he gives me a hearty smile and I force myself.

"This is Brian," one of the assistant directors introduces us. We are on location an hour south of Belfast in County Down.

"Good to meet you, Brian," I say through a tight smile.

"Likewise . . . " he grins.

There's an uncomfortable silence. I can't believe Brian is wearing my Hodor costume. A simmering anger rises in me.

"Weird meeting yourself," I continue, trying to make light of the awkward situation we find ourselves in.

"Haha, yes." Brian gives another hearty smile.

I'm taller than Brian but only by a fraction. Of all the places in all the world, he hails from Ballymena—ten miles up the road from Lisburn.

"So, Brian's going to be your permanent body double from now on," the assistant director continues.

"Great," I say. I cannot think of anything I could wish for less. It's July 2012 and we're due to start filming on season 3 of *Game of Thrones*. I've returned from the break refreshed. Finally, I've found my feet here, I'm inhabiting Hodor with far more confidence, and now this. I've come to expect curveballs in this job, but with Brian I'm completely thrown. The look of him sends me into a white-hot panic, the kind I used to get when I was made to play rugby at high school. I hate squaring up to rivals when I feel this unsure, so Brian feels like my worst torment.

Body doubles are not a new thing on *Game of Thrones*. All actors have them but until now mine have been more makeshift. During previous seasons, whenever a shot was being planned or the light reading needed taken, someone would usually stand on a box and pretend to be me. It saved the crew the bother of fetching me from my trailer every time. And there was one man on standby for action shots, but he was rarely called upon. Besides, he didn't bear much resemblance to me. Not like Brian does. Aside from his lank brown hair, Brian matches me inch for inch.

I've been told he is now a necessity because of the change in storyline. After the sacking of Winterfell, Isaac, Rickon, Osha, and I will be on the run for the duration of the season, heading northwards towards the Wall. There's going to be a lot more carrying of Isaac, not in the harness but in a cart across rough, open ground. It's not a lovely shiny wheelbarrow either. This cart looks like it's been hammered together with rusty nails and wood as heavy as railroad ties. Its wheels are rickety beyond belief.

"It's going to be very hard going, Kristian," the assistant director says. Amazing that it's only now that health and safety's ears have pricked up and decided that no one—not even me—should endure a constant strain on their back. So, enter Brian—the unwanted superhero.

"Is Brian your secret love child?" I joke to Mum when she calls me on the day he and I meet. Apparently, the casting director scoured the

world for a person of my exact height and build. From LA to Moscow, they found no one until they stumbled on Brian from bloody Ballymena, which makes me think Mum has had an affair with the milkman. Brian is only a little younger than me.

"Ballymena?" Mum laughs. "You'd think we'd know him."

In fact, it's a mystery how neither of us have bumped into Brian before. He's been living in Florida for the last year or so, but in Northern Ireland Brian worked as a parking warden for years. At night, he transformed into a wrestler. Once he went by the name of Tron, but now he's renamed himself the Northern Irish Nightmare and is training for WWE stardom.

"I'm just going to have to get over it," I tell Mum, attempting to brush it off.

Isaac has a body double, too. Surprisingly, she's a woman called Samantha. In real life, she's around twenty-one years old and training to be a veterinary surgeon. But she's tiny—Isaac's exact twelve-year-old height. People often confuse Isaac for a girl anyhow, given his elfin features and long hair, which he's had to grow for the series. He despises it and this season he's staged a mini rebellion. In the break, he's cut it short, and no one is happy. So as not to ruin the continuity, he's had to have a wig made. Secretly, I'm proud of his defiant gesture because I understand it completely. At the end of seasons 1 and 2, the first thing I did was go out and have my hair dyed a crazy color—a kind of liberation ritual. Hodor's salt-and-pepper flecks aren't *me* at all. And I couldn't wait to grow out Hodor's crew cut for a few months before filming resumed.

FOR THE NEXT FEW DAYS WE'LL BE LOCATED IN THE MOURNE Mountains, a stunning wilderness on the border between north and south. Here, the sudden shift in weather can be formidable. As we decamp before filming, storm clouds take on a menacing shape over the granite range. The wind is fierce. And on our first day, we climb for half

an hour up the mountainside so we can shoot a scene of our group making its way down a dirt track. While many of the crew and props are transported by quads and trailers, the cast must walk.

"Is anyone headed up there?" I hover around beforehand, dropping a *very* unsubtle hint that I'd like a lift, but it's met with a shake of heads. Only designated people can travel by vehicle. Insurance purposes, apparently.

If my back wasn't already in shreds from carrying Isaac, it's ten times worse now. In between seasons I DJed an all-nighter at Kremlin, then drove to an audition for an upcoming sci-fi film called *Our Robot Overlords*, scenes of which are to be filmed in Northern Ireland next year. A mile or so from home I fell asleep at the wheel and veered into a farmer's field. When I came to, a telegraph pole had smashed through the windscreen and narrowly missed my shoulder. Heaving it off pulled muscles that I didn't know existed. I know I'm lucky to be alive. But that was no consolation to the farmer who, to add insult to injury, charged me £45 for damage to his crop of carrots.

The incident has made me take stock of my life, though. I was disappointed I didn't get the part in *Our Robot Overlords*, but the fact that I went to an audition, and I *really* cared about it, tells me that I'm invested in my newfound career in a way I haven't felt before. Whereas previously I've juggled—often DJing at Kremlin until 3 a.m. before arriving on set at 5 a.m.—I've given up my residency there. It's been a tough decision, but I know I have my DJ career to fall back on. For now, I need to concentrate on *Game of Thrones*. I'm in for the duration of season 3 without getting "the Call," so a fourth season looks likely. I also have a new, more permanent manager called Guy who runs an agency called Coalition Presents. We got introduced through a DJ contact, and through his representation I've been upgraded on the show to be paid as a season regular. For me, it's another sign that I've been accepted—someone somewhere must like my work.

This season, however, I notice other anxieties creeping in. It won't be long before Isaac turns thirteen. Whenever we've met off set I can hear his voice breaking. He's growing up. *Will a teenager want to climb over me?*

I worry. *Or launch himself at me and give me a big squeeze?* For the first time I feel like a parent at the school gates mourning the day your child is too embarrassed to hug you. I've realized that maybe I need Isaac more than he needs me. I've come to rely on him as my human compass. Thankfully, those anxieties are quickly erased.

"Kristian!" Isaac takes a run and jump. I love that he remains exactly the same.

This season I know I'm going to need that because we are going to have to dig deep. As much as my heart craves the windswept scenery of my homeland, being out in it feels grueling. The trek up the mountainside in full costume is made worse by Brian, who manages it effortlessly. Whenever he's next to me, I feel myself stretching up, trying to get some height on him. *You're on my turf now, pal,* I'm saying. But in a weird way, it's life-affirming: it's the precise opposite of what I've done for most of my life, unless I'm dressed as Revvlon. Of course, it's designed to put Brian in his place, but it does tell me how far I've come. Maybe for the first time, I'm owning my difference.

We're also joined this season by the characters Jojen Reed, played by Thomas Brodie-Sangster, and his sister Meera, played by Ellie Kendrick. I've only ever seen Thomas as Sam in the hit film *Love Actually*, so it feels surreal to be acting alongside him. Both Thomas and Ellie seem lovely, though, and I'm also drawn to this season's storyline. Our time together will build on the already mystical journey Bran, Osha, and I are taking through Westeros. Hodor feels more real and more special to me than he's ever done. Kristian, on the other hand, will have some unforeseen challenges to overcome.

First is the frustration of having to maneuver the tarpaulin of our camp tent, which flaps violently in the wind. It's obvious that I'm no Boy Scout, nor are we given any campsite training. On our first day we film a scene in the morning's early light, and when the sun's rays hit the hillside, I do take a moment to bask in it. *Wow.* The Mourne Mountains take on the character of the African savanna—rich, golden, and misty— even though the gusts of wind are icy cold and there are several instances

off camera when I am left wrestling with the thick tent material, which almost whips my head off.

Out of the corner of my eye, there's also the sight of two assistant directors galloping around the clearing enveloped in gray sacks, with their sticks and tennis balls mirroring the shape of the dire wolves. At this, I still can't stop giggling whenever I see it. Today, though, it's my costume and the cart that become the most bothersome.

Up until now Brian hasn't had much work to do, but as we move on to filming the traveling scene in the afternoon, I start to reluctantly accept why Brian is here. The cart isn't only heavy, it's *really* awkward. I need to drag it behind me with Isaac stretched out in it like a little lord under his fur throws. I can't help feeling irked that he can lie back while I do all the work.

"Who do you think I am, route-master Nairn?" I joke while he feigns a smug look.

Isaac also teases me. "Hodor, I've lost the use of my arms! Can you fetch me a drink?" he'll ask when we're not filming.

"I will not, you cheeky wee fucker!" has become my stock response, which makes Isaac giggle.

My Italian leather shoes are also far too flimsy for the rubble path, and I feel every stone pierce the sole. Added to this is the discomfort of my under-tunic breeches. Since the end of season 2 I've been begging the costume department to sew them up. They've had so much wear and tear that the seam along my inner thighs has all but disintegrated. We've been handed "on-location" thermals, but I've not brought mine because I'm constantly overheating. Instead, I'm wearing thin cotton boxer shorts. But it becomes quickly apparent that I've made a grave miscalculation. *Keep your mind on the cart, Kristian,* I keep telling myself. *Do not say a word in front of Brian. Do not show any weakness.* But the cart is almost impossible to maneuver with my back about to break and my balls slapping against my upper thighs. Furthermore, the temperature has taken a nosedive.

The scene takes some hours, and we film well into the evening light. Every time we retake, some poor crew member has to wheel the cart

back up the mountainside. Halfway through, I am forced to abandon all hubris. Now I'm secretly begging for Brian to step in.

"Okay, for the next takes we just need back and shoulder shots. Take a break, Kristian. Brian, if you can stand in for these," the director finally says.

Thank fuck for that.

But then, I notice another uglier feeling taking over. I find myself watching Brian closely as he trudges up and down the path. *Dammit*, I think. Brian is quite good at my Hodor lurch. In fact, he's a pretty adept mimic. I notice, too, that he's super keen: very friendly to the director and the surrounding crew and also very accommodating of whatever's asked of him.

If I am to pick fault with Brian—and I *really, really* want to pick fault with Brian—it would be the shape and color of Brian's wig. To make it, the special effects department have faced a challenge. Apparently, gray hair has undertones and pigments that are incredibly hard to replicate with human hair. Somehow, they've managed a close-enough version but it's definitely not Hodor. *Brian is definitely not Hodor*, I keep repeating in my head.

There's another voice that's trying to be more reasonable, though. If Brian and I are going to work together, I'm going to have to untangle these conflicting emotions. I'm going to need Brian's help, even if today he feels like an unmanageable threat. I need some reassurance, and in a moment of naked insecurity I approach one of the producers.

"Should I be worried?" I whisper in his ear. I make sure my tone sounds jokey even though inside I know I'm deadly serious.

"What do you mean, Kristian?"

"About Brian. Is he going to take my place on the show?"

The producer laughs. "Is that really what you think?"

"Yes," I say, although now that I've said it, I don't feel good admitting it.

"You've nothing to worry about, Kristian, Brian's a great extra. But you're Hodor," he says.

It takes a while for that comment to sink in, and it's still running around my head as we wrap up for the day. Maybe meeting myself isn't so bad. Deep down, it doesn't change the person I've worked hard to become. It makes me think that I should have more faith in myself, not succumb to being so easily knocked off course by the slightest hurdle. *It's my problem, not his*, I think. On the way to our night stop, I make a promise to myself that from now on I'm going to make friends with Brian. After all, he's there to help me and to do a job, and he's doing that job well.

—

THAT EVENING WE STAY IN A HOTEL IN WARRENPOINT, A SMALL port town at the head of Carlingford Lough, which sits in the shadow of the Mourne Mountains. I eat dinner with Helen and Isaac before crashing out briefly on my bed. It's been a long day, and we are all exhausted. I'm still fully clothed, just closing my eyes, when my phone pings. It's Isaac.

"Want to come on an adventure?" he says.

I'm not sure I do. There's light rain drizzling against the window and I'm ready to descend into a deep sleep. But if Isaac wants an adventure, I don't want to let him down.

"Have you asked your Mum?" I check.

"Yes, so long as you're with me," he replies.

When we meet at the front entrance of the hotel, we can see the outline of the mountains lit by a last gasp of sunset and the rising moon. In the distance there's the sound of waves tumbling over the breakers. As we start to walk, I can feel my clothes getting soaked by the rain, but for the first time that day it really doesn't matter. Isaac and I walk and talk and take moments to look out across the lough and breathe in the thick air.

"You always talk about your mum, but do you know your dad at all?" Isaac asks. It's an innocent question, but it momentarily pricks me.

"No, he's only ever seen me once and I was too young to remember," I reply, shrugging.

"Would you have liked a brother?" Isaac continues with his inquiries, which are curious questions, but strangely penetrating.

"I don't know. It's only ever been me, so I guess I've always been a mummy's boy," I admit.

"Me too," Isaac replies. "Mum says it's because I'm an only child like you."

Somehow, I do see parts of myself in Isaac. It's all the vulnerable parts, and I want to nurture and protect him in a way that no man has ever done for me. But he's lucky. He has his stepdad, Tim, who's a lovely man, and Helen, who's a wonderful guiding force just like my mum. And I think what an amazing opportunity he's having, finding out who he is and who he wants to be without barriers. Half of me envies him that, but the other half enjoys that he has so much freedom to explore. And Isaac is *so* free—he's free with his questions, he's free with his mind, and he's free with his affection.

When we eventually reach the harbor wall, the storm has picked up. We both agree we're magnetically drawn to it. We sit with our legs dangling over the wall for around an hour, looking out at the black water glistening and the raw power of the surf as it crashes against the concrete. It's vital and primal and we both feel alive. We talk about growing up, what music Isaac is listening to now, and how we're glad we've found each other on *Game of Thrones*. We've never said it outright before, although both of us know it's an unspoken fact.

"Will we be friends after *Game of Thrones*?" Isaac asks.

"Absolutely," I say.

After a while, I look at my watch. It's almost 11 p.m. and we both have an early start tomorrow: another day of freezing my balls off on a blustery Mourne mountainside while Isaac lies down a lot.

"Probably time I get you back to your mum," I say.

"Awwww," Isaac moans in the same way he does whenever he's yanked off set to do his schoolwork. As we head back towards the hotel, my heart is filled with love.

BALLYHORNAN

THE BUNGALOW I'VE RENTED SITS ON THE EDGE OF THE BEACH. Inland, I can look over to the peaks and ridges of the Mourne Mountains. Out to sea, the sand sparkles and there's little between me and England other than miles of turquoise water. It's 2005 and I am thirty years old.

I'm here, in a tiny village called Ballyhornan in County Down. I've escaped from Belfast. I needed to. Over the last year my drug habit has become so extreme it's dangerous, so I truly think my life depends on it.

Not long ago I bought a car—a bright blue VW Beetle with a camp pink daisy on the dashboard. I packed it with as many of my belongings as I could fit in, and I've driven south to an old army chalet one hundred meters from the coast. Whenever I glance at the pink daisy it makes me smile. My life has been too dark and lately I hit an abyss.

So much for facing the terrifying sight of my own strung-out reflection in the mirror. That didn't move me into pumping the brakes one jot. The next morning, I got up and put my foot straight back on the accelerator.

Then I did the thing that most cokeheads do at some point. I moved on to ketamine. It wasn't intentional—purely accidental, in fact. I was searching through the house for something—anything—to snort when I found a bag of white powder. As cocaine and ketamine look identical, I worked my way through it and very nearly died.

Those twenty-four hours are still so fresh in my mind, it gives me sweats just thinking about it. I lay in bed, my heart beating furiously, gasping for breath, my body melting like hot mercury. I was calling out to Jim thinking he was in his room, only I wasn't calling at all. I couldn't get any of my words out.

"Help me," I was mouthing but there was no sound.

What happened next, I don't remember, but I must have reached for the codeine tablets on my bedside cabinet. All I know is that however many hours later, when I finally forced my eyelids open, the foil packaging had been blistered over and over and there were no pills in sight. *Holy shit*. And beside that there were three notes, handwritten in my spidery scrawl.

> *Dear Mum,*
> *I'm sorry. I'm too tired to get to the hospital. I've taken too much codeine, and I haven't made it. I don't have the energy to save myself, so if you find this letter and I'm dead, I'm sorry. You need to know that I didn't kill myself. It's an accident. You're the best Mum I could have wished for and my best friend. If you are reading this then I'm sorry. I'm really, really sorry.*
>
> *Love, Kristian*

The second letter was written to Jim: "Sorry if you've had to find me dead. You've been a great friend." The third was written to Liam: "Sorry my heart got broken." I am filled with so many sorries. But seeing them stark on the page sent a sharp pain through me. Tears spilled from my

eyes. I don't want Mum or Jim or anyone to find me dead, so I have to find a way to live—not with the superficial bravado of Revvlon, but with a real confidence that's Kristian's. So I'm here, trying to work out how.

Probably a doctor would have recommended that I book myself into rehab, but as is my will, I've crafted my own insane plan. The week after I woke to find the letters, I locked myself in my room and drank nothing but water. The sheer agony of going cold turkey felt cathartic in its masochism. And here, I've isolated myself from everything and anything that might pull me back. Mostly, I've cut off all contact with Liam.

On the drive to Ballyhornan, one other thing made me smile. As well as my car with the pink daisy on the dashboard, I've bought a little dog and named him Hannibal. On the journey he sat on the passenger seat and stared up at me with his small, dark eyes. He's a Maltese breed—a tiny ball of bright white fur. Whenever I look at him, my heart swells.

At first when I told Mum my plan, she warned that I shouldn't get a dog. "Don't do it, Kristian," she said. "You can barely look after yourself at the moment." It's a fair point, but when she turned up at my house and I stood on the roadside and held him up to her through the car window, she crumbled.

"Jesus, he's so cute!" she cried.

And Nan, who never lets dogs in the house, has also buckled.

"He can come in," she said when I took him to meet her. That afternoon he surpassed himself by disappearing off and shitting on her bed. I tensed, waiting for the thermonuclear meltdown, but there wasn't one. Nan just tittered: "I think Hannibal has left me a wee present."

Hannibal doesn't know it, but he's been enlisted as my guardian angel—my anchor. I had the same when I was growing up in Lisburn and I need it more than ever now. Back then, we kept a German shepherd called Major. He was the most loyal friend I could have wished for. Apparently, he used to stand guard by my pram if Mum ever took me out, and attack anyone who came close. But I only remember him as a gentle giant with the softest brown and black fur and the widest, pinkest tongue that slathered your face.

Hannibal, on the other hand, is mischievous. He keeps me on my toes. He has crooked teeth and an underbite that makes him look like an old man with ill-fitting dentures. But he's playful like a mini trampoline. I've made a promise to him that every day I'm going to take him walking across the bay: up early when the tide is at its lowest. But who am I kidding? It hasn't happened yet and as Hannibal has shown little interest in going outside, I've launched myself into another habit that I'm convinced might also save me.

I've brought with me my PC and I'm plugged into *World of Warcraft*. I could play from dawn till dusk. I've always played computer games, graduating from *Pac-Man* when I was a boy (a game I had to wrestle from Mum, who got hooked on it, too), but *World of Warcraft* taps into the escapism that I love the most. Making my way through the fantasy world of Azeroth, I'm never focused on the destination, only what I can learn from the journey. And I love the *World of Warcraft* journey.

At first, I play solo, but it doesn't take long for me to want to interact with others. As much as I'm enjoying the peace of Ballyhornan, at times I also crave company. When we shared a house together, I introduced Jim to previous incarnations of the game, so he often logs in from Belfast and plays in my team. In the opposing factions of Alliance and Horde, I always choose Horde—the dark side. I never want to be a human-looking avatar either—who the hell wants to plug in and look like an accountant? Instead, I'm a werewolf or a blood elf priest or a demon hunter. I want rays of fire and shards of ice to leap from my fingers and destroy everything in my path. I'm a damage-doer—this alter ego, of which I think Revvlon is also a part, mostly wants to hit out at the world.

I'm also under no illusion: gaming gives me the dopamine hit that I crave. If I can't get it through drugs, then I'll find it elsewhere, but this way feels cathartic, healthy even. I'm not hurting anyone, not even myself. In fact, from a safe enough distance, I'm making new friends. One guy I talk to a lot is called Jake, who's based in Utah and is online all the time. I also have a Norwegian friend called Odd, who adores me after I helped him kill a bear in Darkshore, the long strip of coastline in the

northwest region of Azeroth called Kalimdor, contested during the War of the Thorns.

Since being here, I've come to realize that I'm the classic introverted extrovert. I love to draw energy from a crowd, but on my terms. Then, I need to retreat and recharge. At times I need to crawl back to this place of solitude and barricade myself from the outside world.

Thankfully, I've held on to my job at Kremlin. More than that, the management there has supported me. I'm in serious debt—the kind of debt that swallows you up in the blizzard of a drug haze. But I'm still their best DJ, so they've offered to help me pay off the £60,000 I owe, which feels like a mountain to climb and eats me alive whenever I think too hard about it. We've agreed that they'll put money aside each week from my wages so I can pay it in installments.

Now I have a new routine. If I want company during the day, then I'll take Hannibal with me and meet Jim or other friends for lunch or visit Mum and Nan. I'm always back at Kremlin in the evening to play my set. Then, back in Ballyhornan I'm here with Hannibal and *World of Warcraft* and the wilderness of the coastline, where the tide ebbs and flows and the clouds shape-shift every time I stare out at them.

Mum visits when she can, too. Nan is so much frailer now and Mum doesn't think it will be long until Nan joins Granda, for her sins. Mum also loves to see Hannibal, who is always at the window, jumping up and yelping whenever her car pulls up.

"My God, Kristian, he's like a little lord!" she says.

And she's not wrong. Hannibal must be the most spoiled dog on the Emerald Isle. I've bought him his very own blue velvet cushion with a leopard-skin underside, which he stretches out on if I'm playing on my PC or watching TV. But he's the kind of dog who loves attention and jumps up on your chest. And when Hannibal needs attention, he needs it right that minute—and for that I have some sympathy.

It's so remote here that every week there's a man who drives around in his van—a corner shop on wheels. He sells fruit and meat and vegetables and bread, so I put a regular order in. I feed Hannibal fresh chicken every

day, like an aristocrat. And when the mobile shop runs out of chicken, I'll find a note stuck to the door: *Sorry, chicken has been replaced with apples this week.* But apple crumble is hardly to Hannibal's taste, so I drive miles to the nearest town to get him what he's come to expect. I love that he relies on me for his care, and I love that he looks out for me, too. I can't explain it, but there's something about caring for this little dog that helps me care about myself. Slowly, I can feel the thunder passing and a lightness creeping in.

BEYOND THE WALL

As THE END OF SEASON 3 OF *GAME OF THRONES* DRAWS TO A close, I feel everything that I've been observing and learning on set over the past two years is coming to fruition. I'm a better actor than when I started out, but I also feel myself changing into a person who's more centered than I've ever felt in my entire life.

Despite my initial reticence towards Brian, we're working well as a team—in a weird way, he's become my safe parallel universe. I don't feel scared anymore to ask him for help. And I know that I'm becoming more confident because I'm openly voicing my utter horror at the things I hate the most. There's a lightness to being me.

On our last day of filming in the Mourne Mountains I am forced to lean up against a tree. It's a campfire scene and we are resting for a while, but soon after I'm positioned for the first take, I confront my worst nightmare.

"Sure," I agree enthusiastically at first, but with my back pressed up against the trunk, I make the mistake of turning around and peering in closer. The bark is alive, crawling with hundreds of spiders.

I don't care whether people think I'm a wimp or not, I've reached my limit, I think. Kristian Nairn does not do spiders. Thinking quickly, I fashion a protective suit from fly netting that's lying around on set and sit encased in the material like an oversized tea bag until the cameras are ready to roll.

"Is Kristian ready?" the director shouts.

There's a roar of laughter from the assembled crew.

"Hang on!" I shout before I jump out like a tree frog. After filming I dive back in and clamp the netting shut while the dressers prepare the set for the next take.

I'm learning more about myself, too—the sight of rabbits being skinned makes my stomach wrench. Poor Natalia has had to de-robe several while we've been on the run. The dead rabbits are real—ethically sourced, we've been reassured—and their fur pelts will also be recycled in future costumes. Little comfort, though, when their thin skins are slow roasting on an open fire, stinking the glade out with their earthy aroma.

I can only bow down to Natalia's iron constitution. Scenes like that mess with my appetite (I now have several tattoos of rabbits because I love them so much—that stems from a childhood love of the film *Watership Down*), but she can happily skewer several in the morning and still order up her daily mountain of sausages from the canteen at lunchtime. Natalia *loves* sausages.

As for campfire food, don't even get me started. On every take, I've had to shovel in freezing-cold potatoes, rice, and peas. It tastes disgusting and I cannot swallow it for fear of vomiting, so I play with it in my mouth, desperate for someone to shout "cut" so I can finally spit a mouthful out on the grass.

More positively, I've become a Jedi master at catching a few winks of sleep. Stretch me out near an open campfire, and I'm not even acting. On several occasions I've properly nodded off. Sometimes I hear myself

snoring, but I've also developed a sixth sense. As soon as I hear my name being called, my eyes fly open.

"One more take? Sure . . . " I feign a burst of energy.

What's also made the end of this season so enjoyable is that I'm back working with my favorite director, David Nutter.

On all the episodes where he is at the helm, he hands me even more ownership of Hodor and myself. When we discuss my upcoming scenes, I wonder whether I'm being rewarded with better material to work with as the season progresses. My hope is that I've become less of a wild card and more of a trusted actor, and David is a director for whom I want to get it right.

One sequence is filmed in a quarry just outside the town of Newtownards near the banks of Strangford Lough. It's another of those places that I've spent a lifetime knowing but never really noticing, and this has become another strange dimension to working on the show. Throughout, I'm seeing my own country through a fresh lens. I've begun to appreciate the wild beauty that I've always taken for granted, and all the hidden gems so deftly sought out by the location teams. It's made me proud to be Northern Irish and to know that every season it's being shared with the world.

Outdoors, I will wheel Isaac in the cart past an abandoned mill which sits on the edge of the quarry. The day is overcast and the ground slippy, but filming is now made easier by me having to push Isaac in front rather than pull the cart from behind. Even so, I am thankful the next day when we relocate to a secondary studio based in Banbridge to film several interior scenes.

In the *Game of Thrones* story, our party has left Westeros and entered a tract of land called the Gift. We'll shelter in the mill while a storm rages around us, but as we do, Hodor will become distressed by the thunder, so much so that he threatens to reveal the party's location to a group of wildlings nearby. Hodor's crying is stopped only by Bran using his special powers—warging—to enter Hodor's mind.

Ever since that episode's final script has landed in my inbox, I've been turning it over in my head. I have another idea that I want to share with

David. As Hodor will play a more prominent role in this scene, I'm keen to make the job more challenging and interesting, but since being on the run I also feel that Bran and Hodor are connected with an intensity they've never felt before.

"David, whenever Bran is warging, his eyes turn white. To show that special link between us, maybe Hodor's eyes could do the same?" I suggest.

David's bullet-speed brain considers this for a nanosecond.

"That's a great idea, Kristian," he says.

The bonus is, I can warg for real. It's not something I'd boast on my CV, or tell David, but the upside to drug abuse and years of crazy sleepless nights is that I have been gifted a natural ability to roll my eyes into my own skull with considerable ease. Isaac's warging, on the other hand, will need to be added in at the postproduction stage.

This is also the first scene where Hodor will show real fear. To prepare for it, I've thought about how this large man would react hemmed in to a dark, confined space and hearing noises that he doesn't understand. I've imagined an innocent, defenseless child trying to break free from a straitjacket, becoming more and more distressed as the noise of the thunder and lightning edges closer. Every time the thunder roars, I'll say the name "Hodor," over and over, getting faster the more distressed I become. I've always wanted the word to be more than a name—the expression, the feeling, I've envisaged for Hodor since the outset, and although I never truly know if I've achieved that, showrunners David and Dan do tell me: "Kristian, you are Hodor. There's no one else for this role."

The moment of connection between Bran and Hodor is brief, and it takes several takes to get it right, but David's multipronged camera angles mean that we get through the scene with far less fuss—a welcome departure from recent shoots that have dragged like a slow-burning hell.

For the first time, too, I feel a real conviction about the way I've played Hodor. I notice that I'm not questioning him anymore. I also feel pleased with myself that I haven't hogged the limelight. As this is my first major scene, I've had to temper my inner drag queen. Privately, my impulse has

been to burst out in a top hat and dance under the spotlight, but I've purposefully stamped that down. I've been repeating in my head: *Be understated; be nuanced; don't overdo it.* Less is more is my new working mantra.

"Really good work," David says as we finish for the day, which gives me an added boost. I don't know yet how Hodor's story is going to unfold (I've now given up completely on even the pretense of reading George's books. Plus, everyone on set is very respectful and avoids dropping spoilers because several others have chosen not to read the books, too), but any chance I have to build Hodor's character and my skill, I'm keen.

Maybe it's because we've also been filming in the dryness of a studio, but that day I bounce off set like Bambi rather than feeling too much self-pity—that exhausted, bedraggled feeling I've only come to understand since being on the run.

—

FILMING FOR SEASON 3 FINISHES AROUND DECEMBER 2012. BY now, *Game of Thrones* isn't just a hit in the US or Brazil, where it's massive. It's made the crossover to the UK and Europe, which is both exciting and daunting.

Now it's impossible to walk down the street without hearing the name "Hodor" being shouted. At first, I'm always anxious. I've always associated being shouted at, name-calling, as something to defend myself against. But I've begun to take it in my stride. *It's a compliment*, I remind myself. Slowly, I'm giving myself permission to enjoy the series' success. Although our little team is its own outpost, the viewers' enthusiasm that seems to build with every season makes it feel as though we're part of a more transformative moment in TV, which feels unreal. I often wonder how A-listers cope. Around Belfast it's become a regular occurrence to bump into some of them hiding. Whenever I'm in Deanes restaurant, in the city center, I often see Gwen or Kit or Alfie or Richard. Venues like that have a reputation for being places where actors' privacy is respected and they're unlikely to be mobbed by autograph seekers and selfie hunters.

Between seasons, my spirits are also lifted because I secure a handful of DJ gigs in the UK and abroad. One idea that's been mooted is that I combine *Game of Thrones* and being Hodor with a DJ set—a kind of Hodor-hits-the-decks extravaganza, but it's an idea that I've shot down. As much as I want to be the yes guy, I also want to retain my integrity, especially when it comes to music. The thought of becoming a novelty act makes me cringe. Some of the recurrent comments I've read on social media, which I can't help peeking at, are that I'm an actor turned DJ—a "celebrity DJ"!

Whenever I see it, I feel irritated. *I've always been a DJ! I've never been a celebrity*, I want to scream. I'm also scared that as Hodor I'd be restricted to a set list of cheesy, gimmicky tunes: precisely the opposite of any of my DJ sets. In the end, I do the gigs, but I decide to keep my two worlds completely separate. When I DJ it's under my own name: Kristian Nairn.

I also travel to Dublin for some additional acting work. The part is a minor one: a character called Barnaby Silver, a human trafficker in a BBC production, *Ripper Street*, which is based on the Jack the Ripper story and being filmed there. It's my first ever speaking role and I'm proud to have landed it, even though I'm practically disappearing off set while delivering my one tiny line. But I love the tweed three-piece suit I wear, plus my beautifully coiffured mustache—it's all sweeter-smelling than Hodor.

But all of that pales into insignificance when I reach San Francisco in the spring of 2013. I've only attended one *Game of Thrones* premiere before, in New York, which took place at the start of the series. All I remember is the overwhelming feeling of insignificance among the thrum of stars—an onlooker observing the action rather than feeling like a meaningful participant. Since then, ratings have soared, and we've been warned that walking the red carpet downtown may feel more like an obstacle course. And just like any *Game of Thrones* promotional events I've taken part in, we're under strict instruction to keep the upcoming plot under wraps.

Some of the cast, including me, stay at Hotel Zetta in a very cool part of the city. I'm also happy because I'm with a bunch of actors I know and like. Richard Madden is there. And Finn Jones, who plays Loras Tyrell,

has also become a firm friend. Although we've never acted alongside each other, Finn and I hit it off as soon as we met each other in and around the Paint Hall. I'm also super jealous of him as he gets to have a full-on gay relationship with Renly Baratheon, played by Gethin Anthony.

"How come I drew the short straw? I have zero words and a boy to carry!" I often joke.

Daniel Portman, who plays Podrick Payne, is also someone I've come to know well, mainly through HBO events, and he's always joined us in the past on many after-shoot dinners if he's been working in Belfast, where the interiors for King's Landing are also constructed.

The screening is due to begin late afternoon, and when a car comes to pick us up around midday Finn and I are both suited and booted. Room-service hair and makeup, all arranged by the very efficient team at HBO, has also been working wonders. We travel in the same car and it's the first time I've ever been transported in a large black SUV before. As we pile in, I'm transfixed by the plush seats and blacked-out windows.

"I'm a farm boy from Lisburn! But I feel like a gangsta rapper!" I laugh.

This feeling only intensifies when we step out into the black entrance tent that's been erected in front of the city's Palace of Fine Arts.

"Jesus, look at it!" I say to Finn. In the tent there's a throng of TV PRs. Everyone is running around with iPads and headsets and shuffling us into order before we're led out to a more exclusive press area. The principal cast members will lead, while I'm positioned farther back. But as we begin to walk, I am temporarily blinded: *flash-flash, flash, flash, flash.* I've never been in front of an onslaught of paparazzi like this before. There's a wall of them, shouting and clicking like a baying mob. At first, it's terrifying, but this feeling is quickly replaced by an unexpected surge of anger. Up ahead, the younger female actors Sophie Turner and Maisie Williams are making their way along the line, but I can't believe the barrage of comments that are being thrown at them from the waiting wall.

"You've put on weight!" I hear one photographer yell out.

"Oh my God, you're busting out of that dress!" another calls. *Why are they being so cruel?* I think. This is baffling to me. These women are

inspirational, and today they look amazing! Then it dawns on me: The paparazzi are playing a game. They want a reaction. They want to capture more than a poker-face expression or a dead-behind-the-eyes smile to print in their magazines or post online. They want an open-mouthed shock-horror shot, or an angry frown. They want a story.

Yet as we continue, I find the shouts more uncomfortable to hear. I know what body-shaming feels like, even though for once it's not directed at me. I feel protective. I've rarely used my size to intimidate anyone, but now I debate whether I should step up: *Maybe if I stand in front they'll stop*, I think. I eye up the bank of photographers and then look across at Sophie and Maisie. Inside, I don't know how they are coping, but actually I'm struck by how perfectly they seem to be handling it. They aren't falling for the bait at all. *They don't need protecting!* I realize, which gives me an added respect for all the women on *Game of Thrones*. Their storylines are brutal enough without them having to suffer the real-life ordeal of the red carpet.

In the main press area, I remain in line while the interviews take place. I watch as journalists chat with Peter Dinklage and Lena Headey. Alongside Natalia, Lena has become someone else I love to talk to on and off set. She's incredible fun and very down-to-earth—a far cry from the person I assumed she would be when I first watched her being led through Winterfell's muddy courtyard in Castle Ward more than three years ago—and so different in real life to her character, Cersei Lannister.

From this area our procession then moves to a viewing point where members of the public are gathered. Cameras are still flashing, and everyone is smiling and talking. Then, I hear it. At first the call is faint in the distance, but as I edge out farther, the sound intensifies.

"Ho-dor! Ho-dor!"

What? I think.

It's hard to believe that people are calling Hodor's name, so I peer into the crowd to see if I can read people's faces. There's a crowd of lips mouthing:

"Ho-dor! Ho-dor!"

This is unbelievable! A feeling of confusion hits me right in the pit of my stomach: I'm so embarrassed but I also feel a rush of exhilaration and a swell of pride.

When I look down the line of actors, Sophie, Maisie, Peter, and Lena's heads are all turned towards me. They're staring at me, and for a split second I worry they might be angry. *How dare Hodor get the attention!* Instead, their faces are beaming. Sophie is giggling, and Peter gives me an all-knowing wink.

"They love you!" Finn mouths over at me.

They do? I think back to Mum's prediction that Hodor is going to be special. And David and Dan's promise that I would become a much-loved character on the show. But this isn't Hodor standing in front of this crowd: it's me, Kristian. When I look over again and watch people chanting, I wonder who it is that the crowd sees. *Try not to overthink it, Kristian,* I tell myself. *It doesn't matter. Just enjoy it.* It feels powerful and validating to be Hodor. Mostly, though, it feels powerful and validating to be me.

BECOMING
KRISTIAN

I'VE NEVER OWNED A PAIR OF SHOES SO EXPENSIVE BEFORE, and these are to die for. I've chosen bright purple with a high stiletto heel. But it's the finishing touch that I love the most: two giant purple lips attached to the vamp of each shoe. They cost me £700, which is peanuts in the land of bespoke, but it feels like a fortune to me. Divine-style drag opulence made by a 3-D artist somewhere north of London. Kiss my feet, bitches.

Until now I've never replaced the wedge heels that I've always had. Instead, I've sprayed them different colors over the years to match whatever outfit I'm wearing. I own a killer pair of platform boots, too, which are far kinder to my toes. Often, though, I don't wear costume shoes at all: a DJ trick we call "horizon drag." Above the waist, I'm Revvlon, but

below the decks I'm dressed in jeans and trainers. No one knows and no one cares, so long as my head and torso are unmistakably her.

Trudy Scrumptious, a friend and fellow Belfast drag queen, is very handy with a sewing machine, and she's offered to make my accompanying outfit, which is also sublime: black leggings with a green-and-gold Chinese silk brocade miniskirt and a gold-and-red kimono blouse. The blouse even has a hood. My inspiration is pure Gossip; Beth Ditto, eat your heart out. This ensemble has been months in the planning, and it's all focused on one special occasion. It's 2008 and the city's annual Pride festival.

At thirty-two years old, I sometimes have to pinch myself at how Belfast has changed, how proud I feel to be part of a movement that feels integral to the city's metamorphosis. Over the last fifteen years, the Pride parade has mushroomed from a trickle of attendees to thousands lining the streets. Now every July, we don't feel the fear of the past. Truly, it's hard to think back to eleven years ago when I was twenty-one years old and standing traumatized outside Parliament club, giving a witness statement to police after the murder of Darren Bradshaw. *What a tragic waste*, I think now. And today that street is lined with rainbow flags and balloons and floats. There's drag queens dancing, fairies, dykes, fruit flies, fags and their fag hags, brothers, sisters, trans-whatever-the-fuck-you-choose.

Of course, there will always be the haters—the odd placard on the sidelines consigning us to the sin-bin of hell and damnation. This is God's country, after all. But these are far fewer than they used to be. Besides, the groundswell of music and car horns and laughter stifles that unwanted noise.

Being the largest gay venue and one of the main sponsors of Pride, Kremlin has its own stage at the end of Union Street, which today has been closed to traffic. Following the main procession, Revvlon has been lined up to play a fifteen-minute set, so in preparation I've put together a mash-up tape. This year, I've pulled out all the stops. I've recorded my own backing track, which I'll sing to: "Show Me Love" by Robin S meets the Killers' "Mr Brightside"; Sugababes' "Freak Like Me" segueing into

Gary Numan's "Are 'Friends' Electric?" All the highs and lows and twists and turns of sound that I adore. Every instrument on the tape is played by me, recorded in a home studio at the back of Mixmaster Records.

I'm excited to share this with the crowd, but there's another feeling that's been creeping through me lately that I can't explain. It hit me when I received my shoes, but I think its seed was planted in Ballyhornan. Ever since I've returned, I've been free of drugs, seeing the world more clearly.

On the day I got my shoes, the designer asked me to ring her.

"Do they fit?" she asked, hanging on the other end of the line while I unwrapped them from the box and slipped my feet into them.

"I don't think so!" I cried. "But I've never worn stilettos before."

"Okay . . . what do they feel like?" she asked nervously.

"Like my toes are being pushed down and squashed. Like I can't walk!"

All I heard was laughter.

"Welcome to the world of women's heels," she cried.

At that moment my heart went out to each and every woman whose feet get imprisoned in these dagger heels.

"How the hell do women do it?" I asked.

"Don't ask, and good luck walking in them," she said before hanging up.

But it's not just my shoes that I feel imprisoning me. Revvlon feels like she's closing in on me, too. Trapping me. Whereas once she handed me the key to put myself out into the world, now I worry that she's holding me back. Something has shifted. I love Revvlon. She's given me so much, but I'm starting to dislike her company night after night.

My set is due to kick off at around 3 p.m. Aidie, Kremlin's entertainment manager (Aaron left and got replaced some months before), has left me alone in the upstairs office to get ready. When he knocks on the door at around 2:30 p.m. I'm in full makeup but standing in my regular clothes.

"Really sorry, Kristian, we've got a technical hitch, it's going to be a while," he apologizes. Apparently, one of the speakers is not working

properly. The crowd is getting restless but several of the technical guys are trying to fix it.

"Sure," I say. "Just call me when it's time."

As I wait, I begin to run through my backing track and act out my performance in my head. Then, I glance over at my outfit. It's draped over the back of the office chair and it does look amazing. But I don't feel amazing. Whenever I'm getting ready, that is usually the time when I feel pumped up, desperate to get out onstage, ready to give it to the crowd all guns blazing. Instead, an uneasiness washes over me—a weird combination of sadness and frustration. I'm sad that I don't feel the way I used to about Revvlon, but I'm also hungry, in need of something else that I don't think Revvlon can give me.

Out of the window, I watch as more people squeeze into the narrow street, some in costume, others holding banners. Then I have a thought: *I could play all night long, but who in that crowd would know that I recorded all of this music myself? Other than Event Horizon regulars, no one knows that I'm more than a drag act or a drag DJ. I need more*, I think.

Half an hour ticks by before Aidie knocks the door again and cranes his neck around. When he realizes I'm still not dressed, he looks me up and down and frowns.

"We're almost ready, Kristian," he says. I can hear an unease in his voice, and I stare at him, searching for the right words to say.

"Ten minutes?" he says quizzically.

Then, I feel the words spilling from my mouth. As they do, a feeling of sereneness comes over me. There's no hesitation in my voice whatsoever.

"Whoever's on after me, bump them up. Let them take my slot," I say.

Aidie's mouth opens in slow motion, like he's just seen an apparition.

"What do you mean?" he asks.

"I'm not doing Revvlon. I'm not performing today and I'm never performing as her again," I say.

There's complete silence before Aidie double-checks, like I've lost my mind.

"Okay, Kristian . . . you sure?" he asks.

"Yes, never been surer," I confirm.

As soon as Aidie disappears, I stand in front of the mirror and wipe off my makeup. Again, that feeling of sadness and frustration engulfs me. Something is ending but I don't know yet what's beginning. All I know is that, just like the computer games I play, I need to find a way to get to the next level. *You can do this on your own*, I tell myself. *You don't need Revvlon anymore. You can be Kristian*, I repeat over and over.

That afternoon I go home and sleep for a while before I'm back at Kremlin later to DJ an all-nighter at Event Horizon. My new shoes get packed in their box. If there's one regret I have, it's that they are the most ridiculous shoes I've ever owned and I never got to wear them. At the same time, there's also something exciting and liberating about shutting them away alongside my outfit. Tonight, it's Kristian: baggy T-shirt, jeans, trainers, headphones, and hours of banging tunes.

Over the next few days, I make peace with my decision. I figure that I haven't lost Revvlon. She'll always be part of me, part of my genesis, but as the days go by, I feel better about retiring her. What's annoying is that when I turn up to work, people greet me as her: "Hi, Revvlon," they say, and others do not stop asking where Revvlon is and when she's coming back.

"She's not," I say. "I'm sorry . . . "

When I tell Mum what I've done, she smiles.

"Good for you, Kristian," she says. "The world's your oyster."

Other changes are happening, too. Nan's not long passed away and so has the old order of the farmhouse in Lisburn I grew up in. Mum and her brothers, Lawrence and Raymond, sold the property not long after I came back from Ballyhornan. Until we can buy our own place, Mum and I have moved in together into a small rented house in Dunmurry, the town where Mum grew up. While I work out what to do with my life, it feels good to have Mum around as my constant, my rock. I think it feels good for her, too, and gives her something other than Nan to focus on.

As far as my career goes, Connor, the talent agent who approached me in Kremlin all those years ago, has kept in touch. In the past he's secured

me the odd audition for acting roles in local productions, but they've not come to much and it's made me think my hunch is right—music is at my heart and it's where my strength lies. Acting is not for me.

And before I left for Ballyhornan I did fly to England for an audition for a part in the upcoming Simon Pegg movie *Hot Fuzz*, but I heard nothing back. And when I think about it now, I can't believe I had the audacity to play an all-nighter at Kremlin, then step off a plane in London still wired from drugs and alcohol and stand in front of Nina Gold—one of the top casting agents on the planet—and not give an actual fuck. The character I was auditioning for was the lurching, monosyllabic supermarket assistant called Michael Armstrong, who only says two words: "Yarp" for yes, and "Narp" for no. I wasn't keen. I've tried to shake off the shackles of the big dumb guy, the giant, all of my life. *I want to be true to myself, so I'm sticking firm. Something else, something good, will happen soon*, I think.

⊢

I haven't heard from Connor in a while, so I'm surprised when he calls me months later. It's midday on a late summer Saturday in 2009—the kind of day when Belfast's redbrick buildings sit distinctively against the Celtic blue sky.

"Where are you, Kristian?" he asks.

"I'm meeting a friend," I reply. In fact, I've arranged to meet Jim in Union Street for lunch. Jim has now been promoted to general manager at Kremlin. All these years we've been joined at the hip, though neither of us can explain it. But our friendship doesn't need explanation. It just is.

"Turn around, Kristian." Connor's voice sounds insistent. Urgent, even.

"Turn around? What? No! I'm on my way to lunch," I tell him.

Why are you even calling me? I think, irritated. Plus, I haven't eaten that morning—hangry when my blood sugar is low.

"Sorry. I'm meeting Jim," I snap. "I'm in the taxi already. I'm not turning anywhere!"

"Kristian, call your friend. Explain you can't make it. Head to mine. I'm telling you, it's the perfect opportunity. I strongly advise you to come," Connor pleads. It doesn't *sound* perfect to me. There's a new fantasy show called *Game of Thrones* that's to be filmed in Ireland the following year, and the creators are casting.

"They need a strong, tall character. A giant. He only says one word, so not exactly a speaking role," Connor explains.

Here we go again, I think.

"I don't think that's for me," I reply.

"*They've* called *me*. The casting director has asked for you specifically."

"Really?"

"Yes, Kristian!"

"And who is that?"

"Nina Gold."

"Nina Gold? *What?* And *how?*"

Connor explains how Nina can't think of anyone else she wants in the role, but I'm still in shock that she even remembers me. The part sounds like the usual frustrating stereotype, but maybe I'd be a fool if I didn't give an audition a try. *What is there to lose?* I think.

"Okay. Where do I need to be? What do I need to do?"

"They want to see you act with a small boy. I've found one. Meet me and I'll take you there. They've asked me to send a taped audition," he says.

"I'll be there," I concede reluctantly.

A FREE CAPTIVE

I'VE BEEN A CAST MEMBER ON *GAME OF THRONES* FOR ALMOST four years. Crazy to think that it's a role I never wanted in a series I'd never heard of. Yet the shape of my life is different now. Literally, the shape of it. I'm not mega-rich but my new existence has finally put a deposit on a house for Mum and me: a house in its own grounds that I can fit into. It's bought me a car—not just any car, but a 4x4 that I can fit into. A car large enough for a six-foot, ten-inch man. It's bought me clothes that fit, good clothes, suits and shirts that I've had specially made. A far cry from the two pairs of jeans and the handful of T-shirts I owned when I was growing up.

Shopping is my new addiction and I remain a sucker for anything that sparkles. In my more extravagant moments, I channel my inner magpie towards jewelry, or diamanté-covered wallets or man-bags. Headphones are a weakness—I own twenty pairs. And trainers, too. I'm almost embarrassed by the size of my collection: two hundred pairs and

counting. Admittedly, there's a ridiculousness to lots of the items that I buy, but it's not just a reflection of how far I've come. I think underlying this is also a newfound freedom.

I've lived so long with canoes as feet shoved into ill-fitting shoes and makeshift clothes. Now this entire wardrobe—this entire life—built for me brings me so much joy. For the first time ever, I can bend the world to my will, even just a little bit. It's a world that fits me, rather than a world that I am constantly trying to fit into.

With her typical honesty, Mum has warned me not to let this success turn me into an arsehole. Yet when I overhear her talking to others, I know she's incredibly proud of me, too.

"That's my son, Kristian, he's an actor," I hear her telling strangers she chats to if we are out shopping together. But being from Northern Ireland I don't think there's much chance of it going to my head. That said, I've seen the *Game of Thrones* juggernaut change people. Already, one leading actress confided in me and apologized.

"I've become such a twat," she said.

She stopped returning people's calls, stopped coming out with us for dinner—we'd become too small for her.

"Well, I didn't want to say," I replied diplomatically.

I guess everyone deals with the pressures of success differently. As far as I'm concerned, though, I think it's made me a kinder, better person. It's given me less to fight against, less to hate, and less to hide from. And it's in between seasons when I fully take stock of what *Game of Thrones* has given me. More than ever, I feel it's allowed me to be authentically me.

⏤

WHEN THE FIRST SCRIPTS FOR SEASON 4 START TRICKLING IN, I realize I have a big job on my hands. I'm going to need to draw on every shred of confidence I've amassed by being on the show. Beyond the Wall, Bran, Jojen, Meera, and I will be taken captive by mutineers after we stray into their encampment while trying to rescue Bran's dire

wolf Ghost. In one scene Hodor will be bear-baited by men with spears while held in iron chains and tied to a post. In truth, I'm not looking forward to it at all.

To help me prepare, I've had several conversations with Alfie Allen. Throughout the series, Alfie has needed to go to some very dark places. Not only has his dick been cut off by the monstrous Ramsay Bolton, but he's been subjected to a myriad of tortures. On some filming days, I've noticed Alfie doesn't join us for dinner afterwards and he's often withdrawn. I also know that fellow actors and crew have rallied round him on set during some particularly harrowing scenes to make sure that he is okay.

"How do you keep going?" I ask him.

"Some days are really hard," he admits. It makes me dread what's coming up. So far Hodor's seen some gruesome sights, but he's never been captured or tortured or bear-baited.

For these episodes we're joined by the only female director on *Game of Thrones*—Michelle MacLaren. From the outset I sense that she's a no-nonsense director, and in the run-through she's very precise about the performance she wants from every actor. As this style is a departure from David Nutter, I'm unsure how well I'll work with Michelle, but I'm drawn to her professionalism and I'm determined to give it my all.

The location for our capture is Craster's Keep, north of the Wall. Instead of its interiors being filmed in the Paint Hall or at the studio in Banbridge, a standalone set has been specially constructed on the Clandeboye Estate, not far from Belfast. It's home to clearings, woodlands, and large tracts of farmland. By the time we arrive, the encampment is already standing alongside the timber hut where our party will be imprisoned. My heart sinks. Already in the half-light I can see the mud glistening—an added distraction I could seriously do without. Then, my attention turns to the snow that also covers the glade—another of the most bizarre things I've seen on set.

As it's midsummer, the evening temperature is comfortable, but the crew have me baffled. Where the snow machine has liberally spread a

dusting of flakes of tiny white paper across the wood, they stand in puffer jackets and hats. Outside of that line, everyone else is dressed in cargo shorts and flip-flops. *But it's exactly the same temperature!* I think. I'm not sure whether this is part of a world-building technique—so everyone believes the make-believe—or whether people are genuinely convinced it's cold on that side of the divide. Either way, I can only think they must be sweltering!

I'm sweltering, too, even though I love the latest addition to my costume. Between seasons I spent a morning being fitted for my beyond-the-Wall winter coat. It's been so cleverly put together by the costume department from the pelts of the rabbits Natalia has been skewering on the run. Of course, it stinks of dead rabbit, but I'm prepared to put up with it just to rock my new look—which I think is epic. I'm Thor and the woolly mammoth rolled up into one big Hodor.

Because it's a night shoot, we wait for darkness to fall at around 10 p.m. Years of DJing means that I can get through night shifts without a nap, but Isaac will need to catch a few winks in his trailer at intervals, just so that he can keep going.

Michelle begins to run through the first scenes with us.

"If we can have your party lying down on the snowbank looking over to Craster's Keep. Remember, you're trying to work out how to retrieve Ghost, so it's whispers," she says.

Meera will be the first of our party to be seized by the mutineers as she tries to leave our dugout.

"Kristian, if you could leap up as soon as Meera's taken. *Really* jump," Michelle continues. *A Spiderman leap? In these leather shoes and coat? I don't think so,* I think, but Michelle doesn't seem to be the type of director I can share any kind of joke with.

As soon as the cameras roll, I focus on the intensity of the moment. Bran, Jojen, and Meera talk among themselves before Meera steps up and turns back. As she does, a mutineer grabs her and holds a knife to her throat.

Jump, Kristian. Leap! I tell myself.

"Hodor, Hodor," I shout in quick-fire, ramping up my distress. So far, so good, but then I feel it. *Fuck. Fuck. Fuck.* Then I feel it a little bit more. No sooner am I upright than I feel my feet sliding down the bank. My heels are sinking into the mud, and before I know it, I'm rolling on my back.

"Okay . . . cut," Michelle calls out.

When I look over at Isaac he's trying hard not to laugh. Ellie and Thomas are quietly smirking, too.

"Sorry, really sorry," I say, trying to keep a straight face.

As much as I try to hold it together for the next take, that also descends into a slapstick comedy.

"Hoooooodooooooor!" I shout as I slip again, this time landing with a massive thud on my arse.

"Ouch! Sorry," I call out to Michelle. *It's these shoes*, I want to tell her, but I don't want to be the workman who blames his tools, so I stay quiet, dust myself down, and wait for the next take. Now Isaac can barely contain his glee. He's absolutely loving it.

"Okay, let's go again!" Michelle shouts, but I sense a terseness to her voice.

On the third and fourth take, I slide around so much I'm like a human toboggan on Antarctic ice. Isaac, Ellie, and Thomas are now collapsed into hysterics. I take a deep breath, close my eyes, and try to haul myself up, balancing on one very muddy hand. I'm concentrating so hard, I don't notice a figure loom into view. When I open my eyes, my heart jolts.

Michelle is leaning over me, staring me down.

"Are. You. Ready. To. Go. Again?" she says through a tight smile.

"Sure," I reply, trying to stifle any sniggers. I feel like a naughty schoolboy, reprimanded by the headmistress. If I so much as glance at Isaac, he'll set me off, so I pick a spot on the horizon and stare. On the next take, I strain every sinew not to slip.

The next day we film the torture sequence. I've been close to a panic attack just thinking about it. So far on *Game of Thrones* I've wanted to

keep looking forward—*how can I get this right? How can I improve? How can I keep going? How can I make a success of this?* But I know that if I have any hope of acting this scene with authenticity, I'm going to have to return to the past. I'm going to have to draw on the person I was as a boy—mute, not in control, bullied, and abused. It's the last place I want to go to in my head. I know that person is still inside of me but it's not the person I've become. I'm terrified that by revisiting him it will trigger thoughts that will set me back years, thoughts I won't be able to handle.

The night before the shoot I attempt to work out a strategy. I try to envisage it as an emotional dump. *Whatever happens in Craster's Keep gets tossed on the floor of Craster's Keep*, I tell myself. *I'm not that person anymore.* But I'm also aware that thinking this is not the same as living it, and on the day of the shoot, I can't stop pacing around my trailer. Even Isaac fails to lift me out from where I'm focused.

Just before we begin, Luke Barnes, who plays the part of the mutineer Rast, steps over to have a quiet word with me. During the scene he is going to have to stab me hard in the leg with his spear.

"I hope it's not going to upset you," he says tentatively.

I love that Luke is concerned about how this might hurt me, but outwardly I want to be professional.

"It's not me you're stabbing! It's Hodor!" I say, brushing it off. "Just do it. Do whatever feels right for the scene."

Jesus, I wish I felt that breezy underneath, but I don't want any actor feeling guilty for simply doing their job.

"Sound . . . action . . . and go," I hear Michelle shout as soon as we're in situ. Five men with spears surround me, shouting and hurling insults at me. All I can see is their screwed-up, angry faces. I feel my anxiety rising.

"Hodor, Hodor!" I shout as I pull on the chains restraining me. *This is Hodor, not Kristian*, I'm repeating in my head. *Hodor, not Kristian.*

But I know what's next—it's a line I've been dreading, and I brace myself.

Please don't say it. Please don't say it, I think. But Rast looks at me with contempt: "If I were your size, I'd be king of the fucking world," he says. Then a globule of his spit lands on my face.

Now I'm exploding from the inside. I'm back at school on a rugby pitch weighed down by a coach's expectations. I'm on our family farm in Lisburn lugging hay bales when all I want to do is feed the calves. I'm a teenager on a train, absorbing the abuse, too frightened to stand up for myself. It's visceral. In that moment I hate myself, but I also hate Hodor.

Come on, fight! I'm willing him to take on the mutineers, but I know that's not who Hodor is. It's not in his character.

"And . . . cut," Michelle shouts.

"Kristian, are you okay?" I hear Luke whisper over, nodding concernedly at me.

"Yes, I'm fine," I reassure him, but inside I'm badly shaken.

Please tell me what to do, I think. Now I'm willing Michelle to be explicit in her direction, to absolve me from the responsibility of thinking.

"Okay, great, Kristian, but we need more panic here, more intensity," she says before showing me where she wants my feet, how she wants me to move, how to express myself. Michelle is demanding, but I listen carefully. Although there's a shortness to her tone, she does command respect.

"Thanks," I say. And I mean it. I'm scared and I need her firm guiding hand.

We film for the majority of that day, and by the end of it I'm exhausted. Yet as the hours roll on and I weave in and out of a complex tapestry of emotions, I notice a calm washing over me. That initial short, sharp shock that I felt when the vitriol hit starts to fade. *I don't have to fight,* I think. *I don't have to conform to who people think I am.* I can be Hodor. I can be scared. I can own this. Hodor is gentle. He's not a fighter, he's a loyal protector. Every time, I try to find the beauty in his submission.

What also makes each take easier is the concern of fellow actors and crew, who do check in on me after each take to see that I'm coping. Isaac, too, asks me repeatedly how I am. "I'm fine," I tell everybody. But that

night, when I finally step into the taxi and head home, I am dizzy with tiredness.

Surprisingly the next morning when I wake, my eyelids ping open. I feel different. It's as if I've been pried open and my batteries replaced. There's clarity to my thought. I lie there for a while trying to work it out. Maybe I'm more resilient than I've given myself credit for. It's as I hoped: a spirit has been exorcised, purged on the floor of Craster's Keep. This realization of how far I've come feels like an epiphany, and a relief. The last thing I want is to go into a next night of filming running on an empty tank.

The next scenes will be as mentally and physically challenging. Our party will be chained up in the hut at Craster's Keep, where the clubfooted villain Karl Tanner will terrorize Meera, threatening to rape her. It's a blistering, heavy scene—the kind that often disrupts my core—especially since I've stood on the sidelines and watched Burn Gorman, the actor who plays Karl, in action. Among a plethora of lights and cameras, he can cut an atmosphere dead. As soon as he flicks a switch and steps into character a frost descends on set. Sometimes I have to remind myself I'm even on set, his performance is so absorbing. It's as if he's possessed.

By now, I've warmed to Michelle's style, even though I don't always understand what she's asking of me.

"Can you say the word 'Hodor' less happily and a little more joyfully?" she asks during one rehearsal. I'm wracking my brain to know the difference.

"Pardon?" I say.

"Less happily and a bit more joyfully," she repeats.

Nope, I still don't understand, so I simply repeat what I've done before.

"That's perfect," she says. It makes me realize that Michelle is a director who needs to know that she's being heard. At times like that, it's best not to argue.

And when it comes to shooting the very final scene in Craster's Keep, I am grateful for Michelle's meticulous direction. It's a sequence I've been secretly very excited about. Finally, after being in the shit-pit of capture,

Hodor gets to stand up to his tormentors and kill the mutineer Locke after Locke attempts to abduct Bran during a raid by Jon Snow's men. When Bran wargs into Hodor, Hodor can at last break free from his chains and be a bad guy. *No more passive, reactive Hodor!* I think. I have license to let rip. But I also feel I've landed in the best of two worlds—a get-out-of-jail-free card. For a brief moment I get to use my giant strength but only because Bran is controlling me. A bad guy who's *really* not that bad at all.

To get into character, I have imagined that Hodor is possessed by someone else. Had this been written for me three seasons ago, I doubt I would have a clue what to do, but now that I understand Hodor I can play him in a far more multilayered way. Thankfully, I don't have to exact any actual violence on Noah Taylor, who plays Locke, but I do have to place my hand firmly around his neck. In reality, when I lift Noah off the ground, he'll be hauled up on a winch attached to the tree behind, made to look as if I'm dangling him above my head. When I finally snap his neck and he slumps to the ground, I will barely have touched him.

"One . . . two . . . three," Michelle shouts as my fingers clasp around Noah's neck and four assistant directors heave the winch up in the background. There's also a stunt man on the sidelines advising us how to get it right.

As we shoot throughout that night, I enjoy every single minute. Not only is the sequence testing my skills, but I can feel my inner rage being driven out. It's the same rage that Revvlon allowed me to vent all those years ago. *I've got this*, I think. It's unbelievably cathartic and I run with it. And when Hodor snaps back into being Hodor and realizes what he's done—that he's killed a man—I try to summon up how Kristian would feel if I ever did physically hurt someone. *Horrified*, I think. Utterly horrified is my only answer.

CHAPTER 21

RAVE OF THRONES

"SO, WHAT DO YOU THINK, KRISTIAN?"

"I'm not sure," I tell my manager, Guy. The idea of a Hodor DJ tour has come full circle. Guy thinks it's a great idea. A name has been mooted, too: *Rave of Thrones*, which admittedly makes me smile. Yet my instinct is to shut it down. I'm still not 100 percent sure that blending my two worlds is a credible move. But one factor is shifting the dial.

Isaac and I have been told that we will not feature in season 5 of *Game of Thrones*. The news dropped like a stone, but I've tried to focus on the positives. *At least we're not dead!* I think. Yet when I dwell on it for too long, all I can think about is how I'm going to miss Isaac—Helen too— even though I know we'll be in touch. What's also going to be tough is being in and around Belfast. I imagine actor friends flying in and out of the city. I'll bump into them alongside crew members, knowing that I'm not part of this year's action. A distraction might be just what I need.

Thankfully, over the past couple of years, whenever I've had breaks in filming, I've been able to stay connected to *Game of Thrones*. Throughout, I've always said yes to promotional work, which now includes sci-fi festivals and conventions like the comic-book gatherings, comic cons, that take place all over the world. When I think back to the trickle of fans who turned up to see George and me in Dublin four years ago, it's incredible how those fans have multiplied. Now when I take part in any panel discussion, I look out to a sea of them, many of whom are in full costume, armed with their questions. One surefire favorite: "Does Hodor even have a script?" *Good one!* I think for the umpteenth time. And I've seen some amazing Hodors, too: Hodor in full costume, drag Hodor, Hodor with a harness, Hodor carrying a sled. HBO has even released a Hodor doll, which must be the most unflattering version of myself I've ever seen: a rotund shepherd with a white goatee. I suppose I should be delighted. David and Dan's prediction has also come true: every time I search for Hodor online a new meme appears.

Because of this, there's a part of me that thinks Guy may be right about *Rave of Thrones*. As a manager, he's good at pushing me out of my comfort zone. Besides, like the conventions, it could be a lovely way of bringing people together, albeit from two very different worlds. Eventually, when I do agree, it's with one caveat—that during my set I am totally in complete control of the music: no gimmicks, no cheesy tunes unless I've planned it.

"I'll make sure of it," Guy promises.

"Okay, I'll do it," I concede, although I spend much of the run-up worrying about what I've let myself in for.

The tour starts at the beginning of August 2014 and is initially planned to cover six cities across Australia: Sydney, Brisbane, Perth, Melbourne, Darwin, and Adelaide. As the day of my flight edges closer, the penny starts to drop. This is me, Kristian, performing. It's not Revvlon, it's not Hodor. *Should I take my Hodor costume, for protection?* I wonder. My thoughts then swing the other way. *I am enough*, I tell myself. I don't need any contrivance or costume. *I am enough*. But I do ring Guy constantly.

"How are the tickets sales going?" I ask, trying to find ways to make myself feel more in control. Thankfully, several venues have sold out. The others are close. It's the news I need to get me on a plane.

To help lift my DJ profile and promote the upcoming tour, Guy, alongside an Australian agent, has set me up with a string of interviews with local media, which I'm happy to do even though media is an aspect of my career I'm only just getting my head around. So far, any dealings with the press have been few and far between and also baffling. Only a few months ago a journalist interviewed me for a *Game of Thrones* fan site. Halfway through, his question completely threw me.

"Do you know you're very popular in the gay bear community?" he asked.

What? I thought. I couldn't help myself blurt out: "That's *my* community!"

Fast-forward a couple of days to when the article appeared online followed by a flurry of other outlets seizing on the story. Headline: *"Game of Thrones* Actor Comes Out as Gay." *I've not just come out! I've not hidden who I am since I was a teenager! Don't make it out like I have!* I thought. While it's not deterred me from publicly talking up my own community or concealing my identity, it has made me wary about how stories get sensationalized.

In Australia, the first interview I do in Sydney is on the night of my first gig. I don't know the name of the publication, but I've been told it's an LGBTQ+ entertainment outlet. Immediately, that makes me feel more at ease. *With luck I'll be among like-minded people*, I think. The female journalist who turns up also seems warm when she greets me backstage. She's brought one man clutching a camera, so that the interview can be broadcast.

"Do you mind?" she asks.

"Not at all," I say, wanting to appear helpful even though I can't remember whether or not I knew about the camera.

We cover all things *Game of Thrones*, and all things *Rave of Thrones*. I notice that I'm more comfortable with the former. *Game of Thrones* feels

like being part of one big family where everyone shares responsibility for what goes right or what goes wrong. If there's any criticism, we all take the hit. I also find it easy to talk about Hodor, and about Hodor and Bran and the special bond that we have. When it comes to myself, however, I feel unexpectedly uncomfortable.

"What are you playing tonight?" the interviewer asks.

"Big chunky house tunes. Nothing people would expect Hodor to play," I say jokingly, but underneath the self-doubt is screaming. Experience tells me I just need to get up there and perform, but as this is my first big tour, this evening feels agonizing. In venues where I feel comfortable, I deal better with my inner diva. Besides, those who know me well know that I need to be left alone before a gig. But in an unfamiliar space in an unfamiliar country, it's harder to communicate this. Instead, I just feel irritated and angry.

As soon as the interview finishes, my tension softens. The journalist chats a little while the cameraman looks as though he's packing up.

"What can you tell us about next season's storyline?" she asks casually.

"Oh, Bran and Hodor don't feature in the next season, so I can't give anything away," I reply. By now I know the HBO mantra *never* to reveal anything about future episodes, so this feels as though I've dodged a bullet.

"Right . . . " she hesitates before wishing me good luck. I barely have time to compose myself before the tour manager collects me and escorts me to the stage. As we get closer, I can hear that chant again: "Ho-dor! Ho-dor!"

"Looks like you're in for a great night!" he says.

To kick-start the evening, I've created a fitting intro: a monologue by Old Nan, in honor of Margaret John, that booms from the speaker. At that, the chants become louder and louder. And when I walk in and take my place on the stage, it's hard to know why I ever doubted *Rave of Thrones*. The venue, the Hi-Fi, is wall-to-wall jammed with people.

My heart is thumping. At first, I'm so preoccupied I can't take it in. As well as a selection of my deepest, darkest, bassiest house tracks, I've

mixed in some of my own music that I've been working on in preparation. The crowd receive it well, which calms me, and it's then I take a moment to peer out. The room is bathed in bright light and smoke, and I can't stop laughing. Everyone is head to toe in their finest Westeros attire: ravers in dragon onesies, men of the Night's Watch, several Daenerys Stormborns. I'm sure I spot a Bran and Hodor in the distance. There's a blanket of plastic swords punching the air.

And what gives the night an extra-special touch is the onstage entertainment, which takes the focus off me. Although I was doubtful at first, a huge replica Iron Throne that's been created looks incredible. Actors have also been drafted in to play characters from the show, including a White Walker, a lap-dancing Robb Stark, and a raving Khaleesi. *Sometimes, Kristian, you just have to say yes and go with the flow*, I remind myself.

"Ho-dor! Ho-dor! Ho-dor!" I don't think I'll ever tire of that sound.

The set finishes at around 2 a.m. and I'm relieved the night has gone without a hitch. I'm also bowled over by the warmth of an Aussie crowd. Talk about embracing the moment—no one seems afraid to let themselves go, all of which bodes well for the next cities on the itinerary.

Until now, I've only just gotten my head around fandom at home and in the States, but I'm starting to realize the extent to which *Game of Thrones* is a truly global phenomenon. Seeing and feeling it adds another surreal dimension. When I touch down in Perth two days later it's as if the world has lost its mind. As I turn the corner to head through passport control, I see a blur of people in the distance. And when I walk closer I recognize my own face. They're holding up blow-up press shots of Hodor from season 1.

How the hell do people know I'm on this flight? I wonder. *And how can they even get into this restricted area, way past the main terminal?*

When I turn to ask the tour manager, he explains:

"People buy flight tickets to get past the barrier."

"Pardon?" I'm not sure I've heard this correctly.

"They want to meet you and get their pictures signed so they buy a cheap air ticket."

"People do that?" I say, gobsmacked.

"People do that," he smiles knowingly.

As we approach, the small crowd do seem friendly. And I don't want to disappoint them even though it's hard to believe that they're here for me. I stay for a while to sign photographs and take selfies. In fact, these people couldn't be a nicer bunch of Hodor-lovers and *Game of Thrones* enthusiasts, but it does make me question a fan's sanity. Buy a ticket for my DJ set, by all means. Buy a ticket for a flight you're never going to take to meet Hodor—that is *serious* dedication, arguably tipping into lunacy.

The Perth gig follows Sydney in pure unadulterated joy. "Ho-dor! Ho-dor!" the crowds chant throughout, and I've even added a little twist to my encore. Before I come offstage, I take the microphone. "There's only one word left to say: Hodor!" I shout. *If you can't beat them, join them,* I figure. And as the tour continues, I embrace being up onstage in strange cities with my arms wide open. In truth, I don't think anything can bring me back down from the high I'm on. But, of course, something always ruins the vibe.

I'm in Melbourne when my mobile rings early in the morning. As I didn't reach my hotel until the early hours, I'm half-asleep when I take the call.

"Hi, Kristian?" I recognize the voice immediately. It's the head of press at HBO, a lovely woman and someone who has been so encouraging of me taking on extra promotional work. Yet this morning she doesn't sound encouraging. She sounds angry.

"Hi," I say, yawning.

"Kristian, did you tell a journalist that you and Isaac weren't in season five?"

I'm awake now, rifling through the disorganized filing system which is my brain. I can't remember. I've done several interviews since arriving in Australia and they all mash up into one after a while.

"I don't think so," I say. "Why?"

"Because it's all over the press, that's why," she says firmly.

As soon as the call ends, I frantically search online. I'm numb. I thought the interview had ended, but the cameraman at the end of the backstage chat in Sydney must have continued filming. There I am casually spilling the beans to the journalist over something I didn't know I wasn't supposed to say. Several media outlets have picked up on the story and it's out there in full, blazing Technicolor.

My phone rings again, and several more times that morning. Each time I answer it's a person higher up the chain at HBO who sounds sterner and more pissed off.

"Kristian, what have we told you about spoilers . . ."

I am mortified. I feel like I've betrayed people who have supported me and have even allowed me to embark on this *Rave of Thrones* tour.

"I'm sorry. I'm really, really sorry," I repeat grovelingly.

Then I make a mental note in big, flashing neon signs. *Do. Not. Trust. Any. Tabloid. Journalist.*

RAVE OF THRONES PULLS IN MORE CROWDS THAN I COULD ever have imagined. This means my schedule for the next few months gets filled—so much for languishing at home, feeling the pang of self-pity at not being part of the show. I do miss friends, though, and I love it whenever we can catch up. That October I sit on the panel at the New York Comic Con festival alongside my friend Daniel Portman, whom it's great to see. That same week I DJ at B.B. King's club in Times Square and Daniel joins me hilariously dressed as a dire wolf, supposedly in disguise but I can spot him a mile off. Gigs follow in Wellington, New Zealand; Istanbul; Los Angeles; Chicago; San Francisco; Denver; Pittsburgh; Atlanta; Tampa; Vancouver; Calgary; Toronto—more cities in six months than I've traveled in an entire lifetime. Mum hardly ever sees me, but I do ring her once, sometimes twice, a day. This *can* drive her nuts.

"I have things to do today, Kristian!" she cuts me off if I stay on the line too long. And while there's no limit to the amount of lukewarm

McDonald's I can shove down my throat when my set finally finishes, no limit to the room service I love to order or the skylines to look out over from five-star hotel windows, I also dream of arriving back in Northern Ireland. My new life as Kristian Nairn feels exactly like I've reached the next level I've been searching for, but weirdly it's home that I now crave the most. And when I fly back into Belfast, a peace engulfs me. I'm reminded of Northern Ireland's mountain ranges and its wild beauty and its people: everything and everyone that I love.

THE FINAL PUSH

"KRISTIAN, HAVE YOU READ IT?"

The voice on the end of the line is Finn Jones's and he sounds strange, slightly shaky. I can't work him out. It's an early morning in June 2015 and I've just woken up.

"No," I say groggily.

"It's just that . . . "

"It's just that what?"

Finn pauses and I hear him draw breath.

"I'm sorry, Kristian. You don't make it," he exhales.

I'm upright now and my chest thuds like a boulder has hit it. Finn begins to furiously backpedal, trying to make everything okay.

"It's so cool, though. It's the coolest death, Kristian. It's all about you."

"Is it?" I say emptily.

In the recesses of my mind, I knew this moment was going to happen. Every season whenever I input the name "Hodor" into the search tool and

skipped to my scenes, it was always with a feeling of dread. *Do I make it?* There was always dread, followed by the lightheadedness of relief.

I've lived with Hodor for five years. I've grown him from a stable hand to a man, from a protector to a savior. I cannot imagine losing him. I love him. Then, my mind turns to the person who's been by my side throughout.

"What about Isaac?" I ask Finn. I'm terrified to know, but I need to hear it.

"He stays," he confirms.

It's a lot to take in. Not only will my time on *Game of Thrones* be ending but I'll be leaving Isaac and the others, too. My little family. I feel dazed, like the moment someone dies but grief hasn't yet kicked in.

"Thanks for letting me know," I hang up before I fire up my laptop, download the script, and try to digest the news.

In the *Game of Thrones* story, Bran, Meera, and I will be the last surviving of our party. From a cave we are sheltering in, Bran and Meera will continue on their journey, but their getaway will only be made possible by Hodor sacrificing himself. He'll hold shut the cave door to keep in the wights and the White Walkers—the army of the undead—long enough to help the pair escape. The name Hodor and the instruction "Hold the door" will morph into one when Bran revisits the past and connects a young Hodor with his adult self. When I think about it, it's devastating. Most of Hodor's existence has been spent living for this moment of death. *George, you really know how to twist the knife in, don't you?* I think.

I also see the pathos. Hodor will remain kind and selfless even in his most powerful moment. Although I've been building an internal world for him, he's always remained an innocent, never able to hide his disability or his vulnerability. Now it's his superpower. *This ending isn't pitiful*, I tell myself. *It's heroic.* In my mind, Hodor doesn't change. He accepts who he is.

Later on that day, I formally get "the Call." It's David. He's typically businesslike and I sense that he's done this a hundred times before. But his delivery is soft and smooth.

"Kristian, I don't know if you've heard but your journey with us is coming to an end."

"I do know," I reply flatly.

"I promise you, you're going to love it. It's one of our best scenes. In fact, we think it's our best scene," he gees me up.

"Okay," I say meekly. In the world of make-believe, I have to surrender to fate.

"Trust me, people are going to love you even more," David reassures me.

In the following days, my dull mood lifts and a feeling of excitement starts to creep in. *The final push*, I think. Now I'm focused on my performance and the shit-ton of work I need to do to get it right. But I'm also battling self-doubt. I've had a year off DJing around the world. Wherever I was, I was reminded of Hodor, but I didn't have to inhabit him. I worry that I've lost him, that I might not be able to summon him back.

Unusually, the filming of my final scenes will fall in chronological order, which calms me. *Thank God I won't have to do what Donald Sumpter had to do—die and then return*, I think. Now I understand so much better how hard that must have been for him. At least all of my energy will be channeled towards a crescendo when I finally say farewell.

Most of the scenes will be shot over one week and in several different locations. As well as Brian working alongside me, I'll have another duplicate Hodor: my younger self, the stable boy Wylis who, the story reveals, becomes Hodor. This will be played by a young actor named Sam Coleman.

"The guy has more words in an episode than I've had in six seasons!" I joke. In truth, I'm a bit pissed off. Sam will play me when I had a voice, and words, and before Bran, lacking more control of his ability, wargs into my young mind and renders me speechless—the result of a seizure in the story's complex time loop. *Hodor talks!* But this is also an aspect to the story that I adore. It validates how I've imagined Hodor's character throughout. Hodor was never the big dumb guy—ever.

There's also a surprise element that's exhilarating. The TV series has moved beyond the *A Song of Ice and Fire* novels. This means that Hodor's death will be a shock to even the most stalwart of George's fans. When I

tell Mum her eyes ignite: "I told you Hodor would become special. There was always something big planned for him," she says.

———

THE DIRECTOR FOR MY FINAL EPISODE IS JACK BENDER. AS soon as I find out, I Google him. We've not met, but I try to second-guess how he'll work. If this is to be an epic scene, I need to get it spot-on. His past accolades tell me what I need to know: he's an old hand, a longtime director on the 1980s hit TV series *Falcon Crest*. *The Sopranos* is also in his back catalog. My hope is that he'll draw out the best in me.

When our first day of filming rolls around, Helen greets me with a warm hug.

"Great to see you, Kristian!" she says. But I also sense her hesitation. Neither of us want to acknowledge that our time together is drawing to a close.

"Kristian!" Isaac also rushes up to say hello, but I notice that he doesn't run to hug me. Immediately, sadness surges through me. I haven't seen him for months, but what's obvious is just how much Isaac has grown. He's fifteen now. *Fifteen!* He's also nearly six foot tall. My rational brain kicks in. Would I have wanted to bear-hug anyone at that age? Categorically no. But it's also weird to think of our first day together when Isaac used me as a human climbing frame and smashed my iPhone in the Paint Hall. What a journey we've been on since then . . .

"I still can't believe the script!" Isaac tells me.

"It's going to be *really* tough," I gulp. Already I can feel the emotion rising. How I'm going to survive the next few days will be anyone's guess.

"Hey, Kristian," Jack greets me with a firm handshake when we finally meet. He has small, round glasses, a shaggy-dog demeanor, and a beard to rival my own. Since season 4 I've been rocking the Methuselah look. And whenever I glance in the mirror, I laugh. There's been so much to-ing and fro-ing over my facial hair over the years. First David

and Dan wanted Hodor with a beard, but then reckoned I looked too much like a college professor. Now that I've been living in a cave for a year eating moss while Bran hones his powers and the White Walkers edge closer, I've unleashed the beast and let my hair and beard run free. That, too, feels liberating.

"Great to meet you," I say to Jack before we launch into work.

Before we begin our first run-through there's one thing I'm concerned about. "Will I meet Sam?" I ask. As Sam is going to be playing me as a young boy, we are going to have to follow each other's movements in certain scenes while Bran is warging, so I feel I should meet him face-to-face.

"Sorry, Kristian," Jack grimaces. Because of the schedule, Sam's scenes had to be filmed several days ago, but Jack does have a set of outtakes to show me on his iPhone, so that I can get a feel for what's needed. The challenge, he explains, is that he's going to have to match up our performances later, so they'll need to be as exact as we can get them.

The exterior of the cave of the Three-Eyed Raven is constructed in a quarry near Ballymena—an almost perfect bowl-shaped hollow now filled with scenery, tents, and cabins. The cave's interior and its various tunnels have been constructed at the studio in Banbridge, and it's there where we'll spend the majority of our time. The walls have been covered in moss and the floor strewn with real animal bones. On our first day, we're also joined by the eighty-five-year-old actor Max von Sydow who plays the Three-Eyed Raven—one of the old guard of actors I love to watch so much. Physically, Max seems more frail than even Margaret John had been, and I worry about him sat for hours in the cold. But just like Margaret did, he can snap into character like an old pro.

Since I've returned to the series, this is the first scene where Hodor has to interact. Meera will talk with him about the food she's been dreaming of when they reach home. The mention of home and sausages lights up Hodor's face.

It's supposed to be a lovely, lighthearted moment before all hell breaks loose and the undead descend on us, but I just can't relax. In fact, I feel suffocated by the enormity of everything that's expected of me. *Jesus*

fucking Christ, Kristian. You need to be on your A game, I tell myself, but I'm agitated, so much so that Jack notices I'm struggling.

"Are you okay?" he asks after a few takes, which I've barely managed to get through. "Are you having difficulty?"

"Yes, it's awful," the words tumble from me. Hodor's subtle tics used to come easily to me, but now I'm tying myself in knots trying to express them. I explain to Jack the mad journey I've been on for the past year, and the personal journey I've been on, too. I'm finding stepping back into inhabiting someone other than myself very hard. Then I stop. *Did I just say all of that . . . to a director I don't know?* I think. Years ago, I would have kept silent, like when my back was breaking in the Great Hall. I stop talking and watch Jack's eyes carefully. *Is he going to understand? Help me work this out? Or dismiss me and move on?*

"Okay, just take it easy," he smiles.

"I'll be fine, but everyone might need to be a bit patient," I say quickly. Jack gives me a shoulder squeeze.

"Just relax. It will all come flooding back," he reassures me.

Jack is right, just like John Ruskin had been years ago. And after a while, I do start to remember: *Do not overthink Hodor; do not overthink your performance.* As the morning wears on, Hodor reappears like an old friend.

Brian is also worth his weight in gold. As soon as the magical shield keeping us safe in the cave vanishes and the wights and White Walkers come for Bran, we need to hotfoot it out. This means take after take of me pulling Isaac on the sled, which is attached on runners to the tunnel floor. Thankfully, Brian will take the reins on many of these shots—the shots where my face is not in view. My back hasn't yet completely recovered, and this also gives me the chance to concentrate on what's ahead. Besides, Isaac has gotten even heavier in the intervening years.

At the far end of the tunnel is the door Hodor must push to reach the outside world. But it's jammed and I'll need to use all my strength to push it. Seconds of action will take the best part of a day to film. At first, I test the door. While much of the cave and its tunnels have been constructed

in a thinner balsa-type wood, so that our enemies can crash through it, this door feels as heavy as solid oak.

"Really push your weight against it," Jack stresses in the run-through. I need to give the impression that there's snow and fallen branches on the other side, jamming it. For the first take, Brian and an assistant director will stand behind the door, pressing their weight against it so it's harder to budge.

"Sound . . . action . . . and go," Jack shouts.

I fling my shoulder against it, but surprisingly it opens almost immediately, as if I've casually strolled through.

"And . . . cut," I hear.

"Okay, we're going to need more weight," Jack shouts, summoning one more crew member to join Brian and the assistant director. But it's still not enough. After every take, the snow machine also has to be fired up and fake snow blown in so that when the door is ajar the storm outside looks as though it's raging. Today, there's a lot of hanging around.

"It still looks too easy," Jack concludes on the fifth take. One more person is enlisted, then another. By now I've lost feeling in my shoulder and the sweat is pouring down my tunic, but I don't care. I have to get this right.

"Sound . . . action . . . and go," Jack shouts again.

"Ahhhhh," I cry out as I fling myself once more against the solid wood. I push hard, really hard. Hard again. Then, I feel something shift. I hold still and keep pushing. *Oh shit. Shit. Shit. Shit.* Out of the corner of my eye I see an assistant director waving her hands and mouthing "Stop."

"Okay . . . cut. Cut! Cut! Cut!" Jack hollers in rapid fire.

And then I realize. I haven't shifted the door at all. I've brought the entire fucking tunnel along with me. Even the sled runners have been dislodged. I look around sheepishly. *God, I'm so embarrassed.*

"Sorry, everyone." I shrug. I know the crew must be cursing me. It will take at least an hour to fix the damage and redress the set. Eventually on the final take of that day we number eight people behind the door to act as the perfect counterweight.

—

ON OUR FINAL DAY, WE MOVE TO THE QUARRY WHERE THE reverse side of the door has been constructed, this time in the thinner balsa-type material, and covered over in branches and leaves. In the scene, Hodor will lean his back up against it long enough for Meera and Bran to get away, but as he does so, the army of wights will pierce their hands through and savage him. I've barely slept worrying about it. If there's anything I've inherited from Mum, it's a pathological fear of being in enclosed spaces, or being mauled by strangers. There's hours of work ahead and something tells me I'm going to lose my shit. Plus, I've been stamping down another feeling, too. This will be my final day with Isaac. The thought comes in waves. Every time, I try to think of something else.

By the time I arrive at the quarry at 5 a.m., the wights and White Walkers have been there for three hours having their makeup applied. Like the previous cave and tunnel scenes where several broke through to attack us, those on set will be in full costume while the bulk of the army will be added in later using CGI. Those already dressed look ridiculous: half zombie, half Christmas elf. Every body part that will be enhanced later using CGI is dressed in a thick green latex fabric. The sight still makes me laugh.

When Isaac arrives with Helen, I feel myself sticking to both of them. I notice that Isaac does the same. We have breakfast together. We sit in the trailer together. I've even had a gremlin thought: What if I fuck up so badly today that we get to be Bran and Hodor for another day, maybe another after that? As soon as Jack arrives on set, though, that thought rapidly dissipates.

"Big day ahead, Kristian," he flashes a smile.

"I know . . . " I reply feebly.

We start by watching the iPhone outtakes of Sam in Winterfell as the young Hodor. Sam's performance is terrific, especially considering he's only just been drafted into the series. From the moment Bran wargs into him and he collapses to the floor, convulsing on the ground, I start to

track how my body is going to have to match his. What I'm unsure of is how I'm going to juggle this with being savaged by zombies.

First, we practice with me pinned with my back against the door. I jolt one way and then the other, but already I can feel a stiffness to my movement. I don't know why this performance is not happening for me. I need to loosen up, let go. I think it's become like a mountain in my mind.

"I just don't feel I'm getting there," I confess to Jack.

"Okay, let's try this a different way."

Jack suggests that because much of the camera action is going to be concentrated on my head and shoulders, he can crouch down slightly out of shot and punch me in the stomach. Repeatedly. This will help Hodor's movements become far more reactive. In the moment, he says. *Hmmm*, I think.

In five seasons of *Game of Thrones*, I've endured the indignity of standing naked with a prosthesis; the indignity of my balls slapping against my thighs in the Mourne Mountains—an official Area of Outstanding Natural Beauty; the indignity of spiders, dead rabbits, freezing camp food, more filth than a fucking mud bath. Now I'm about to become a human punch bag.

"Okay," I reply nervously. I'm not sure I can envisage how this will work.

Jack bends his knees and starts to hit. He's kinder than I've anticipated. Instead of rolling his fists into a ball, he slaps me with the palms of his hands: one-two, one-two, one- two.

"How does that feel?" he checks.

In fact, the rhythm helps me imagine the physicality of the scene far more easily. Automatically, I feel my upper body and shoulders moving to his beat.

"Much better," I say, although I'm also mindful that we've not yet started filming. *Ask me on take twenty and it might be you getting punched.*

On the initial takes, I now have the full force of the wights mauling me. As I fight to hold the door in place, their hands pierce through. Fingers pull at my coat, my face, stretching my skin, yanking at my costume.

And below I also have Jack crouched down, bobbing around, slapping my torso in rapid succession.

I don't even need to be in character here. Naturally, my chest feels tight, my heart is pounding. I am cursing the actors behind the door. I fucking hate them. I hate the feeling of their hands, but I'm also trying to reason with myself. *Come on, Kristian*, I'm repeating. *This is acting. It's not malicious. It's actors doing their job.* The longer it goes on, the more rapid my breath becomes, like the panic attacks I used to have at school. I need this to be over. But I also need this to be fucking brilliant. *Come on! Come on!* I spur myself on in my head.

Throughout the day, the repetition of fingers dragging across my cheeks means my scar needs to be retouched constantly. A wight's sharp nail has also knocked a real scab on the left side of my forehead. On that take, I become aware of a warm, wet trickle running down the side of my cheek. As soon as we cut, makeup come to inspect it.

"It's real blood, Kristian, but it looks amazing!" they agree.

"Can I see?" I ask.

When a mirror is held up to my face, I also agree that the blood should stay. It looks as though I'm about to spill my guts up against this door. As soon as it dries, we continue shooting. Take ten, take eleven, take twelve . . .

Every time the first part of this scene is shot, I need to drag Isaac out on the sled, knowing that it's the last time I'll see Bran and Meera. As well as being relentlessly mauled, I find this element the hardest to act. In the story I'm saying goodbye, but I also know I'm saying a real-world goodbye. I've tried to dismiss this feeling, stuff it down all day, but at that moment it feels as though it's going to break me in two.

The day finally starts to draw to a close, but I sense Jack wants to squeeze one last drop out of it. One last drop out of me. As I understand it, he wants one more take of the death scene. I am empty, completely spent of energy, but I'm also determined. For a moment, I lean up against the set, close my eyes, and wait for the dressers to appear and reset the scene.

Suddenly, I hear Isaac's voice.

"Kristian! Kristian!" he's shouting, and when I open my eyes, he's beckoning me over. As I approach, a director's chair has been placed out in the middle of the quarry, and there's a semicircle of actors and crew standing around.

"We're done?" I mouth to Jack.

We're done, he nods. Apparently, Jack's happy with the last take. *Already? It's over? But I'm not ready! I'm not ready for this to end*, I think. I swallow hard to stop myself from choking up.

By now, Isaac is stood on a chair. He's looking at me with an expression of pity. Then, he gently smiles. I smile back and I watch as he lifts up a megaphone and presses it to his lips, as is the custom for all actors leaving *Game of Thrones*.

"It's a series wrap, and a season wrap for Mr. Nairn!" Isaac shouts. The applause ripples around the stone basin.

When Isaac jumps down, he does come over to give me a hug. Not a Barney the Dinosaur pile-on, but a little brother embrace.

"Thanks," I say, trembling.

"I can't believe it!" he tells me.

Helen is now also by my side.

"We're going to miss you, Kristian, you've been such a big part of our lives."

"I cannot thank you enough for everything, Helen," I say.

I can't believe this either. I can't believe this will be the last time I'll say a morning hello to Helen. I can't believe it's the last time Isaac and I will act together, go to lunch together, tease each other. We'll stay in touch—that much I know—but I also understand that our lives fork here. Isaac and I will never experience this intensity again. In the series, Isaac will carry on, but who knows what direction my life will take. And when *Game of Thrones* is eventually history, who knows anything.

The crew is starting to pack up around us. I'm still stood in my Hodor undergarments and my epic coat. In a couple of days' time it will be my fortieth birthday, so we'll go on to celebrate at dinner in a while. I head

towards my trailer to get dressed. And that's when it hits me like an iron bar. For years, I've cursed these filthy stinking clothes. I thought I'd be glad to step out of them, but when I drape my coat on the sofa and peel off my tunic and breeches, I break down. I sob from the pit of my stomach. My heart hurts as much as my battered body. *Season wrap for Kristian Nairn*, I think. But where does Kristian Nairn go now?

OWNING THE
THRONE

"Excuse me . . . " An old woman with patchy dyed hair and crooked teeth bangs through the glass doors.

"Excuse me," she shouts again.

I'm seated alone at a Formica table, about to shovel a chicken hot wing into my mouth. She sits down opposite and scowls, then glances up at the counter, which is empty. She looks back at my name badge.

"Kristian, is it? Why aren't you working, Kristian?"

"Erm . . . "

I'm lost for words, but I realize her confusion. I am dressed in a maroon shirt and black trousers: full Kentucky Fried Chicken garb.

"I'm really sorry," I smile. "This drive-thru is closed today."

"Closed? So why are you in uniform?" she harrumphs.

"We're actually filming here. It's my lunch break," I explain. By now I'm ravenous, turning over the hot wing in my fingers. This woman is clearly so desperate for a chicken bargain bucket that she's not noticed the cameras.

"Sorry, we're closed today," a manager rushes in and politely ejects her.

It's spring 2017 and I'm filming an advert for the brand KFC in a drive-thru in East London. It's a funny take on Hodor's "Hold the door" morphosis—only this time the words "chicken with fries" gradually morph into "chicken with rice" to advertise a healthier fast-food range. It's one of the few commercials I've agreed to since leaving *Game of Thrones*. Many offers have come my way, but I'm choosy about what I accept. From the outset I've decided that I want to retain some integrity—nothing too tacky. A generous paycheck may sway that on the odd occasion, but so far I've been able to stick to my guns. Plus, while I'll always be Hodor, I don't want him to be my sole calling card. It's why, when auditions land for upcoming acting roles reminiscent of the dumb stereotype I've always resisted, I say a polite thanks, but no thanks. Even so, this advert tickled me.

Instead of acting, I've been mainly in the air or on the road. Touring *Rave of Thrones* has consumed me since I hung up my Hodor coat. Every night I appear with two folders of music and play a different set. I prerecord nothing, just go where the crowd and the music takes me. Sometimes I'll play an arena of thousands, sometimes a hall of three hundred in America's Midwest. I've played Gorky Park in Moscow with laser lights bathing the colonnades of its grand entrance. I've headlined at the Bomb Factory in Dallas to a crowd of six thousand. *Six thousand people* all dancing and chanting. What an incredible buzz I felt stepping out to that. *How the fuck did I get here?* I recall thinking as I stood onstage taking it all in.

In Belgium I was recently approached by the tour manager of superstar DJ Dimitri Vegas. I was appearing at the FACTS comic con festival in the town of Ghent when I was tapped on the shoulder and asked if I'd like to meet him backstage. My eyes almost popped out of my head.

Dimitri was dressed as Jon Snow—one of the most authentic costumes I've ever seen, with a proper sword and real leather tunic.

"Do you want to open for me at Tomorrowland?" he asked.

Tomorrowland is *the* electronic dance music festival held in Boom in Belgium: a crowd of one hundred thousand plus. I thought about it for a nanosecond.

"Absolutely," I said, wondering when this luck that's been following me around might run out. But I could play in a cardboard box and be happy, so long as the crowd is jumping. That reward means everything to me.

In the space of twelve months, I'm booked for as many as seventy dates spanning every single continent. And from Russia to China, Romania to the Philippines, the words "Hold the door" have been shouted at me in every possible language. My rider is simple: all I want is to travel business class with oodles of extra legroom. If I'm taking a red-eye shuttle to wherever, I don't want to do it in pain, legs rammed against the seat in front. Or to be a burden to anyone squashed next to me. I haven't come this far to return to the school bus of thirty years ago. And I want a five-star hotel with a bed big enough for me to crash out in the early hours of the morning.

Most of the time, though, I don't remember my own name. Time zones tumble into one another. The jet lag makes me dizzy. I wish I could throw myself into a wormhole of time travel to reach places. But something keeps driving me. When I get out in front of the crowd, I *fucking* love it. And when I think about it now, *Game of Thrones* seems like a dream—one big mind-blowing fantasy where a guy who's never acted a day in his life is gifted the chance to change his life. More than that, to change who he is—to wear a crown on his own self-styled throne, to place a value on who he is.

For sure, not everybody understands that value. But I'm tougher now, more able to take a hit. Nevertheless, when one article appears in a well-known DJ magazine with the headline "Step Away from the Decks, Hodor!" I feel crushed. The feature is about celebrities-turned-DJs and while it mentions other DJs, it mainly name-checks me. The journalist

accuses me of dumbing down the club scene—precisely the criticism I've worked so hard to avoid from the get-go. When Guy rings to tell me, it feels like the ground is being pulled from under me. Yet when I regain composure, I wonder whether this journalist has even bothered to watch one of my sets. *I don't play dumbed-down tunes!* I think. In response, I write a post to the magazine. I never engage in arguments online, but this felt like a step too far. I've been a DJ for twenty years, I tell them. And at a time when the dance music scene is in the doldrums, I'm bringing house music to a fresh audience. Shouldn't that be applauded and supported? Not stamped down and lambasted.

Two days later the article is retracted, but by then my faith in human-kind has been well and truly restored. As it turns out, I didn't need to write a post. Online, so many fans and DJs have staged a pile-on and fought my corner for me. Even the legendary Canadian DJ Deadmau5 has posted—*Deadmau5*! He says I'm the real deal and what I'm doing should be celebrated. *Thank you. Thank you. Thank you*, I think. To have that momentum behind me gives me new wind in my sails.

—

IN JULY, THE MONTH THE KFC ADVERT FINALLY AIRS, I'M ON tour throughout the States. I'm due to play a festival and a club in San Diego when an Instagram message lands in my feed: "I see you're going to be in my city tomorrow. We should get married when you come."

I have no idea who this person is—whether he's a fan of Hodor or a fan of Kristian—but I have fun with my reply.

"There's no time! At short notice who'll arrange the flowers or the catering?"

I press send and wait.

Answer: "My cousin's a florist and my mum's a cook."

Ah, got me there.

When I look closely at the guy's profile picture, he seems like just my type. After all these years, I think I do have a type. Studious looking; I

love a pair of glasses. Someone who looks like they have a spark and a crazy sense of humor to match mine.

"Maybe we should have a drink first, before we get married?" I suggest.

"Sure, I'd like that," he agrees.

My random caller's name is Trevor. As it turns out, he isn't just good-looking but he's smart and funny, too. When we meet in downtown San Diego, I've given him an hour in my head. Immediately, I'll know if I'm interested, but the hour turns into two, then falls headlong into three. He's less self-deprecating than I am, but we laugh. We laugh a lot. And he seems caring. He talks a lot about his family who live nearer the Mexican border. He's also a high-flyer—a leader at an e-commerce company.

That week, Trevor ends up watching me DJ at both gigs, and then flies with me to Las Vegas where I'm due to support the legendary DJ Steve Aoki at Hakkasan nightclub. The schedule is so tight between gigs that the only way I can get to Sin City in time is by private jet—at my expense. Private jet? This seems unreal, and I hope Trevor doesn't think this comes as standard. But it's so unbelievably cool, too. As we speed down the runway at San Diego, my legs might be cramped into this dragonfly of an aircraft, and I can't help clocking up the dollar signs as we lift off, but there's also champagne on ice and luxury fittings and our own personal pilot. Besides, there's no way I would have missed warming up for Steve Aoki. Honestly, if a private jet hadn't been available, I would have flagged down a stork carrying a diaper bag or wrestled a witch on a broomstick to take me there. Some opportunities you can't say no to, whatever the cost. It's also the first time a limo has ever picked me up from the runway. *Wow! If people back home could see me now*, I think.

When we get to the venue, the lights, the sound system, the graphics, the crowd are all to die for. As for Steve Aoki—he's lovely, and turns out to be the biggest fantasy and sci-fi geek on the planet. For days after, I replay that night in my head. *Me? Kristian Nairn? On the same bill as Steve Aoki? Jesus fucking Christ!* At times, I have to pinch myself. I pinch myself about Trevor, too. After an intense week together, I fly to my next stop in Atlanta, but we talk every day. You could say we're an item, albeit a

long-distance item. And a few months later when I'm back in San Diego we agree: let's get married.

The strange thing is, it's the most understated proposal ever—not me at all: no get-down-on-one-knee-surrounded-by-a-flash-mob affair. We're in bed when Trevor and I are chatting:

"I've never met anyone before who I've wanted to marry," I say.

"Have you thought about marrying me?" Trevor asks.

"I have," I reply, which is the truth. Trevor feels different to anyone else I've ever met. He's loyal and dependable and kind.

"So, are you asking?" he says.

"Well, what if I was asking?"

"If you're asking, then I'd definitely say yes," he smiles.

"Well then, I guess I'm asking . . . "

That week we dream up a wedding in Iceland in the depths of winter under the glow of the northern lights. We'll plan it, we say. But when my tour schedule restarts, we're back to snatching snippets of time in between long-distance flights and hotels and DJ sets. As 2017 rolls into 2018 Trevor and I do go to Iceland to check out wedding venues (and the northern lights, which don't materialize) before my schedule kicks in again. As agreed, I play Tomorrowland in Belgium (DJ Ferry Corsten opens his set with two tracks that I've written) and also the Sunburn Festival in Delhi where I support the DJ trio Above & Beyond—so far, the most terrifying set of my entire career. Beforehand, I was unsure about how my music would go down in India, so some bright spark suggested that to give my set added oomph I play guitar during one track while real flames shoot from the guitar's neck during the finale. Not only did the contraption fitted to the back of the guitar by the pyrotechnics team make the instrument almost impossible to play, but minutes before I walked onstage Guy noticed the floor cables leading to the decks buzzing and sparking.

"Just don't step on anything," he warned.

It'll all be fine, I told myself. But there's nothing worse than playing for an entire two hours wondering whether you're going to spontaneously

combust at any moment, like the ill-fated drummer in the *Spinal Tap* movie. On a positive note, it turns out India is completely mad for house music!

Alongside the gigs, I still love doing comic con appearances and sci-fi festivals (Hodors now turn up complete with a full-sized door!). And when 2018 rolls into 2019, there's the final season premiere of *Game of Thrones* to attend in New York. Cast members old and new have been invited. Isaac is there—it's wonderful to see him, and I'm also so proud of him. Over the years whenever he's texted, he's smashed some exam or another and he's due to begin studying neuroscience at university in London. Isaac was always going to be brilliant at anything he turned his hand to.

Every other cast member I've held in my heart since my departure is also there. Our strange, disparate family joined once again for a few hours. During the evening, I also hear a rumor that there had been a plan to bring me back for season 8—Hodor risen from the dead and now part of the undead, a White Walker. I'm so glad it never happened. Hodor needs to stay just where I left him.

At the event, Trevor is my plus-one. That feels good, too. It feels good to have him here as my partner. But it also feels good because I want the world to see us. Others on the red carpet are with their boyfriend or girlfriend, husband or wife, but we're the only visible same-sex couple. But when we walk out to the bank of photographers, Trevor and I are in sync.

"Are you ready?" I say to him.

"I'm ready . . . " he winks back.

His hand firmly clasps mine. *Let's give these paparazzi something to photograph*, I think. If I have this platform, I'm going to use it. And if my red-carpet shot is going to be fired around the world, then I want every gay person out there to know that they can walk down any street, whether it's in Belfast or Birmingham, and know that they are enough. They are okay. This is okay. They're not different or weird. They don't have to feel shame. If a big freak like me is out here doing this, they'll see they're not alone.

Flash–flash, flash, flash, flash.

And as we leave the Radio City Music Hall venue and head on to the post-screening dinner, I hear that familiar chant once again—a street spilling over with fans: "Ho-dor! Ho-dor!" Trevor thinks it's crazy and funny and completely in-your-face overwhelming. I do too, but I also love it. I still *really* love it.

—

IT'S THREE MONTHS SINCE THE FINAL SEASON OF *GAME OF Thrones* airs on TV. Controversy is still raging about its ending (which, for the record, I love) but I've continued touring. I'm in St. Charles, Missouri, when I call home to speak to Mum. When it comes to her, I've become a terrible worrier. While I'm away, as I so often am these days, she's home alone. Only our two dogs keep her company. Hannibal, my little super-hero who saved me in Ballyhornan, has long since passed away, which was tough. But now I have two more to take care of: Cora, an adorable white Maltese, and Ebony, a Lhasa apso with a long, black regal coat.

For a few years now, I've also installed CCTV and heavy-duty security around our property: a front gate linked remotely to an actual guard who snarls through a loudspeaker at anyone crossing the barricade. Mostly fans are lovely, but after season 6 I received one message on Twitter that sent me into a frenzy. *The plant in your living room needs watering*, it read. Too freaky to ignore, and I knew I'd never be able to live with myself if anything happened to Mum. The CCTV system also means I can log in from wherever I am in the world.

It's a few hours before my set in St. Charles when I call home. The dial tone clicks in. It rings . . . and rings . . . and continues to ring out. It's late afternoon Mum's time, which is strange. She's usually there. *She'll ring me back. She'll be distracted by the dogs*, I think. Besides, I'm due to fly home the next morning.

That evening, I play my set—one thousand people packed into a down-town nightclub—yet throughout it, Mum plays on my mind. When I

finish, I check my phone: no missed calls. Concern niggles me, but it's too late to call. *It'll be fine*, I reassure myself. *I'm home tomorrow.* But the feeling doesn't go away and the next morning, I call again. Nothing. Normally by now Mum would be ringing me—asking me what I want for dinner after a long-haul flight. I log in to the CCTV. I search through every inch of the house where there's cameras. I scan the living room, the kitchen, but there's nothing: no movement, no life—just the sound of Cora and Ebony clawing at the hallway floor and their torturous yelping. My mind is racing: *What's happened? Where the hell is Mum? Did she go somewhere and not tell me? Did I forget what she's told me?* I'm punishing myself, too. *I should have flown earlier. I should have canceled. I should have listened to my gut feel.*

When I eventually arrive in Dublin airport it's more than thirty hours later. Still no missed calls. But I'm in Dublin, landing here for the convenience of a direct flight, when I should be in Belfast. I need to be in Belfast. As I jump into a cab, I obsessively check my phone.

"Belfast, please, as fast as you can," I tell the driver.

Every few miles, I remind him.

"Please, can you hurry? Faster, please. You have to go faster." As we cross the border the sweat is pouring from my forehead and my hands are clammy from clutching the handset. And when I finally arrive, I hear the dogs howling in the distance as I make my way down the driveway.

Now another problem kicks in. I don't have my keys. I rarely take them. It's one more thing for me to lose, but also why would I? Mum is always there: reliable, dependable Mum, the one constant in my life. My very own Wonder Woman.

"Mum! Mum!" I look up and shout. *You should have taken keys, Kristian,* I berate myself. If I thought I could open the door, I'd ram my shoulder up against it and push hard, really hard, but I know it's futile. I've had five mortice locks fitted, and the door is the thickness of a bank vault. "Mum!" I keep shouting and banging harder.

Suddenly, a voice breaks my concentration.

"Is everything okay, Kristian?"

When I turn around it's our window cleaner, staring at me confusedly.

"No, I can't raise Mum," I say. Then, I have an idea.

"Can you lean your ladders up against her bedroom window and have a look?" I ask. I'm too terrified of what I'll find to do it myself, so I watch him climb and press his face against the pane.

"Anything?"

"She's here, Kristian. Lying on the bed, in her underwear," he calls down.

"Jesus, can you bang the glass?" I shout.

"Pat! Pat!" He hammers the glass so hard that I think it's going to shatter. Every second he bangs feels longer than the last.

Eventually, he shouts down: "She's alive!" *Thank fuck*, I exhale. Apparently, Mum is now bolt upright, turned to the window, staring straight at him.

"She's no idea who I am, Kristian. She's out of it," he reports back.

Jesus. Fucking. Christ. What the hell has happened?

That day, it takes three firemen and two police officers to batter down the door. By now, I've phoned Jim, who's arrived. The second person I've called is Trevor, who's working in Chicago.

"I'm on the next flight over," he tells me.

"Thank you. Thank you. Thank you."

When the officers enter Mum's room, she's still upright, now pinning herself against the headboard, shooting daggers at them. "Fuck off! Go away!" she's shouting. And when they try to lift her, she loses her shit, just like I knew she would. I crouch down on one knee and hold out my hand.

"Mum, it's Kristian," I say softly. But when she turns her head, there's nothing. No recognition. No flicker in her eyes.

Mum is first taken to our local hospital, and then moved to a specialist ICU ward at the Royal Victoria Hospital in Belfast. She has a bleed on her brain, I've been told, and doctors have had to put her into an induced coma.

"Your mum's brain is swelling dangerously," the nurse tells me with a tender half-smile when Jim and I are taken to an anteroom. It has padded chairs and there's a vague smell of disinfectant. *Dangerously? Coma?* I think. *How can that happen? How can a person be okay when you leave them, then not? Not even conscious. Not even able to recognize her own son?*

"I'll give you a few minutes," the nurse says before she slips from the room, leaving us alone. Jim puts his arm around my shoulder.

"This can't be happening," I tell him.

Whatever I win or lose in the world, it's nothing compared to Mum. She means everything to me. She knows every inch of me, every emotion: the deep shame I carried about myself for years, my insecurities, my addictions, my strength I've had to pull myself up. And I know her in the same way. *This can't be over. I'm not ready! I'm not ready for this to end,* I think.

When I first enter her room, I feel a spasm of longing. Mum helpless is a real shock. Whatever Mum is, she's never been helpless. Now she's hooked up to a spaghetti of tubes and wires. A breathing mask covers her face and the steady rise and fall of her breath sounds heavy and labored like a human from the future—an Immortan Joe.

I slip my fingers through hers. She has bruising to the back of her hand where her IV tube is attached. She can't see me. As far as I can tell she can't hear me either, but I stay with her for the rest of that afternoon before Jim drives me home and stays with me.

—

MUM REMAINS UNCONSCIOUS FOR WEEKS, AND AFTER TREVOR lands I visit every single day with him. When she gradually comes around, she has little memory of what's happened, only that she vaguely recalls falling down the stairs and hitting her head before crawling up to her bedroom. I notice that she's not exactly the mum I know. Parts of her seem missing, like she's lost her sharpness—frayed around her edges— and she tunes in and out like a radio.

Mum has her own private room, and to cheer her up I buy a pram and wheel it into the hospital with Cora and Ebony secretly smuggled under some blankets. She loves to see them, and I love to see Mum happy. And when staff suspect something, they turn a blind eye. In fact, after a few weeks of sussing my game, they line up to give Cora and Ebony a cuddle: "We won't say a word."

Trevor stays with me on and off for the best part of three months before Mum is finally discharged. It's not long before Christmas 2019, and in preparation for her homecoming, we decorate the entire house with lights and streamers and trees.

In the intervening months, the majority of my gigs have been put on hold and I realize something else, too. I can't keep touring like I have been, catapulting myself around in a metal tube across the globe from time zone to time zone. I can't keep killing myself at the expense of the people that matter to me the most. I need to find a way to pump the brakes, to be near Mum. I need to find a way to give back all the love she has given me.

OUR FLAG
MEANS DEATH

I'M WALKING INTO THE STUDIOS AT BURBANK IN LA ON A bright summer morning. The pickup car dropped me right outside its entrance, even though I've rented an apartment no farther away than the length of two football pitches. After more than a decade in this business, I still need that wake-up call. Besides, Kristian Nairn does not do walking. But I reckon it's better to understand your strengths and weaknesses, and I know mine better than I've ever done before. It's June 2021 and I am forty-six years old.

Today, I feel lucky. *Really* lucky. When I stroll through the glass doors, the receptionist asks me to wait while someone is called to collect me. As I do, I'm thinking about my first trip to LA, to study with John Ruskin, whom I've kept in contact with all these years. *I must drop in on John while I'm here for a dose of his fatherly calm*, I remind myself. I'm also thinking

back to 2019, after the grand finale of *Game of Thrones*. Following the premiere in New York, cast members gathered in Belfast at the Titanic museum, for one last wrap party to be filmed for the series DVD.

I still recall finding that experience strange. Among some actors I sensed an elaborate façade—a need to present a glittering version of themselves to everyone they'd worked with over the years: a brag sheet of which major casting director had offered them a blockbuster, which hit Broadway musical they'd landed a part in. Halfway through, I'd taken a breather on the side when one leading actress sidled over and joined me.

"It's all a bit dick-swingy, isn't it?" she laughed.

"It is, isn't it?" I smiled.

Following my departure from *Game of Thrones* I had no major casting agents clamoring, no Broadway supremo calling. I had my DJ tour. But that felt okay. *More than* okay (last year I even opened for Tiësto and Fedde Le Grand). And as well as my handful of commercials, I've also now starred as the underworld god Tek in *Mythica: The Godslayer* alongside a small part in *Robin Hood: The Rebellion*. At the back of my mind, though, I knew that when a meaty part came along—a part that was right for me—I'd embrace it. And now, since almost losing Mum, I've become even more grateful for everything this life has given me. Today feels like one more incremental step in that evolution.

"Hi, Kristian, would you like to come through?" A studio executive appears and we wind through the studio lot towards the aircraft-hangar-sized building I'll be working in for the next five months. Thankfully, Mum has made a decent enough recovery that I can be here for this length of time. She'll never fully be back to her old self. I joke that like computer software, there was Mum version one, now there's version two. We've also had a global pandemic to sit out—just me, Mum, and the dogs for months on end going slowly insane. Mum can be forgetful, irrational, and angry one day and as light as helium the next. But she's doing okay. In truth, I think she's glad to get rid of me for a while. And I feel far more at ease, so long as we can speak by phone every day.

This production is called *Our Flag Means Death*. It's a pirate comedy created by the writer and showrunner David Jenkins. Its executive producer is Taika Waititi, the New Zealand actor and director riding high on his 2019 hit film *Jojo Rabbit*. Even before the offer to audition, I was a fan of his offbeat style. The series is also produced by HBO, so I feel I know the ropes. What's more, my part—a character called Wee John Feeney—feels as though he's been written especially for me. I'm not even sure I need to act! From the outset something about it felt perfect, although when I feel like that I've also learned to be on my guard. When I *really* want something, that's often when I don't get the callback. "Audition the fuck out of it, then let it go" is my carefree new mantra—a self-preservation technique in place before any disappointment swallows me whole.

The call for *Our Flag* came in at the end of last year through my new acting agent, Sasha. While Guy remains my manager overseeing all of my career, I've recently employed separate agents for acting, conventions, and music—a bigger setup than I've ever had. And the audition itself turned out to be a departure from what I'm used to. As well as a short read-through, I was asked to write a mini script to show how I might develop the part, the only brief being that I was a pirate on a pirate ship held hostage by the navy.

As I've never auditioned for a comedic role before, I did what any self-respecting former Belfast drag queen would do in that situation. I called Jim, who's a brilliant scriptwriter, and asked him to help. Jim knows me so well and I knew he could capture my humor. I'm also becoming fearless at highlighting my physicality, pushing my abilities. So, in a tiny window of opportunity punctuating successive Covid-19 lockdowns, Jim came with me to a studio in Belfast. I made my tape and sent it off. I auditioned the fuck out of it. Then, I let it go . . . The callback came two days later. "They really want you," Guy told me.

Today is the first time I've stepped inside Burbank, and I can't help thinking of the superstar names who have graced these corridors. Much of the action for this production will take place on a galleon ship, and

during several conversations I've had with the team, they've been desperate for me to drop by earlier to see the real-life replica that's been constructed here. But in the week since my arrival, I've refused.

"I only want to see it on the first day of filming," I've stood firm.

That's been met with sighs of dismay.

"But it's amazing, Kristian!"

It's been hard to explain. I might be hurtling towards fifty, but I still want to feel the surprise of being transported to another world. When I think about it, I've never lost that feeling of wonderment when I step onto a set for the very first time. I've never lost that childlike love for make-believe. At heart, I swear I'm still innocently Wonder Woman. I'm still Kristian Nairn running headfirst into the driving rain brandishing Granda's golf club, imagining myself as Thor. I hope to God I never lose that, or feel jaded.

I have met almost all of my seven fellow cast members, though. Everyone except Taika, who before today has been wrapping up production on *Thor: Love and Thunder*, a film to be released next year. I've also seen that as a good omen. Thor, HBO, Burbank, my first ever substantial speaking role. Somewhere in this universe, stars have aligned. Moreover, this ten-parter is not just a pirate story, it's a gay pirate story: a love story apparently based on a close relationship between the notorious pirate Blackbeard (played by Taika) and the aristocrat-turned-criminal Stede Bonnet (played by Rhys Darby), who meet on the high seas. Embellished, of course, for this dramatic retelling.

This week, I've been reading through the most recent script. Admittedly, in the six-month run-up to filming I've had my fears. Mainly I'm irritated by queer stories on TV. There's always tragedy; we're dying of some hideous disease, we're dancing to Gloria Gaynor, we're the gay best friend, we're depraved, we're twisted psychos. But this script seems different: a sweet love story between two fellas aboard the pirate ship *Revenge*. I'm not even sure there's a mention of the word "gay"—it's just a fact of life: We're here. We're real. We're just people in this story. And after all

these years, that's how I want to be portrayed. I'm not a gay man. I'm just a man who happens to be gay.

Admittedly, too, I've rolled my eyes over my ironic name Wee John Feeney. But the more I've understood of my character, the more I've loved him. He's sweet, he sews, he loves makeup and drag, but he's got a demon wit and he's also a pyromaniac—not afraid of violence when the need arises. Not so much of a gentle giant—but a big man with a big heart, a wicked sense of humor, and a burning underbelly. I have so much to bring.

What hasn't aligned for me so far, or anyone, is our pirating skills. Earlier this week we were complete strangers, piling onto two minibuses and driving to the Port of Los Angeles for a day's preproduction bonding.

What could be easier than practicing our techniques on a schooner docked in the harbor? Answer: every other activity known to mankind.

We've spent hours being shown the ropes by three professional crew: how to tie knots, how to belay a rope, how to brush the deck, how to tie a sail. Yet the only thing that any of us were able to remember is how to tie a sail. Half the actors, myself included, also refused to climb the ladder to the crow's nest. Way out of reach for my vertigo! And even stoking a cannon is a far more involved task than I ever expected. At the rate I put the gunpowder in, soaked the rag, and stuffed it down, then poked down the ball, I'd be dead in a hail of enemy fire.

And maybe with the exception of Vico Ortiz—who plays pirate Jim and seems as agile as G.I. Jane—and Con O'Neill—who plays Izzy and who's also achingly fit—everyone's physical test was abysmal. I didn't even attempt a forward roll. But bond we did, and I'm looking forward to working with this eclectic bunch. Naturally, there's always someone you gravitate towards on a first meeting and Nathan Foad (who plays Lucius) and I both seem to share a similar sense of humor. On the bus back from LA Harbor we stuck to each other like magnets and laughed like drains. And I can tell Nathan loves a good gossip, too. He's way camper than me, but I suspect we would even have a catfight about that!

MOST OF THE CAST ARE ALREADY ON SET WHEN I'M FINALLY LED through the studio doors, including Taika, who I'm introduced to for the first time. Taika seems fun and lively and I'm looking forward to watching him act alongside Rhys. As both hail from New Zealand, they've known each other for eons and it's always magical on set when there's that special kind of spark.

David Jenkins, the showrunner, is also present.

"So what do you think? Worth the wait?" he asks.

I'm actually gobsmacked.

"Wow. I think it's incredible . . . "

Slap-bang in the middle of the studio is a ginormous boat resting on billowing airbags so that when we're on board, it will rock as if it were really at sea. Already I feel as if I'm in this capsule universe—the only hint of reality being the green screen draped behind, plus a video wall, and an assistant director wandering past with a coffee and a croissant.

Then, when I climb up on deck, I'm shown around. There's hatches for cameras to hide in and ropes are cleverly laid out, even though they don't actually connect to anything.

But when I lean back to admire the giant sails, I'm immediately stopped.

"Please don't lean up against here, here, here, or here!" one of the crew runs forward and points.

"Okay!"

Apparently, only certain elements of the boat are made with real wood while other parts are made from balsa. One misplaced hand or foot and I'll crash right through it, so I make a mental note to memorize the weak spots. I fear that mental note is going to be lost many times over.

"I'm from Belfast, home of the *Titanic*—we don't have a great track record when it comes to boats that stay afloat," I joke.

One bonus is that I can roll onto set a little later. Unlike the hours I spent in makeup in *Game of Thrones*, nobody wants my tattoos covered. I

can have on show the five stars on my temple as well as the Thor across my shoulder, plus any other of my ever-evolving array of body art.

There's been some prior discussion about my accent, too. Having had one word to say for six years, it's played on my mind. "Do you really want Wee John to have this Belfast accent?" I've asked repeatedly during pre-meetings. Naturally, I'll have to tailor it—no one will have a clue what I'm saying if I speak the way I do to friends back home—but I've been told that my accent stays, too.

"We just want you, Kristian," David keeps repeating, which is still hard for me to believe.

—

Our first two days on set turn out to be brutal. Because of an anomaly in the schedule, we work nonstop that day and throughout most of that night.

"Is this how it's going to be for five months?" I say to Nathan in between takes.

"If it is, I'm one dead pirate!" he replies.

Throughout, we try to lighten the tension by taking photographs of each other laid out and snoring in between takes. The bell buzzer to indicate when cameras start rolling also goes off what feels like every thirty seconds. It's torture, so to keep ourselves amused we film actors' tired reactions to it.

I start to wonder what I have signed up to. Now that I'm a principal cast member I can't drop in and out. I have to be here and working every day. Thankfully, the overnight shoot is a one-off and we resume a regular schedule. Even so, by Saturday—my only day off—I'm exhausted.

Yet when I ring Trevor at the end of that week, I'm upbeat. He and I never did get married in Iceland. Our lifetime plan became a bit like the northern lights we hoped we'd see when we visited—ultimately, it didn't happen. But I put that more down to circumstance than anything else. My crazy touring schedule, plus lockdown upon lockdown, has made it

impossible, but we talk a lot. There's a lot of love there and, in truth, I'm not sure we've ever really broken up.

"How's it going?" he asks.

"Good," I say before I give him a rundown of everyone I'm working with.

"So far we all seem to gel," I say. Samson Kayo, who plays Oluwande, is turning out to be a joker and it's been hard to get through scenes with him without corpsing. The constant boat motion doesn't help. Taika is high-octane but keeps to himself a little more. Rhys and I share a love of gorgeous fabric, we've discovered, and I am more than a little jealous of the beautiful silk ensemble he gets to wear. Vico, the first openly nonbinary trans actor I've ever worked with, is so bubbly. Vico takes enthusiasm to a whole new level. Con's sarcasm cuts me up, but he seems warm and worldly. Nathan brings everyone together. And Joel Fry as Frenchie has a sense of humor so dry it needs hosing down. It dawns on me that we are the most random collection of ragtag misfits who have ever come together—not unlike this group of fictional pirates on this fictional ship.

"And you? Are you happy with your performance?" Trevor asks.

"I don't know . . . " I say.

In truth, there's been a lot of improvisation in our first scenes. It's a completely new style to me, and I'm unsure of how I'm doing. But I do notice I'm not consumed by that new-boy feeling I've battled with all of my life. I'm not drowning. I think I can do it. After all, I'm not in the Boy Scout hut of a Belfast studio anymore. I'm here, in LA, in the mother ship. That said, I do need to know.

The next day, when I arrive at the studio I take David Jenkins aside. He's been glued to the monitors and watching the action while Taika directs. As he's the show's writer, I want to make sure that I'm doing his character justice. I also want to do myself justice.

"Am I getting this?" I ask him.

"You're doing fine," David reassures me.

"The accent? It's okay?"

"It's really fine . . . you're leaning into Wee John well, Kristian."

"So . . . it's all okay?" I say nervously.

David looks at me, a little exasperated.

"Kristian. You're here because of you. We want your size. We want your accent, we want your tattoos, we want your humor. We want everything you have to offer. It's why we chose you. Just be yourself and go for it . . . "

Just be yourself and go for it. Those words sit with me. *I can do that now,* I think. I can really do that.

ACKNOWLEDGMENTS

I KEEP SAYING THAT I NEVER EXPECTED OR FORESAW WRITING a book. But, it seems, that's exactly what has happened. I feel very lucky to have lived the life I have, even with its ups and downs, and that wouldn't have been remotely possible without some very fine people.

Firstly I want to thank Helena Drakakis, who has been with me on this journey since the very first word. Without Helena, frankly there would be no book and certainly nothing coherent. So thank you, H, for daring to enter the churning morass of my brain, and helping to create something I'm very proud of.

I'd also like to thank Guy Robinson, my manager. It's been quite a trip so far, and it just keeps getting weirder! I never doubt that you have my best interests at heart and always push me to raise my game. Thank you for constantly making what's in my head a reality.

To everyone at publishers Hachette US and UK for believing in this project from the start. In particular to Brant Rumble and Emily Barrett, who commissioned it. Also to Kelly Ellis and Serena Brett.

UK agent Ben Dunn was instrumental in getting this book off the ground, and thanks also go to Kirsten Neuhaus at Ultra Literary in New York.

On a personal note, my sincere thanks go to Jim Crawford-Smyth, who I consider to be more of a brother. Thank you for countless laughs, inspiration, and keeping my head out of the clouds and my feet on the ground. You have many musical and literary talents the world has yet to see and I hope you'll get to show these off like you deserve to.

Jake Stormoen is brother number two. We met through *World of Warcraft*, as I have many friends. We spent countless hours in Azeroth, mostly annoying people and messing around. Thank you for always having my back and being a sensible ear I can confide in. I truly consider your family as my "American family" and I feel blessed to do so.

Trevor Brannen, things might not have worked out between us after many years of trying, but I'm so grateful to you for breaking the mold of people I have dated in the past. You taught me how to accept love, even though I was a slow learner. You are going to do great things in life, and I'll always wish the very best for you.

Martin Luney, my oldest friend. We endured Methody together, neither of us fitting in and with our own dreams outside of a school system that did not accommodate us. You have done *so* well, exactly what you said you would do, and I'm *so* proud of you! Thank you for a lifetime of friendship, and those times being yelled at for laughing in class.

To Lawrence Fryers, Mum's oldest brother. I don't think I've ever told you or said thank you, but to call you a "stand-in" father figure would be a gross understatement. You were 100 percent my father figure in the early part of my life, and you taught me so many valuable lessons. I think I get my love of collecting and "stuff" from you! May your health continue to improve and Christine, Christopher, and yourself continue to thrive.

Nan is sadly no longer with us but she was the kindest little lady in the world. Growing up, I never wanted for anything, and Nan was definitely on Mum's team. In fact, I feel incredibly fortunate to essentially have had two mothers. I miss her giggling in the kitchen when funny stories were told. I miss everything about her.

Leigh Wilson—you came into my life at a time of huge seismic change. All I needed was a little encouragement and not to be judged. You gave me that understanding along with a massive dose of fun. Not least, you helped me invent the creature that would morph into Revvlon!

Bridie Walsh, my old Australian friend. We've known each other since working the red-eye shift in a building society back office. I

commented on your badger (fake) fur coat, which I *loved*, and we embarked on a friendship that has spanned the years and the globe. You are one of the kindest people I have ever met and you are never far from my thoughts.

Nathan Foad—we met on the first day of *Our Flag Means Death*. We gravitated to each other straightaway and, honestly, the last two years with you have been an absolute hoot. I can't *wait* for you to write me a part. I'm ready . . . Nathan? Hello?

Isaac Hempstead Wright—my GoT onscreen charge who occupied and still occupies a very special place in my heart. Thank you, and thanks also to your mum, Helen, and stepdad, Tim, for making those years so much fun. I miss you all.

Michelle Chapman—you are never afraid to have the tough conversations with me, and also give me so much love and support. We connected instantly in Belgium at a convention in a way I have rarely done with anyone before. Now I think of you as my sister. You are killing it in this life, and you are one of my biggest inspirations.

Nathan Fillion—it's always heartening to discover that one of the world's best-loved actors is an even better person behind the scenes. You are warm, funny, and intensely generous. Truly, I look up to you.

Kathy Rose—you are one of the first people to become an island for me in LA and an island full of love and joy. You are so kind and talented and I love to see you doing so well. Thank you for always seeing the positive in everything and fostering my magpie-like love of shiny things!

Zander Hawley—you have such a beautiful heart and soul, and you are so insanely talented. I'm kind of in awe of you. It's so nice to meet one so young, and so turned on to the big feelings and emotions in this life. You are rising by showing your heart and it's incredible to watch.

Odd-Ragnar Stagnes—you helped me through a very important and transitory part of my life as I said goodbye to partying to begin the life I now lead. You were killing a bear (in *World of Warcraft*) in Darkshore when I ran past and healed you. And that was that! We met in the

Philippines many years later and I hope it's not long before we meet again.

Leigh Wilson—anyone who reads this book will see how important you were on my journey to becoming who I am. It still feels as important today as it did then. Don't think I can ever thank you enough, Leigh.

Mark Lowe—you are a steadfast and eternal friend, and even though you are bonkers with your south Belfast unofficial petting zoo, I want you to know that I appreciate it.

Raymond Fryers—one of two close uncles. You've had an interesting life and I'm really proud that you have found yourself again. I know it's not easy. Be good to yourself.

Thanks also go to Kelvin Collins, Kelly White, Graham Williams, Gerry Johnston, David Clawson, Andre Graham, Seamus Sweeney, Anthea Wilson, Aoibhinn MacManus, Luke Joynes, Ryan McKay, Jade Collins, Raymond Fryers, and Emma Hargreaves. As I type this I know there are many other names that should be here—far too many to list. Know that I haven't forgotten you and I will always hold a place for you in my heart and be thankful that you were part of my life.